# RICHMOND PARK

# RICHMOND PARK

## PARK

From Medieval Pasture to Royal Park

PAUL RABBITTS

AMBERLEY

First published 2014

Amberley Publishing
The Hill, Stroud
Gloucestershire, GL5 4EP

www.amberley-books.com

British Library Cataloguing in Publication Data.
A catalogue record for this book is available from the British Library.

ISBN 978 1 4456 1856 2 (hardback)
ISBN 978 1 4456 1875 3 (ebook)

Typeset in 11.5pt on 12pt Sabon.
Typesetting and Origination by Amberley Publishing.
Printed in the UK.

# CONTENTS

*To my ever lovely wife*
*Julie*
*With love and gratitude*

# Acknowledgements

Following on from the completion of my first detailed history of one of the Royal Parks, Regent's Park, I was keen to learn more about the others and there seemed to be two obvious ones – Hyde Park and Richmond Park. Not knowing Richmond Park very well, a number of visits in the winter of 2011/12 persuaded me that this was indeed a very special park, as well as a delicate but ancient landscape. Summed up by Richard Church in one of the earliest guides to the Royal Parks, Richmond Park is described by him as

> a great repository of history, and especially Royal history, the tale of our kings and queens, and the part they have played in the growth of our democratic way of life, a way which works because of the things shared between all the people; the rights, privileges, and constitutional pleasures, such as these Royal Parks so substantially represent … but having in common that Englishness which is so difficult to define, but which we recognise instantly, when we enter the gates of Richmond Park at any point.

He could not have summed up Richmond Park any better. It had to be this one, so there were many more visits throughout

2013 and I will continue to be a regular visitor and attempt to avoid the manic Mondays associated with every bank holiday! As with my first book on Regent's Park, I have attempted to capture not only the early history of the park, but its much later history, and to describe and understand the daily pressures this ancient park undergoes. There has been much written about this park already, and I can certainly recommend out-of-print studies by C. L. Collenette and former Superintendent Michael Baxter Brown, but especially interesting are the extremely detailed studies of Richmond, the palaces and associated parks by John Cloake; they are exceptional. As ever, my thanks to many for supporting me during this adventure. I am especially grateful to Richard Flenley and John Adams of landscape architects Land Use Consultants; Stewart Harding and David Lambert of the Parks Agency; Simon Richards, Superintendent for Richmond Park; Daniel Hearsum of Pembroke Lodge; and Nicola Gale and Emily Brewer from Amberley Publishing. Many of the images are my own, and those which are not I have appropriately acknowledged. My thanks as always to my family, but especially to my wife Julie, who never once complained as we hit the M25, heading down to Richmond for the day, where we truly enjoyed getting lost in this ageless landscape. To her this book is dedicated, as it is one of the parks she *truly* enjoys to visit.

# Introduction

The Royal Parks of London are without doubt a unique part of our national heritage, set around the River Thames. Their survival over the centuries is due mainly to their privileged royal status, which they still enjoy today, though they are open to the public, and financed and administered by government departments or trustees. If they had not been thus privileged by their associations with royal palaces, their gardens and parkland, they would in all likelihood have shared the fate of so many other fine estates, which have been engulfed by the roads and bricks and mortar of the 'Great Wen' of London, and now are remembered only in nostalgic street names and ancient maps.

The singular gift of the British to make changes while preserving the past is nowhere better demonstrated than in the continuing connections between the royal family and these parks. From Buckingham Palace – surrounded by St James's Park, Green Park and Hyde Park – via Kensington Palace and the adjacent Kensington Gardens, then the two fine palaces designed by Inigo Jones and Christopher Wren at Greenwich, through to Richmond Park – with its White Lodge, built by George II as a hunting box and now the Royal

Ballet School; and the Thatched House Lodge, which is the
home of Princess Alexandra, the Honourable Lady Ogilvy. So
it is that, although the upkeep of these Royal Parks has been
for a long time defrayed by the taxes of the public, which in
return has the right of access, the ambience of royalty, both
past and present, remains.

These parks wear a domesticated air with their planned
avenues and copses of trees, their carefully tended beds of
flowers, their artificial lakes and all the necessary adjuncts of
signposts, litter bins, lavatories, cafeterias and restaurants.
However, they were not always so. When William of Normandy
conquered England, he treated the kingdom as his own. The
royal estate was a third of all the land, and the royal forests
a sixth. The herds of deer and other game were protected by
savage laws. At that time in the eleventh century, England was
a primitive land of forest and marsh with agriculture confined
to clearings round towns, villages and monastic foundations,
linked by worn paths. The elaborate, civilised infrastructure
of the flourishing Roman colony, Britannia, with its network
of roads linking planned towns in a landscape of fertile fields,
orchards and vineyards interspersed with sumptuous villas,
had been utterly destroyed by successive waves of northern
barbarians. For the Norman and Angevin kings of England,
the forests were farmed for meat, especially venison, to feed
the royal family, the court officials, guards and trains of
hangers-on. Food was not plentiful. Bread, meat and ale were
the staple diet. When meat was needed from the royal forests
the deer were driven by beaters towards a line of hunters,
concealed at the edge of the wood. They had to be placed near
the run of the deer, for the effective range of an arrow from a
longbow was no more than 50 yards. This was deer farming,
but there was another much more exciting and prestigious
way of pursuing game – the hunt.

The Royal Parks of today are, for the most part, relics of
royal hunting preserves. The purpose of the hunt was not,
except fortuitously, the pursuit of game for food; it was to

satisfy the primeval desire to kill, with all the embellishments of elaborate ceremonial dress and customs, the coded notes of the horns, the baying of hounds and the ritual disembowelling of the prey.

Of all the Royal Parks, it is Richmond Park that is most associated with the royal hunt. The royal home of the manor of Shene on the Thames in West London was a particular favourite of Henry VII. The river ran through at a gentle pace, there was fine hunting to be had across its lands and it was discretely removed from the busy centre of the capital, standing on raised ground with fine views of the neighbourhood. Partly as a nod to his former Yorkist enemies, but mainly out of respect for his favourite earldom – Richmond in North Yorkshire, he decreed that the manor of Shene no longer be so called, and England acquired its second Richmond. Henry built his fine palace, and Richmond became a Tudor favourite, with its hunting lands providing them with great sport. However, it was Charles I who was to create the New Park of Richmond in 1637, amid great local controversy. He surrounded 2,500 acres, still the largest patch of green in London today, with an 8-mile wall and declared the land his and his alone.

Yet today Richmond Park is one of the oldest and certainly most fragile of 'urban' landscapes. Of all the Royal Parks, Richmond has retained its substantial historical character best, and many would still argue that it is one of the finest examples of a medieval pasture and deer park that remains today. There were no great designs here – no Nash, Mollet, Bridgeman, Wise or London – and no great remodelling, as occurred in St James's Park, Hyde Park or Regent's Park, just the dogged ambition of monarchs and park rangers, and commitment from individuals such as Walpole, Sidmouth and Lewis. From its evolution as the 'New Park' at Richmond to a Royal Park of the twenty-first century, this book tells its story and covers not only the history of medieval deer parks, but also the creation of Richmond Park through successive

monarchs, highlighting the current pressures on its fragile and delicate ecology. The history of Richmond Park is unlike that of any of the remaining Royal Parks and is a fascinating story.

# Early Days and the Pre-Enclosure Commons: The Medieval Parks

The ancient tradition of park making was brought to England with the Norman Conquest in 1066. Parks clearly existed here before, for example Ongar Great Park, the oldest known park in England, which was mentioned in an Anglo-Saxon will of 1045 under *deerhay* or *deerhag,* an enclosure for deer, as well as Dyrham Park whose name probably derived from the Saxon *deor-hamn,* another word for deer enclosure, suggesting that it too predated the 1066 Conquest. Little is known of these parks, although it is possible they were part of the traditions of the east brought over by the Romans and kept alive by the clergy, who travelled so much in the time of the Venerable Bede, but there really is little evidence of this.

There were, however, only thirty-one parks recorded in the Domesday Book in 1087; during the period 1200–1350, the heyday of the medieval park, this number had risen to over 1,900 at various times. The word 'park' occurs in many field names, especially in the West Country, and, at its most simple, means 'enclosure'. At first, parks in England were simply areas of land, sometimes comprising natural woodland, which had been enclosed and thereby physically

separated from the surrounding countryside. Enclosure also distinguished a park from a forest. These enclosures were made primarily as preserves for beasts of the chase – deer in particular – which were driven into *haias* – pens – from the surrounding countryside, and transferred into the park. These English medieval parks were, to a large extent, utilitarian enterprises, with their primary purpose to provide food for the enormous households of the period. It was the native red deer, smaller roe deer, and especially the more easily reared fallow deer introduced by the Normans in the twelfth century, which were bred in these early parks. These deer could be fed, bred and fattened more efficiently in parks than in the wild. A park of 1,100 acres yielded on average forty-four fallow deer annually in the years 1234–63, whereas an unenclosed area of royal forest in Essex, ten times the size, yielded precisely the same.[1] Along with deer, also kept in the early medieval parks were wild cattle, sheep, falcons, herds of swine, and studs for horses. By the end of the thirteenth century, swine had all but vanished in some parts of the country, and were only to be found in parks, their stock reduced perhaps by the selfishness of preceding kings, such as Henry III who ordered 100 boars from the Forest of Dean for his Christmas banquet in 1254.[2]

These parks proliferated, and from the thirteenth century onwards Rackham comments that we have a more or less systematic record in the form of 'licences to impark' – a kind of planning permission for a new or enlarged park. These parks reached their heyday in about 1300. He estimates that there were then about 3,200 parks in England, covering nearly 2 per cent of the country – roughly one park to every four parishes. Anyone who could afford it could have a park. It was seen very much as a status symbol of the whole upper class, of gentry and ecclesiastics as well as nobility. The deer of forests were at liberty to stray on to surrounding land, but those of parks, as previously stated, were confined by a deer-proof boundary. The fallow deer were as strong as pigs and more agile than goats; they were confined by a park pale, a special palisade of

cleft-oak stakes, the maintenance of which was very expensive in terms of labour and due to the cost of using the best timber. An alternative might be a hedge, or a stone wall – even if stone had to be brought in from some distance.

Ongar and other very early parks had a characteristic compact outline with rounded corners, which suggested economy in fencing. Later parks were often small or awkwardly shaped, perhaps because it was difficult to acquire the land, and were often short-lived. A park was a rich man's privilege – a valuable one, since it kept him in fresh meat over the winter – and a not-quite-so-rich man's status symbol. Whatever the original habitat of the fallow deer may have been, the medieval population thought of it as a woodland animal. Many records of parks specify woodland, though not all; they often included heath, grassland and arable, but their distribution closely follows that of woodland in the Domesday Book. Parks were thickest on the ground in well-wooded Hertfordshire, and there were very few in poorly wooded Lincolnshire and Leicestershire. By 1300, approximately a quarter of the woodland of England was within parks. Deer, grazing on young shoots, were one of the causes of shrinking woodland.

Parks were seldom 'set aside for hunting'. Slaughter of deer for the pot could seldom be called hunting, except by courtesy; and parks were no exception to the medieval practice of multiple uses for the same piece of land. Some of these land uses might remain from the previous history of the site, for it was seldom possible to find a vacant piece of land to impark, and usually there were trees as well as grazing. Many small parks were formed by imparking the whole of an existing wood, but we occasionally hear of treeless parks. A woodland park was self-contradictory and its life could be precarious. At Barking, the tiny park of 1251 still survives as one of the many small 'Park Woods' of which only the name remains as a record of a brief attempt to set up a deer park. There were two ways to maintain a wooded

park for a long period. The underwood could be given up and replaced by scattered pollards and big timber trees; the 'uncompartmented' wood-pasture was the usual practice on wooded commons. Alternatively, deer and wood might be combined in a *compartmented* park, consisting of coppice compartments and launds. Each coppice was felled on a longish cycle, and then fenced to prevent the deer harming it. Launds were grassland or heather areas in which the deer could feed and be caught; any trees in them would be pollarded. A grand example is Sutton Park, Sutton Coldfield, surviving miraculously in the midst of the Birmingham conurbation, with its enclosed 'hursts' – embanked woods, formerly coppiced – around a great open plain of grassland and heath ramifying between the 'hursts'.

Besides pollards, the open parts of medieval parks had oaks and other timber trees, which were allowed to grow bigger than those in woods – it being more difficult to replace them. In 1274 royal officials came to Stansted Mountfitchet in Essex and confiscated eighty oaks valued at 4*d* from Hasishey Wood, while the trees that they took from a nearby park were worth six times as much each.[3]

Despite their value in timber, these parks were best known for their game. Rabbits or 'conies' were introduced in the thirteenth century, bred in specially constructed warrens – 'long low earthworks called pillow mounds'. Elsewhere, parks at Petworth were partly used for deer and grazing cattle and horses, while within the Great Park there was a garden or orchard in which were over 250 apple and pear trees, more than likely grown for cider. As previously mentioned, many parks were 'compartmented', not only to separate deer from the woods, but also to separate different breeds of animal. In some instances there were different enclosures for varying species of the same animal. Smaller game such as hares, partridges and pheasants were raised in warrens which might also lie in the park.[4] The variety of game ensured an abundant supply of meat, which could be salted down for

winter use. Fish were also kept in specially dug ponds called vivaria or stew ponds, many of which were later turned into ornamental lakes of eighteenth-century parks. The advantage of a large number of detached ponds meant that fish of different species or ages could be separated for better management and that there was a constant supply should one pond require emptying for cleaning.

With such a diversity of usage, the medieval park functioned as a kind of auxiliary farm. In addition to meat, we know it was an important source of fuel and building timber. Hay, too, was sometimes grown in yet other enclosures within the park, to augment the winter feeding of the deer. A number of parks were rented out for cattle pasture, by a process known as 'agistment', or were even partially turned into arable land. This was especially popular after the Black Death of 1348, when the population was severely depleted and the shortage of labour made it expensive to maintain land in the form of parks.

Initially, these parks were the property only of the monarch and the great territorial magnates – the ecclesiastical and secular nobility who held their lands from the Crown in return for services. These leading members of the nobility were called tenants-in-chief and numbered 170 after 1066. They further divided their lands among smaller holders on a complex variety of terms. The bishops and abbots were granted 26 per cent of the land and the lay barons 49 per cent.[5] The territorial unit by which most of the land was organised was called a manor, and every manor had a lord. In theory, 'manorialism' was an autocratic system of land ownership that mimicked the relationship of a monarch to his subjects: 'The lord divided his manor, as the state divided the kingdom – in two parts: one he retained for his own support ... the other he parcelled out.'[6] The land he kept for his own use was cultivated by his bond tenants and called his demesne land; the rest was divided in return for services. By the thirteenth century, when feudalism had declined, these services were

commuted to money and rents. The latter became the
main source of revenue for landed estates and the one that
continued down the centuries to make them such valuable
properties. 'Manorialism' in reality was never a standardised
system, as it was continually adjusted to suit differing needs.
A man's social standing was indeed estimated by the amount
of land he held – the size of his estate – which might consist
of a number of manors. So the ownership of a park from the
outset was a symbol of power, privilege and prestige. This,
however, gradually descended through the rank of society to
the lesser nobility, down to the newly created gentry at the
end of this period; the latter acquired them through wise
marriages, growing wealth, a widening land market and
above all the system of primogeniture – inheritance of the
firstborn.

The kings owned the greatest number of parks, followed
by the bishops and abbots. Despite a continual sale of Crown
lands from Henry I's reign onwards, at the time of the
Commonwealth there were still between ninety and a hundred
parks that belonged to the Crown. Most great landowners
held manors scattered in different parts of the kingdom,
partly due to fortunes of marriage and partly to the Crown's
concern that no baron should hold too much land in any one
area. Manor houses were also generally at some distance from
their parks, which tended to lie beyond the cultivated strips
of open fields on unimproved or marginal lands. They were
certainly not conceived as aesthetic enhancements to a place
of residence until much later, when this became one of their
most important roles. On occasions, there was no residence
nearby at all, and lodges were built to house the lord and his
household on their hunting trips to the park. However, the
monarch was different – his civil residences, where he stayed
on his progresses through the land, were often located in
the middle of his parks and forests in good hunting country,
enabling him to combine affairs of state with those of the
chase. At times expenditure on these residences exceeded that

on military construction. The Pipe Rolls in the reign of Henry II reveal that £537 was spent on military construction as against £566 for civil. At Clarendon, for example, he turned his hunting lodge into a great rural palace large enough to accommodate the magnates attending the council of 1164.[7]

Initially the king's houses were scattered all over the Midlands and the south of England but, as royal government became more centralised and Westminster became the administrative capital, these houses were gradually given up in favour of ones within a day's ride of London. Edward III had a ring of satellite houses and hunting lodges around Windsor so that wherever he chose to hunt he had somewhere to eat and sleep. Windsor Castle was his main dwelling and the manor house in the park his 'private retreat'. Other lodges were primarily the dwelling place of the parker or ranger and were much simpler buildings, although in subsequent centuries they became the kernel or site of major residences or seats.

The office of parker or ranger was much sought after, especially by the younger sons of noblemen, whom primogeniture – almost universal by the thirteenth century – had left poor and with little means of livelihood. Many of these appointments are listed in the Calendar of Close Rolls such as that of Richard Milton, 'Parker of the Parks of Assheley & Guddesber, in the Manor of Tiverton, County Devon, [and] 6d daily as his wages for the above office during his life'.[8] The average size of a park during this period was probably between 100 and 200 acres. Knowsley, Eridge and Ongar, three of the oldest parks, were much larger, as were some of the Royal Parks, such as Woodstock, Windsor and Clarendon, each having a circuit of about 7 miles, representing an area of some 2,500 acres. As Rackham has stated, the method to enclose a park was a combination of a bank and a fence – the park 'pale', a word which gradually became synonymous with the park itself. These fences were constructed of stout posts and strong stakes of cleft oak fixed to a horizontal rail,

surmounting a bank with a ditch. These 'deer banks', as they
were called, were quite formidable earthworks, measuring
some 30 feet in width with some remains still evident today.
The ditch was usually on the inside – though in some counties
it was dug on the outside, what is known as a reverse ditch.
The boundary of Ashdown Forest, East Sussex, was impressive
and was renamed Lancaster Great Park after John of Gaunt's
duchy in Lancaster. Its 14,000 acres were said to have been
enclosed by a ditched bank and fence around the year 1300
in order to make a hunting park. The abundance of place
names such as Chuck Hatch, Pound Gate and Greenwood
Gate surrounding the park suggests that this was indeed an
immense park, and that these were gates through which it
was entered.

On occasions, hedges, living or dead, replaced fences. The
park at Higham Ferrers was 'fenced with a ditch and a dead
hedge'.[9] Water could also form a natural boundary, and, in
stone country, stone walls encircled the park. It was indeed
a requirement on the lord to make his park secure against
both animals and men. The Statute of Winchester in 1285
declared that not only had the boundary to be 200 feet from
any highway but the lord must 'make a wall, dyke, or hedge
that offenders may not pass, or return to evil', presumably
referring to poaching. Boundaries were well guarded and
accessed by entry gates but also punctuated by deer-leaps.
These were devices whereby deer were able to jump into an
enclosed area but not out again. Licence to construct one
had to be gained from the king, who claimed sole right to
the deer. When granted, this licence was known as the Right
of Saltory or Saltatorium. Before imparking, as many deer as
possible were driven from the outlying land into the park.
The king made a number of gifts of deer to help owners stock
or restock their parks, records of which abound in the Close
and Pipe Rolls of the twelfth and thirteenth centuries. Out of
607 deer taken in one year by Henry III, over 100 were given
away live to stock parks.[10]

The primary physical characteristics of a park were some sources of natural water, woods and 'wood-pasture' (the admixture of turf and trees). The trees gave cover for the deer, and the grassland or 'launds' provided pasture. Rackham described these launds as either treed or treeless, and occasionally pollarded to provide browsing wood for the deer. Such trees – often ancient oaks – are still characteristic of many deer parks, as are un-pollarded trees, with their canopies all nibbled to the same level at their base by the deer. However, of all the uses to which a medieval park could be put, the most desired was that of a private hunting ground. This, more than any other purpose, lent the park its aura of exclusiveness, and made it a 'status symbol *par excellence*'. The king claimed possession not only of all deer, but of all other beasts of the chase, together with the sole right to hunt them; others might do so on his authority alone. Twenty years after the Conquest, the king designated throughout the country enormous tracts of generally wooded land 'forest', wherein he and his court alone had the prerogative to hunt, occasionally granting the privilege to others. A complex system of rules and harsh penalties known as 'forest law' was established both to enforce his claim and to protect and conserve the deer in those areas. The term 'forest' had nothing to do with a forest in the physical sense: it was a purely legal term stemming from the Latin *foris*, meaning outside. Forest law did in fact lie outside the common law of the land, having its own bureaucracy of officials and its own courts to administer it. Transgression of these laws was harshly punished. It was considered less criminal to take another man's life than that of a beast of the chase.

Forest law also included the protection of the *vert* – the trees, undergrowth and herbage needed by the beasts of the forests for cover and food. For this reason many who owned land within 'forest' areas found that not only had they no hunting rights but their rights to timber and 'pannage' – the acorns and beechmast foraged by swine – had also been lost

to the Crown. A park was one of four recognised hunting grounds: forest, chase, park or warren – the latter three being areas in which private individuals were allowed to hunt, and exempt from forest law. A chase was a large, unenclosed area of land in which a few great individuals were granted hunting rights. A warren was initially an enclosed area of private land over which the owner had the right to hunt smaller game, such as rabbits, hares and pheasants – a game park. By the time of Henry II, a quarter of England had been declared royal 'forest'. Forty-two forests are mentioned in the Calendar of Close Rolls for 1244–1326. Needless to say, the forest laws were greatly resented by rich and poor alike, and were one of the issues that united the barons with the people against King John. It was stated in Magna Carta that 'all forests which have been afforested by the King in his time shall be disafforested'.[11] Even so, it was not until 1298 that the forest laws actually began to wane, and land gradually became 'disafforested'.

Certain forests were granted by the Crown to noted individuals; Edward II gave the forest of Lancaster and Pickering to the Earl of Lancaster, and Richard II later granted the Forest of Dean to the Duke of Gloucester. However, as more land became available for private landowners, parks grew in number, while forests diminished. By this period, hunting had developed from basic necessity into a highly ritualised sport with its own laws and observances, brought to England by the Normans. These laws invested it with an almost religious solemnity, with specialised terminology for its procedures. The chase provided opportunities to develop 'courage, endurance, honour, discipline and horsemanship', proficiency in fighting on horseback being the mainstay of Norman military power. Courtesy and the spirit of fair play were an integral part of the chase, and beasts had to be taken with 'nobleness and gentleness … and not killed falsely'. Hunting was very much the domain of the upper classes. With its moral import, hunting was considered a part of the

education of a boy from the age of eight. Because of limited space, hunting in parks necessarily differed from 'hunting at force', for which mounted horsemen with servants, horns and hounds gave chase to a stag for miles, galloping along great swathes cut through the woods of royal forest or private chase – the characteristic image of the 'sport of kings'. The method of hunting in parks was described in detail by the Duke of York in his translation of *Gaston Phoebus*. Men leading specially trained hounds went into the coverts in the early morning to find the game by scent; without disturbing it, they reported back to the master of the game, who would decide which report sounded best. The chosen beast was then roused by running hounds, driven out by beating – the 'battue' – and chased around the park by hounds and horsemen, who drove it towards the stand where the king or queen stood waiting to shoot with a crossbow. A 'feuterer' was a man who led a greyhound; a 'limer' was a bloodhound; 'teasers' were small hounds that teased forth game in the coverts. Bucks, male fallow deer, were the most popular deer for hunting in parks, being smaller than the stag, the male red deer, and thus easier to confine. This form of hunting was to reach its zenith in the Elizabethan period.[12]

By the fourteenth century, it was deemed necessary to own land worth forty shillings a year to qualify to keep greyhounds, or to use ferrets, nets or other means of taking deer, hares and rabbits. For breaching these laws, the penalties were severe and could mean up to a year's imprisonment at least. The common man therefore had no chance or opportunity to hunt for another two centuries. As expected, poaching by the poor became a passion, the only means by which ordinary people could come by game. A landowner was charged by the king not to allow unlawful entry to his hunting grounds, and if he failed to do so he was fined ten pounds. Nevertheless, in such rural, wide-open areas, largely unpopulated, poaching was hard to prevent. Records of the manorial courts are full of accounts of poaching. Four men were prosecuted for breaking

in to a park that belonged to the Bishop of Norwich, and for killing three bucks in 1285. On another occasion a man was excommunicated for deer poaching in the same park.

From the beginning of the thirteenth century until the middle of the seventeenth century it was necessary to have a licence to make a park. Imparking without one could lead to heavy fines. The equivalent of a land search was also carried out to see if any loss of rights to the king or others would be sustained by imparking. Parks often took in the waste or marginal lands of a manor, and also at times common lands where peasants had customary rights of 'estovers' (wood and fuel) and pasturage – rights often held since time immemorial. Such rights were jealously guarded, and any who tried to revoke them were fought in the courts. The Statute of Merton in 1234 was created to ensure that those rights were maintained or that those about to lose them were compensated elsewhere. It was hotly debated. When the bishops of Ely used their manor at Hatfield in the Chilterns for hunting, they were obliged to allow their tenants to continue to exercise their rights of pasture in the 1,000-acre Great Park. Even Edward IV had to compensate the townspeople of Windsor for loss of land when he enlarged the park in 1467; likewise, when he enlarged his park at Castle Donington, Leicestershire, in 1482, he gave up 402 acres of his demesne land to his tenants to persuade them to relinquish their common rights in the area where he wished to build a house.[13]

Nevertheless there were plenty of instances when rights were lost and no compensation given, and parks, like the forests, were much resented, particularly where highways were diverted for the purpose of creating them, though this too had to be agreed in law. On the death of both William I and Henry I, their parks were routed by the people and nearly all the game lost. As in ancient times, laying waste to a park was still a form of protest. By the end of the thirteenth century there was less wasteland for parks owing to increased cultivation. There was also more pressure on

land from the peasantry as a result of increased population. Imparking became more unpopular as the peasants saw potentially arable land disappear into private parks. In 1285 the Statute of Westminster allowed manorial lords to enclose land providing they left enough for their tenants. What was enough was of course often debated and open to dispute. Thus, imparking, like other forms of enclosure, began its long and contentious history.[14]

With the labour crisis following the Black Death, sheep grazing played an increasingly important role in the economic viability of the park, along with the leasing out of pasture. However, by the second half of the fifteenth century, wealthier landowners were already beginning to perceive the park more as an amenity than a resource. They began to build their manor houses alongside their parks or even within them. A new phase in the history of the park was emerging.[15] Many of the most famous deer parks continued to be formed or extended throughout the fifteenth and sixteenth centuries to complement the great houses that were now being built, such as Wollaton, Compton Winyates, The Vyne, Charlecote, Clarendon, Hardwick, Osterley, and many others. In 1617, the diarist and traveller Fynes Moryson observed that

> the English are so naturally inclined to pleasure, as there is no Countrie ... wherein the Gentlemen and Lords have so many and large Parkes onely reserved for the pleasure of hunting, or where all sorts of men a lot so much ground about their houses for pleasure of gardens and orchards.[16]

Moryson reckoned that any man who had an income of between 500 and 1,000 pounds had a deer park.

The prime recreation in these parks still remained hunting. The daily hunt was a habit of many landowners, no doubt in imitation of their monarch. However, increasingly it was the hare or fox, rather than the stag, that was hunted as the main quarry, though for James I and Charles I deer hunting remained

supreme. On his accession in 1603, James I was said to have taken a month for his progress from Berwick to London, hunting in the parks of his hosts on the way, lecturing on the art of venery, and demonstrating his prowess in blowing a mort, the note sounded on a horn at the death of a deer. If he found a park too small for his hunting – or understocked, as he clearly found that of the Earl of Westmoreland – he did not hesitate to order its enlargement. The earl imparked a further 314 acres at Apethorpe, and the king presented him with gifts of deer to stock the park.[17] Likewise James I enlarged his own parks, extending and walling the old deer park of Greenwich (imparked in 1433); adding 9½ miles of wall to Theobalds, acquired from his chief counsellor Robert Cecil by forcible exchange for Hatfield; and adding 168 acres to Bushy Park. At the same time, however, he continued alienating Crown lands for revenue, and by 1609 the number of Royal Parks, which in any case had steadily declined under Queen Elizabeth, was a little over 100. Charles I, who came to the throne in 1625, continued the practice, but his passion for hunting led him to enclose 2,000 acres to form one of the greatest Royal Parks – Richmond Park – on the model of a medieval deer park, and in a manner as autocratic as a medieval king.

# Richmond Park: A Royal Hunting Ground

The connections to royalty in Richmond need to be understood before describing the development of the park and ultimate imparkment by Charles I, as they are closely connected. Local historian John Cloake has studied the area in detail, the connections to royalty, the development of the palaces of Shene, the links to the park and the continued royal connections.

Until 500 years ago Richmond was called 'Shene', with many versions of this name, especially in the Middle Ages. The oldest is 'Sceon', dating from AD 950 in the will of Theodred, Bishop of London, who owned land there. Its meaning is 'of a shed' or 'of a shelter' in Anglo-Saxon English. Its royal connection, however, dates back to 1085 when Shene was part of the manor of Kingston, which belonged to the king, and stretched as far as Kew. Kingston was a place of importance, with seven kings of England crowned there in the tenth and early eleventh centuries. However, it wasn't until the early twelfth century that King Henry I detached Shene and Kew from the manor of Kingston and created the separate manor of Shene, which was granted to a Norman lord, John Belet. By the end of the thirteenth century, the manor was held by

two favourites and close advisors of King Edward I: Robert
Burnell, Bishop of Bath and Wells, Chancellor of England, the
king's chief minister; and Sir Otto de Grandison, a Swiss knight
who had been Edward's companion on a crusade. A few years
after the accession of Edward II in 1307, the manor of Shene
reverted to the Crown; Grandison retired to his castle in
Switzerland, and another part of the manor was surrendered
to the king.[1] By 1314, Edward II had granted the manor
house at Shene to found a monastery of Carmelite friars,
but three years later had relocated them to Oxford and once
again took control at the manor of Shene. He was a frequent
visitor until his forced abdication in January 1327, which
was ultimately followed by his imprisonment in Kenilworth
Castle, and death in September. Almost immediately post the
abdication, Shene was granted to Queen Isabella, the wife of
Edward II, who had plotted his downfall and now ran the
country with her lover Roger Mortimer in the name of her
son, the fourteen-year-old Edward III; ultimately, Edward
arrested and executed Mortimer, and stripped Queen Isabella
of her many lands. She retained Shene, though, until her death
in 1358.

It was, however, Edward III who began to convert the
manor house of Shene into a royal palace by the river, and
he eventually died there in 1377. His eldest son had died a
year before, so the heir to the throne was Edward's ten-year-
old grandson, Richard II, who was dominated by his uncles.
A dynastic alliance was formed by the marriage in January
1383 to Anne of Bohemia, daughter of Holy Roman Emperor
Charles IV. Happily, the marriage became a love match, with
the palace of Shene their favourite residence. Further works
were carried out to the palace, but tragedy was to strike
the young couple when Queen Anne died at Shene in 1394
of the plague. A heartbroken Richard was devastated and
ordered the complete destruction of Shene Palace; only a few
buildings and the gardens were spared. The site was to remain
abandoned for some twenty years.[2] With the lack of interest

shown by Henry IV, it was Henry V who, when he came to the throne in 1413, saw an opportunity to restore some legitimacy to the throne and carry out his father's unfulfilled pledge to found three monasteries as amends for his involvement in the murders of Richard II and Archbishop Scroope. Henry was therefore keen to set about making Shene habitable as soon as possible, and started work on building a new palace, as well as founding a Carthusian monastery on royal land to the north, the Brigittine convent of Syon in Twickenham and a Celestine monastery at Isleworth. Henry's plan was to build a new palace adjacent to the old palace site with a 'temporary' palace adjacent, while works commenced and progressed on the new palace of Shene in the winter of 1413. By the time of Henry V's death in 1422, the temporary complex was more or less finished, but the main palace was nowhere near ready. Work at Shene was suspended until 1429, when Henry VI was crowned king at the age of eight, and by 1439 the palace had been completed. Further activity occurred when Henry married Margaret of Anjou in 1445, and the palace and gardens were extended. The civil wars in the latter part of Henry VI's reign prevented any further work at Shene, and in 1466 Edward IV granted the manor and palace to his queen, Elizabeth Woodville. By 1483, Edward IV had died, and the throne was seized from the young Edward V by his uncle Richard, Duke of York, who became Richard III. Within two years, Henry Tudor, Earl of Richmond, had defeated Richard at the Battle of Bosworth Field and become Henry VII. In 1486 he reclaimed Shene from Queen Elizabeth Woodville, who became his mother-in-law when, in January of that year, he married Edward VI's daughter, Elizabeth of York.[3] It was not long before Henry VII embarked on an extensive programme of repairs and alterations. In 1497, with king and court present for Christmas, a fire broke out in his lodgings, causing extensive damage; yet further rebuilding was required, and was completed by 1501. The Great Chronicle of London records, 'The king, having finished much of his

new building at his manor of Shene and again furnished and
repaired that before was perished with fire ... [commanded]
that from then forth on it should be named his manor of
Rychemount and not Shene.' This renaming was naturally in
honour of the Yorkshire earldom bestowed on Henry's father,
by which title he himself had been known before he came
to the throne. Richmond Palace was by now a showplace, a
palace of some repute and shown off to foreign guests who
would visit.[4]

Henry VII made considerable use of his new palace at
Richmond. Apartments were allotted for members of the
family, with betrothals celebrated there, including that of his
ten-year-old daughter Mary to Philip of Burgundy's six-year-
old son Charles, who was heir to both Aragon and Castile in
1508. Four months later, on 21 April 1509, Henry died in his
Palace of Richmond to be succeeded by Henry VIII.

In the summer of 1509, Henry informed King Ferdinand
that he was to visit different parts of his kingdom. Little is
known about this first progress, except that it was fairly
extensive and included sojourns at Reading Abbey and the
Old Hall at Gainsborough in Lincolnshire, seat of Edward
de Burgh, Lord Borough, who later married Katherine Parr.
Henry went on progress almost every summer of his reign.
His purpose was not only to see his realm, and be seen by his
subjects, but also to enjoy the hunting that was to be had in
other parts. At that time of year, many courtiers had returned
to their estates to oversee the harvest, so the king was usually
accompanied by a smaller retinue and sometimes just by
his riding household. The queen usually joined him. As he
travelled, his hunting dogs came with him, transported by
cart. Progresses could last for up to two months; they usually
took place between July and October, and were carefully
planned in advance, with the itinerary being set out in the
detailed tables called 'giests'. The king's plans were only
altered when plague broke out or the weather was bad. Once
the progress was over, the king would return to London or

to his palaces in the Thames Valley, where he normally spent the winter. Later in 1509, he and Queen Catherine, who was in her first pregnancy, removed to Richmond Palace for the festive season. A contemporary described Richmond at this time as 'an earthly paradise, most glorious to behold'. There were fountains in the courtyards, orchards, and 'most fair and pleasant gardens', set with knots and intersected by wide paths and statues of the king's beasts. Around the gardens were novel timber-framed, two-storeyed galleried walks, and nearby was the recreation complex.

Henry VIII celebrated his first Christmas as king at Richmond. It was marked by a joust before the palace gates, on what is now Richmond Green, where 'many notable feats of arms were proved'. Henry was an energetic, vigorous man who revelled in frequent physical exercise, an unmatched sportsman whose expertise won him golden opinions in an age that valued such manly pursuits highly. He hunted, jousted, played tennis, wrestled, could throw a 12-foot spear many yards, defeated all comers with his heavy two-handed sword in mock combats, and could draw a bow with greater strength than any man in England. Henry was, however, also passionate about the chase. In 1520, Richard Pace told Wolsey that their master was getting up 'daily, except on holy days, at 4 or 5 o'clock, and hunts till 9 or 10 at night. He spares no pains to convert the sport of hunting into a martyrdom.'

Invariably, hunting took priority over business: the king 'was going out to have a shot at a stag', or his huntsmen were waiting and 'he must needs hunt them'. Catherine of Aragon also enjoyed hunting, and was still accompanying Henry as late as 1530. Most of the royal forests, paled deer parks and hunting chases had been imparked before 1200, many being annexed to royal castles, manors and hunting lodges. Henry's favourites were Windsor Great Park, Greenwich Park, Bushy Park, Epping Forest and especially Richmond Park. He established several more parks and chases, including Hyde Park, Waltham Chase, St James's Park, Nonsuch

Park, Marylebone Park and the vast Honour of Hampton Court.

However, by 1512, Henry was involved in war with France, and was personally leading his army in the field there in 1513 when King James IV of Scotland launched an attack on England. Defeated, James's body was brought to Shene Charterhouse where it was ultimately disposed of. A formal treaty of peace between England and France was later signed at Richmond Palace on 9 April 1515.

Henry made much use of Richmond, even more so because of the continued outbreaks of the plague in London, and carried out extensive works on the palace. However, by now Richmond had begun to see the growth nearby of a rival palace at Hampton Court. Cardinal Wolsey had acquired the lease of the manor and had started to build a magnificent palace, which aroused both popular criticism and envy. Catherine's failure to present Henry with an heir meant she was increasingly left at Richmond on her own with her daughter Mary, and Henry spent more and more time at Hampton Court, with Wolsey now a frequent user of Richmond Palace and Catherine ordered to remain in retirement there. Having eventually divorced Catherine and married Anne Boleyn, Henry was frequently at Richmond with his new wife, until she too fell out of favour, and was executed in 1536 for adultery. Henry married Jane Seymour and was reconciled, at Richmond, with his daughter Mary, who again made her home mainly at Richmond Palace. Queen Jane died there in October 1537, and within months Henry had married Anne of Cleves, a marriage that soon ended in divorce, but with a handsome settlement. This included the grant not just of Richmond Palace, but of the manors of Richmond, Petersham and Ham; Henry was no longer a visitor. After Henry's death in 1547, Anne handed back Richmond Palace and the manors to the young Edward VI, who immediately commenced a major programme of works.[5] Edward was a sickly youth and it was unlikely he

would produce an heir or live long enough to do so, but he named Lady Jane Grey, who was only queen for nine days, as his successor. Nevertheless, Princess Mary was proclaimed Queen Mary I in 1553. Her marriage to King Philip of Spain was celebrated at Winchester, and on the way back to London they spent a week at Richmond Palace. Mary made full use of the palace at Richmond, and, of all the previous monarchs, was the greatest user of it. Mary died in 1558 and was succeeded by Elizabeth, who was also a regular user of the palace, entertaining foreign ambassadors there. At the same time, the national concern was the issue of marriage and a successor. A number of suitors attempted to woo Elizabeth, many visiting Richmond; the most persistent was Francis, Duke of Alençon and later Duke of Anjou, the brother of the French king. Elizabeth was quite taken with him, but her council was not supportive. Despite a return visit to Richmond in 1581 and an apparent proclamation from Elizabeth that 'the Duke of Anjou shall be my husband', she changed her mind and sacrificed her personal happiness for her people's welfare. With the execution of Mary, Queen of Scots, it was from Richmond Palace that the defence of the country against threatened invasion was planned, and the Armada was thwarted. Elizabeth continued to be a regular visitor and resident of Richmond Palace, and in her ageing years spent many hours walking Richmond Green. After a bout of serious cold, she died at Richmond Palace in 1603.[6]

Shortly after his accession to the throne, King James, who was an avid hunter, decided that Richmond must have a bigger and better park. This was created, to the north and west of the palace, by adding much of the former Charterhouse land and some of the remaining demesne land to the smaller park made by Henry VI, and finally by adding an extra 33 acres, which the king purchased from the local inhabitants. This park, completed by 1606, with a hunting lodge at its centre, is today represented by the Old Deer Park and the southern part of what is now Kew Gardens. James was also keen to

see Richmond Palace now used primarily as a home for his children; Henry, who was the eldest, and Charles were both installed there with tutors. Henry had little interest in his father's pursuit of animals, but despite his apparent lack of interest was formally granted the Palace of Richmond as a residence, as well as the manors of Richmond, Petersham and Ham. Henry immediately had grand plans for Richmond, appointing Costantino de' Servi, architect Solomon de Caux, and his young surveyor Inigo Jones. In the summer of 1612, Prince Henry and de' Servi had discussed a full rebuild of the palace in Italian style, but de' Servi returned to Florence unpaid, and by October the prince had died suddenly of typhoid. Works were halted with only some aspects completed by Inigo Jones. For four years Richmond Palace remained in the king's hands, but when Prince Charles in his turn reached the age of sixteen he was invested as Prince of Wales and was granted the palace and the three manors. By the time he became king, he had made over Richmond Palace with the manors of Richmond, Petersham and Ham to his new wife Henrietta Maria of France. The palace was once again a base for the royal children. No major works occurred at the palace during this time but the most important royal work at Richmond was the enclosure of Charles I's great New Park up on the hill – it was to become Richmond Park.[7]

Deer parks associated with royalty were not new to north Surrey. As far back as 1293, a park had been mentioned as part of the manor of Shene. The manor formally reverted to the Crown in the early fourteenth century, having previously been owned by Henry I, and by 1437 a second park had been created adjacent to the palace, which had been developed on the riverside. Where the original park was located is still unknown, but the second one was to the north-west of the palace. John Bury, Yeoman of the Hall, was made keeper in 1440. This park was known as 'le Newe Park of Shene Co Surrey', and was stocked with fallow deer, because the grant of the keepership of the park included 'seven acres of

meadow by Chertsey Bridge Co Middlesex to feed the King fallow deer within the said park in winter time'.[8] There has been considerable debate among historians for many years about these two parks and their exact location. Surrey historians Manning and Bray, authors of Surrey's county history for 1760–1832, tell us Richmond Park 'appears to have been situated on the north-west of the present Vill of Richmond, between what are now the Royal Gardens and the River'. Mention is made of a park called 'The New Park', and Victorian historians thought it was probable therefore that the original park belonging to the manor at the time of the survey had had some additions made to it, either by Henry V, when he built the palace at Richmond, or by Henry VII, when he rebuilt it. In the time of Henry VIII, they state, 'the old and new parks were distinguished by the names of the *great* and *little* parks, the former being that which was sometimes occupied by Wolsey – after he presented his Palace at Hampton Court to the King'. Manning and Bray had a very definite theory about these two early parks, although it is still not shared by many. 'Which of the two parks, the old or the new, was the greater does not appear, nor are we told how long they continued separate.' They added,

> They were certainly separate in 14 ... as appears by [James I's] Grant of that date to his son Prince Charles, in which the new Park is distinctly mentioned, but were probably laid out together not long afterwards, one only being noticed in the Survey of 1649, which adjoined to the Green and is said to contain 349 acres. This is that which, together with the manor, was settled on the Queen in 1626/7; and the whole of it was, at the time of the Survey of 1649, called the old and little Park, because a so much larger one had then been lately made by King Charles I.

However, later historians have doubted this and have gone on to say that Manning and Bray were mistaken. Historian Hugh

Findley, writing in the *Surrey Archaeological Collections* on 'The Riverside Parks at Richmond', says that in Tudor times there were two parks – the Great Park, in which the lodge was sited, and the Little Park containing the Monastery or Priory of Henry V. He points out that Manning and Bray, as well as others, have assumed that the two parks were laid together in early Stuart times, because one park only is mentioned in the Parliamentary Survey of 1649. Findley asserts that this assumption is inaccurate, since it was not until about 1770 that they were laid together by George III. Nor, he thinks, is it strictly accurate to say that only one park is mentioned in the 1649 survey, since both parcels of land are included separately in it. The reason for the mistake, he believes, is that there was a change of designation, Charles I having formed the New or Great Park (the Richmond Park of today) on higher ground. What is even more confusing is the fact that the Great Park of Tudor times is described in the 1649 Parliamentary Survey as the Little Park, under the heading of the Manor of Richmond. The Little Park of Tudor times is described in a separate document headed 'Sheen alias West Sheen Priory'. Findley believes that the present Old Deer Park at Richmond and the riverside portion of Kew Gardens comprise the area of the two former parks, and thus suggests that this is where the parks lay.

After Charles I's execution in 1649 and the formal abolition of the monarchy, Parliament set about raising money through the sale of most of the royal estates, among which was Richmond Palace. The palace, together with the Green and the ferry, the Queen's Stables, some small pieces of land and the lordship of the manor, was sold in 1650; the property was divided, with some areas been treated as a stone quarry. By 1660, after the restoration of King Charles II, the surveyor general of Crown lands was sent to inspect what remained of Richmond Palace. The manor had been formally restored to Queen Henrietta Maria, but she showed no intention to return to it, and it was soon leased to Sir Edward Villiers,

who had been appointed keeper of the house and the (Little) Park and of the late monastery of Shene, as well as steward of the manor and its courts. In 1664 the manor and the palace were granted to James, Duke of York, in reversion after the death of the queen.

The subsequent decline of Richmond Palace, however, is not echoed in the fortunes of the New Park or Great Park, which, as we now know, was enclosed by Charles I. The first recorded transaction involving Richmond Great, or New, Park – the name by which it was first known, no doubt to distinguish it from the riverside parks – was in 1630, when one Edward Manning was granted a warrant 'payment of an imprest ... for railing in coppices, making ponds, and cutting lawns in the New Park at Richmond, and bringing a river to run through the same'. Whether this was the Beverley Brook, which bisects the park on the east side, is not clear, and there does not appear to be any reference to ponds along that section of the brook either. The 'river' was probably the watercourse that rises from natural springs in the west of the park, and is shown on the enclosure map prepared for Charles I. Much of the area, consisting of waste ground, Crown lands and commons, had already been a royal hunting ground long before any enclosure, and was known locally as Sheene Chase in the reign of Henry VIII. Later accounts describe it as being covered with gorse and oak trees. The Pen Ponds only first came to notice in John Rocque's Survey of London, made between 1741 and 1745, where they are very much the same in outline and area as they are today. There are references to 'the Great Pond' early in the park's history, and it may well have been that the ponds, as they are shown in Rocque's Survey, were developed from those, for the construction of which Edward Manning was paid in 1630.[10]

Charles I's enterprise and desire to enclose Richmond Park is very succinctly described in the Earl of Clarendon's *History of the Rebellion*.[11]

The King, who was excessively affected to hunting and the
˜orts of the field, had a great desire to make a great park for
˞ as well as fallow deer between Richmond and Hampton
Court, where he had large wastes of his own and great parcels
of wood, which made it very fit for the use he designed it to:
but as some parishes had common in those wastes, so many
gentlemen and farmers had good houses and good farms
intermingled with those wastes, of their own inheritance or
for lives or years; and without taking in of them into the park,
it would not be of the largeness nor for the use proposed. His
majesty desired to purchase those lands, and was very willing
to buy them upon higher terms than the people could sell them
at to anybody else if they had occasion to part with them, and
thought it no unreasonable thing upon those terms to expect
from his subjects.

Obtaining the privately owned lands and commons proved
difficult because of local resistance, and, although Charles I
eventually succeeded in buying out landlord and commoner,
he did so at the expense of personal popularity.[12] It was against
the advice of his advisers and ministers that he conducted
such business. According to Manning and Bray,

Laud Archbishop of Canterbury, Juxon Bishop of London, and
the Lord Cottington then Chancellor of the Exchequer being
solicited from day to day (by the people of the neighbourhood)
could no longer resist their importunity; and did warmly
represent to the King how impolitic a step he was taking.[13]
The major part of the people were in a short time prevailed
with, but many very obstinately refused; and a gentleman
who had the best estate, with a convenient house and gardens,
would by no means part with it; and the King being as earnest
to compass it, it made a great noise, as if the King would
take away men's estates at his own pleasure. The Bishop of
London [Archbishop Laud], who was Treasurer, and the lord
Cottington, Chancellor of the Exchequer, were, from the first

entering upon it, very averse from the design, not only for the murmur of the people but because the purchase of the land, and the making a brick wall about so large a parcel of ground (for it is not less than ten or twelve miles about), would cost a greater sum of money than they could easily provide, or that they thought ought to be sacrificed to such an occasion; and the lord Cottington (who was more solicited by the country people, and heard most of their murmurs) took the business most to heart, and endeavoured by all the ways he could and by frequent importunities to divert his majesty from pursuing it, and put all delays he could well do in the bargains which were to be made, till the King grew very angry with him, and told him he was resolved to go through with it, and had already caused brick to be burned, and much of the wall to be built upon his own land; upon which Cottington thought fit to acquiesce.[14]

By April 1635 only 5 acres had been purchased, but Kingston parish was willing to accept a sale of their common land if payment was not delayed, unlike nearby Mortlake parish, which refused. However, Charles was not to be deterred.

In consequence of the commission, a treaty was concluded, and by indenture, dated 22nd of December 1635, and inrolled in Chancery, between the King on the one part, and William Murray, Gregory Cole, Isaac Jones, and many others, freeholders, copyholders, and inhabitants at large of Petersham, Ham, etc., on the other part, they the same William Murray. Etc., did for themselves and their heirs, in consideration of £4,000 to be paid to them by his Majesty (to be divided into shares proportionable to the interest of the several parties), release and quit claim to his said Majesty, his heirs, and successors all their right and title in and to 265 acres belonging to the manor of Petersham, and 483 acres belonging to the manor of Ham.[15]

Further land acquisitions were made the same year, with a contract entered into with the tenants of the manor of Richmond for commons and wastelands containing 92 acres, and in the following year one with the Earl of Wimbledon and his tenants of Wimbledon, Mortlake and Putney for waste commonable grounds containing 220 acres. Further land was purchased from Humfry Bennett, who sold Hill Close in Mortlake, containing 9 acres, and John and Thomas Juxon and others a further 96 acres and 2 roods in Newgate Meadow, Pond Mead and Commonfields. A further payment was made to Edward Manning and Thomas Young in late 1635 for land to be taken into the New Park, and in the same year sums were paid to the former totalling £2,500 for making the brick wall, and £200 for enclosing with pales a parcel of ground near Beverley Bridge. Surprisingly, Manning found difficulty in recruiting labour to 'make a new park near Richmond, in which work there will be occasion to use many bricklayers and labourers'.

As described by Cloake, Manning's accounts for the works which he supervised in the park are in four parts, divided not by periods but by tasks. The completion of the brick enclosure wall took almost three years: the first payment was authorised on 26 February 1634 and the certificate of completion was signed by the surveyor general on 17 December 1637. The wall, originally estimated at only 8 miles, was a little over 11 miles in length when completed; at an agreed cost of forty-five shillings per rod of 16½ feet for a 9-foot-high wall, the total price, including gates and locks and some extra foundations on soft ground, amounted to £8,122 7s 6d.

The second task identified, and authorised in April 1635, was to make a paddock for deer, enclosed by wooden paling, in the corner of the park near Beverley Bridge. This was soon completed at a cost of £338 5s 2d. In total, nearly a mile and a half of paling was erected, but some of this may have been internal partitioning. Further work followed, and included the building of a lodge, a deer house and a barn, all in the deer

paddock, and some further enlargement of the paddock itself. This started at the end of May 1635, and was not completed until the beginning of March 1636, at a total cost of £874 8s 7d.

Manning's final task, from August 1636 to November 1637, had more to do with landscaping than construction. It was described as 'railing in coppices, the making of a pond, the cutting of lawns, etc, in the New Park of Richmond, and for bringing in a river'. What this quite entailed is not fully understood, but Cloake considers it to be probably explained by the harnessing of the springs by what was to become White Ash Lodge, and in the Sidmouth plantation to feed and supplement the two streams that now run into the Upper Pen Pond. The lawns that were cut may have been flat ground between this pond and Hartleton Farm, which now began a new existence as a lodge for a park keeper. It is likely that Manning's new pond was the embryo Upper Pen Pond. In 1650 we know that a punt was in use on 'the pond', and that between 1673 and 1683 over 8,000 loads of gravel were removed from the park for use in the local building industry. There are several gravel pits in the park, some now ponds. The Lower Pen Pond, if not the Upper, was probably the main gravel pit. Even once the Pen Ponds had been dug to their present extent, possibly at the very end of the century, they were still known as 'The Canals'. The original 'Pen Pond', now known as Leg of Mutton Pond, lies 200 metres west of the Pen Ponds.

The previous refusal of Mortlake parish was soon overcome.

From the inhabitants of Mortlake, who desire to be relieved [in the ship money assessment] in regard his Majesty has taken into his park at Richmond one half their lands. He is to ease them in such proportion as shall be just, and lay the sum abated on some part of the county that is easily rated or may better bear it.[16]

Others followed suit. Anne Cole, wife of Gregory Cole, who had a jointure in lands (an estate or property settled by a husband on his wife at the time of their marriage, to take effect in the event of his death) enclosed at Petersham, including the house which afterwards became Petersham Lodge, petitioned the king in 1637 expressing her willingness to yield her jointure, referring herself to his bounty, 'and beseeching that she might be considered accordingly'.

Despite and against all the opposition, Charles was determined to enjoy his new hunting ground and newly enclosed park. He appeared to keep to his word and paid a full and fair value for all the land enclosed. However, despite this, the way in which he had won possession of those private and common lands had more than a hint of medieval flavour. An account of the enclosure of the park, penned in the nineteenth century, is brief and succinct:

> Charles enjoyed hunting with hereditary zest, and had sacrificed to this passion the long-sacred immunities of British property. He enclosed Richmond Park with as little ceremony as the first Norman conqueror showed to the Saxon slaves, for the greater convenience of having red as well as fallow deer so close at hand.[17]

Much of the opposition arose from the fact, as the Earl of Clarendon remarks, that 'it was too near London not to be the common discourse' and that it embraced no less than six parishes. Collenette even goes so far as to suggest that Charles's actions with regard to the enclosure were one of the primary causes of his unpopularity.

The land enclosed within the 2-metre-high brick wall built by Charles I around his park would have been familiar with the medieval park makers. It was likely that it was well furnished with trees, especially on the higher ground, and dominated by English oak. The large stretches of waste and common land were more than likely a poor-quality pasture, with extensive

patches of scrub, bracken and gorse. The lower-lying areas were in the main wet and marshy, with broken lines of oak trees showing where former field boundaries existed. In a later account, written in 1751, of the making of the New Park, it is described how

> care was taken in the first instance fully to shew that there was no Design of hindering or preventing the Communication between the neighbouring Towns, by properly placing Gates ... [which] ... greatly prevented the grievances that were feared would ensue from this Inclosure.[18]

Gates were placed around the park at Richmond Hill, East Sheen, Roehampton, Wimbledon (now Robin Hood Gate), Coombe (now Ladderstile Gate), and Ham Common, and stepladders against the wall of the park, 'for the more convenient passing and repassing of Persons of all Degrees on Foot'. Whether this level of access was the reality is not fully known, but either way there was still access to the park, despite the enclosure, at least two rights of way across the park were kept open, and poor people were allowed to enter and gather firewood.[19]

Clarendon implies there were a number of houses in the park area at the time of the enclosure but in reality there were probably only two. One of the land parcels purchased by Charles I was an estate and manor house at Petersham in the west of the park, and this house, Petersham Lodge, was enclosed with the park. The second house was located on the west side of what is now Spanker's Hill Plantation, and in November 1637 a warrant for the payment of £290, spent on either the construction or the repair of this dwelling, was issued. There was no great house or palace within the park, and the two aforementioned houses were granted to the two joint keepers, appointed by Charles I in 1636. These two keepers had important roles and were 'Keepers of the Lodges and Walks' as opposed to 'the Keeper of the Park'. The

medieval tradition of granting the keepership of a Royal Park to a member of the nobility or a high-ranking member of the court or household was one that survived until the beginning of the twentieth century. It was a position of honour and great importance. Charles I selected Jerome, Earl of Portland, the son of Sir Richard Weston of Mortlake Park, as 'Keeper of His Majesty's New Park near Richmont' in June 1637.[20] It was not until a few years later that the title of the office was changed to Ranger; there is a reference to the 'Cheife Raynger' in 1650.[21]

The Keepers of the Lodges and Walks were Lodowick Carlile and Humfry Rogers. Carlile was assigned to Gregory Cole's house, Petersham Lodge and Walk, and Rogers to 'Hartleton Farme', which was repaired for his use, and each was paid a fee of £50 per annum. The personal life of Carlile is very well documented and provides an insight into the status of keepers during the seventeenth century. Carlile's father, Robert, a Scotsman whose family came from Broadkirk in Dumfriesshire, was a master huntsman to James I, and accompanied the king to England in that capacity when James acceded to the English throne in 1603. Robert Carlile returned to Scotland in 1608 to purchase some hounds from Dumfriesshire for the king, and made the same journey, for the same purpose, in 1628, by which time Charles I was the monarch. Lodowick was twenty-four years old when he married Joan, daughter of William Palmer, paymaster to the staff of St James's Park, in 1626. Palmer was a man of some standing, being described as a 'St James Park gent'. Lodowick himself was a minor court official as well as keeper of Petersham Lodge and Walk, being 'Gentleman of the Bows' to Charles I, and 'Groom of the Chamber' to the queen. He was, furthermore, a minor poet and dramatist, and some of his plays were performed at court. Joan Carlile was also one of England's earliest female professional portrait painters, and enjoyed the patronage of the court. Her most noteworthy paintings in relation to Richmond Park were her

*The Carlile Family with Sir Justiniam Isham in Richmond Park* (oil on canvas), painted in about 1649, and presumed to be in Richmond Park, and a portrait of Sir Lionel Tollemache, who later became ranger of the park, with his wife and sister-in-law. State papers authorise payment of £100 to Carlile and Rogers for 'pease, tares and hay, for the red and fallow deer in the Great Park at Richmond'. The park appears to have been well stocked, with both keepers likely to have been very busy ensuring deer were well fed and the park was sufficiently stocked. That there were deer to be so enticed is likely, with escapees from several deer parks stocked with fallow in the vicinity. Putney Park stocked fallow deer and was probably a good source of deer for Richmond Park, as it was owned by Jerome, Earl of Portland, who was the first keeper of the king's new park. In April 1640 Thomas Jones Esq., Master of HM Toils, and his two assistants – John Wood and Asa Scandover, the Yeoman of the Toils (toils were strong nets of considerable length, used for catching live deer) – were paid £2,121 16s 4d, in respect of their wages and expenses in catching an unspecified number of red deer in eight walks of Windsor Forest, and transporting them to 'HM new park at Richmond'.[23]

Charles I at first hunted frequently in his new park, especially until the start of the Civil War in 1642, but, as his troubles with Parliament increased, his visits became fewer and fewer. His last visits were likely to have been in 1647, when as a prisoner he was allowed to take part in his favourite pastime. On 28 August 1647, eighteen months before his execution, 'the King was a hunting in New Parke, killed a Stag and a Buck; afterwards dined at Syon', and only a few days later, 'the Duke of York, with the Lords, were hunting in the new Parke at Richmond where there was good sport – the King cheerfull and much company there'.[24] Charles I was executed at Whitehall in January 1649 and the Commonwealth was established; as we know, Parliament quickly passed Acts abolishing the trappings of royalty, and the sale of Crown

lands – with a few exceptions, one of which was Richmond
New Park, which was gifted to the mayor and commonality
and citizens of London, in recognition of the assistance
given by the city to Cromwell during the Civil War. The Earl
of Portland, a Royalist, lost his office as ranger of the park,
but the two keepers, Carlile and Rogers, were retained. The
uncertainty of the times was no doubt a good opportunity
for poachers in the park, but the two keepers stuck to their
posts. It was not easy for them, however; the Carliles fell
on hard times and found themselves in financial straits. To
make ends meet, they ran Petersham Lodge as a high-class
lodging house, entertaining a succession of nobility, squires
and others of similar standing, most of them with Royalist
leanings. It was therefore surprising that Carlile was retained
as a keeper during the Commonwealth period. The City of
London, however, was required by Parliament to maintain
the park to a high standard during their period of ownership,
and may well have considered it advisable, in the light of
their responsibilities, to make use of the expertise of both
Carlile and Rogers. Collenette describes the park during the
Commonwealth in further detail. A day of public thanksgiving
was declared on 7 June 1649, and the Lord Mayor and the
Common Council of the City sent a deputation to ask the
House of Commons to honour the City at dinner at Grocers'
Hall on that day. The Commons accepted the invitation,
and, after hearing two sermons at Christ Church, Newgate
Street, walked in great state to Grocers' Hall, where they
were sumptuously entertained.[25] The proceedings were
well received, and other 'faithfull services done by the Citty
of London to the Parliament and Commonwealth' led to
a resolution of the House of Commons, on 30 June 1649,
'that the City of London have the New Park, in the County
of Surrey, settled upon them, and their Successors: and that
an Act of Favour from this House, for the Use of the City,
and their Successors and that an Act be brought in to that
Purpose'. An Act was passed on 17 July, on the condition

that timber trees for the use of the Navy be excepted, and a recommendation 'as the Desire of this House, That the Keepers in the New Park be continued in their respective Places, and enjoy the Profits thereunto belonging; they continuing faithful to their Trust'. The gift was graciously accepted and a committee appointed among whose duties were to manage the New Park and other properties to the best advantage, and 'to sell all the woods now growing or standing on the said Parke and Mannors or any of them and not prohibited by Act of Parliament'. Concerns reached Parliament in relation to the City's intentions for making a profit from the park, and a later resolution was subsequently passed on 14 February 1650

> that the Parliament doth declare, that it was the Intention of the Parliament in passing the Act for settling the new Park at Richmond on the Mayor and Commonality of the City of London, that the same should be preserved as a Park still, without Destruction; and to remain as an Ornament to the City, and a Mark of Favour from the Parliament unto the said City.

As a result, the Court of Common Council passed an order to the committee 'to take care for the p'seruacon of the said Park and game according to the true meaning thereof And to manage the same with the least charge to the Cittie'. This was indeed timely and Parliament was correct in its concerns. Two contracts were made by the committee, apparently, according to Collenette, in the early part of 1650, one for a sale to Abraham Baker, for £480, of '80 Acres of Wood groweing in Newe Parke' at £6 an acre, and the other to Richard Hussey and Thomas Spicer, for 50 acres of wood at a price of £295. The full value was never received so it is assumed these were cancelled after the area had actually been felled and disposed of.

During these years and throughout the period of the Commonwealth, the two keepers Lodowick Carlile and

Humfry Rogers each received an annual salary of £50, but needed to supplement their income as already described. From 1652 onward, the City obliged them to pay an annual rent of £220 for

> Pannage, Agistements, Grasse, Hay, Gorss or Furs and Bushes and yearely profits groweing being or made of in out of or upon the Parke or grounds called the new Parke of Richmond in the County of Surry (except the goeing depasturing Feeding and keeping of 1300 Fallow deere and 200 redd deere in and upon the said Parke yearly with divers other excepcons in the Lease of the said Parke to them let).

This would seem to suggest that the park was well stocked with deer at this time and possibly beyond; whether this was always the case is questionable, however. On 14 February 1650 the Court of Aldermen for the Corporation of the City of London appointed a committee of several aldermen, together with a Major Salway, to negotiate with Mr Carey Raleigh of Kempton Park concerning the purchase of deer 'for the better storeing of New Park'. It was agreed by May 1650 whereby

> that for every head of Deare as well male as female younge or old that shalle safely delivered into the Carraiges upon the place and adjudged by Mr. Carlile and Mr. Rogers to be sound and well condicioned shalbee pd. to the said Mr. Raleigh or his assignes twenty shillings apiece.

Mr Raleigh was to pay the transport costs but the committee undertook responsibility for 'all Damages and mischances that shall happen to the said Deere or any of them between Kempton Parke and Newparke'.[26] Mr Raleigh was paid for the deer delivered but at the same time the committee was instructed to 'take in as many more good deere as they can'. Deer were also purchased by the City, for the park in 1650–1

and again three years later from Captain Ditcher. Further deer were also bought from 'the great Parke of Nonsuch' for £81, this purchase being made in 1651–2. The restocking programme suggests that the City was taking its obligations to Parliament seriously in respect of the care of the park. In April 1653 the Common Council appointed a committee of aldermen and sheriffs 'to Mannage the New Parke and all the Cityes Interest therein to the honour and best advantage of the Maior Cominalty and Citizens of this Citty According to the Act of Parliament graunting the same'.[27] Only five years later, another committee was set up 'to take a viewe of Newe Parke and the deere there'.

The significant wall built round the park by Edward Manning only a few years earlier was, however, a considerable source of trouble, and up to 1653 over £200 was paid out for repairs. The keepers received a yearly allowance of £20 for ongoing repairs and maintenance, but this too caused problems and the arrangement eventually broke down, as Rogers petitioned on 28 August 1656 that

> a breach in the wall of the sd Parke may be presently made up for the psevacon of the deere, which otherwise may escape by the said breach and that some other decayes of the sd wall may be tymely repaired, and course taken hereafter for the Constant repaire thereof as need shall require.[28]

The committee decided that the wall should be an expense no longer, as an order of the Common Council from 23 November 1659 reads:

> This Court beinge Informed from the Committee for the newe Parke that the wall of the same Parke is very much broken downe and decayed and that they had agreed with twoe persons for the makeinge of such a number of Brickes as should bee needful for the repairing and amending of the same wall. It is ordered by this Court that the said businesse

be wholly referred to the said Committee to Act therein as they shall thinke fittinge and doe further Order that the said Committee have the power to Fell and Cutt such Pollards and underwoods in the same Parke towards the defraying of the said Charges of the said repaires as they shall thinke Convenient.

The City enjoyed the control that they had, making several substantial payments for those days. They also took pains to keep up the stock of deer in the park, while enjoying the privilege of being able to order up from time to time 'a brase of fatt Staggs' as a present to Parliament,[29] or venison 'for entertainment of the Lord Protector and the Common Council'.[30] The new keepers, despite being retained, did appear to have difficulties at times with the new regime. When the Lord Mayor ordered 'a Bucke for the Commissioners of the monthly Assessment in the County of Surrey' – an assessment the corporation was trying to get reduced in respect of the park – the keepers refused to provide it. The Lord Mayor had to 'declare the sense of the Court to them personally that they shall obey his Lordship's warrant for deer, and shall give an account from time to time of what deer they shall deliver thereupon'.[31]

When Charles II was about to return to England in 1660, he wrote a letter from Breda in Holland to the Lord Mayor and aldermen of London. The City Corporation, who had some initial apprehension about the Restoration given the city's strong support of Parliament against Charles I, were quick to grasp this gesture. A deputation of fourteen members was sent to the Hague to wait upon the king, and its members equipped not only with a gift of £12,000 (£10,000 for the king, £1,000 each for the dukes of York and Gloucester), but with the news of instructions that 'the Lord Mayor doe at the first opportunity of his Majesty's comeinge to this City in the name thereof and of this Court, present the newe Parke to His Majesty and inform His Majesty that this Citty hath

beene only his Majestyes stewards for the same'.[32] The Lord Mayor and aldermen waited upon the king on 2 June to congratulate him on his restoration and to make the formal act of restitution of the park. The Lord Mayor took the opportunity in his speech to point out 'that it was well it was in the Citty's hands for that they had preserved the wood, vert and game'. The returning Charles II had the tact to reply 'that he looked upon the said Parke to be kept for him and that hee accepted it not as restored but as freely given unto him by the Citty and thanked them for the same'.[33]

By the time of King Charles II's restoration in 1660, Richmond Palace had been thoroughly despoiled. The splendid turreted and pinnacle building of the privy lodgings had completely vanished, as had the hall and chapel. Nevertheless, it soon became evident that Charles II had no interest in rebuilding Richmond Palace – perhaps the memories of his former home there were too strong and painful. However, he was much more enthusiastic about the very considerable task of repairing and replenishing with deer the royal forests and parks, for not all had survived the Civil War and Commonwealth as successfully as Richmond Park. Red and fallow deer were imported from Germany and elsewhere on the Continent for restocking the forests of Windsor and Sherwood, among others. Landed gentry and major landlords whose parks and estates had been fortunate enough to escape the worst attentions of the roundheads were quick to offer deer from their lands, no doubt with the intention of demonstrating their loyalty to the Crown.

When Charles II received back Richmond Great Park as a gift from the City of London, he promptly appointed as joint keepers with right of survivorship Sir Lionel Tollemache and his wife, Elizabeth, Countess of Dysart, whose father Sir William Murray had lost so much of his manors of Ham and Petersham to the park.[34] Elizabeth, in the words of a contemporary,

was a woman of great beauty, but of far greater parts; had a
wonderful quickness of apprehension, and an amazing vivacity
in conversation ... but what ruined these accomplishments,
she was restless in her ambition, profuse in her expense, and
of a ravenous covetousness; nor was there anything she stuck
at to compass her end, for she was violent in everything – a
violent friend and a much more violent enemy.

Their fee was 1s a day and they were charged with overseeing
and preserving the deer.[35] Another contender for the position
of ranger had been Sir Daniel Harvey of Coombe, who was
given, a month later, a grant of the keepership in reversion
after Tollemache and the countess.[36] At the same time the
two keepers, Carlile and Rogers, had their appointments
reconfirmed, Carlile as keeper of Petersham Lodge and Walk,
and Rogers of Hartleton Lodge and Walk. By September
1662, Carlile was being assisted by his son; Treasury Books
record the payment of £50 per annum to Lodowick Carlile
and James Carlile, his son, 'as fee for the custody and keeping
of His Majesty's house or lodge at Petersham within His
Majesty's Great Park near Richmond, together with the walk
in the same park to the said house belonging, as by letters
patent of 1660, Sep. 27'.[37] Carlile was also reinstated as
'Gentleman of the Bowes in ordinary to his Majesty', and
was granted an annuity of £200 by Charles II, in addition to
the £50 per annum he earned as keeper of Petersham Lodge
and Walk.

In 1661 Rogers resigned, and Sir Daniel Harvey and Ralph
Montagu, his brother-in-law, were jointly appointed to the
Hartleton keepership. The Carliles gave up the Petersham
appointment eighteen months later, and were succeeded by
Colonel Thomas Panton and Bernard Grenville, again as a
joint appointment with the right of survivorship.[38] Sir Daniel
Harvey was appointed as ambassador to Constantinople
in 1667, and his wife acted in his place as keeper of the
Hartleton Lodge and Walk, until his death in Turkey in 1672.

Carlile and his wife meanwhile had retired to London, where he died in 1675. He was buried in Petersham churchyard, as was his wife, who survived him by four years. James Carlile was appointed 'sergeant of the hounds of his Royal Highness the Duke of York', presumably when the family had left Richmond Park.

In the early years after the Restoration, there were a number of concerns for the keepers. Despite the efforts of the City of London, the wall was causing considerable concern and still needed a lot of repair. In 1661 £500 was spent, and a further £400 in 1663. In March 1666–7, £2,000 was spent on repairs to the wall, lodges and gates by the Surveyor General of Works, Sir John Denham.[39] Later the same year he was authorised 'to make bricks in the Great Park at Richmond and to cut furze and ferns there for burning same'.[40] The other problem was the deer stock. Sir Daniel Harvey, despite not being in office very long penned a report to the king about the park, a clear indication that not all was well.

> In the Park under my charge which is the best park that is left, for restoring and preserving the deer etc; no groom or huntsman should be allowed a key, as they steal the fawns, nor should the sergeants of the buckhounds have access when his Majesty is not there as they kill the deer, instead of training the hounds.[41]

Clearly all was not well with the deer herds. Treasury papers of 12 October 1669 record that, 'The Kings says that in the year 1660 there were 2000 deer in Richmond Park and now not above 600 of all sorts and asks the Attorney General which way to [put] out the keepers [whether] by a quo warrant or inquisition.'[42] The Attorney General decided on the latter action, with a hearing arranged for 25 October 1669. The first called was Colonel Panton, together with a Captain Coop acting on behalf of Lady Harvey, and explained that he himself had killed about ten deer, that 500 had died in one

year and that the king himself had taken away 200. Other
keepers were also called and admitted that about thirty brace
of bucks were killed in 1668. A royal commission was set
up and viewed 'the lodges, the condition of the officers, what
lodges they hold and by what title, the supply of hay for the
deer, the timber felled, the deer killed'. It seems, however, that
no conclusions were reached as a result of the investigation
or the commission and there is no record of their findings,
but restocking of the park to a target figure of 2,500 deer was
put in hand.

Without doubt, there had been some abuse of the park.
Poaching was not unknown, and in December 1633 George
Layton and Enoch Wicklox were indicted for deer stealing
in Richmond Park, the informer being none other than Sir
Daniel Harvey. Hogs were being illegally brought into the
park, to feed on beech mast and acorns at the expense of
the deer, and the keepers were instructed to put a stop to the
practice. One unnamed keeper was so diligent in doing so,
in 1667, that he became involved in an argument with the
owner of a herd of dogs, the outcome of which was a broken
leg for the owner. The unfortunate keeper duly appeared in
front of Bailiff Young at Kingston and was bound over to
keep the peace.[43]

However, in 1673 a new appointment was made. Sir Lionel
Tollemache had died and in February 1671–2 the Countess of
Dysart had remarried. Her new husband, and the new master
of Ham House, was John Maitland, Duke of Lauderdale, to
whom the keepership of the park was granted for life on 8
May 1673.[44] No mention of the countess was made in the
grant, but she continued to share the keepership by virtue of
her original grant. Lauderdale brought in two of his own men
as working keepers, John Somerville and Thomas Burford,
with their appointment confirmed by royal warrant in July
1673. They were granted as a residence 'a brick building
lately erected on a hill in the said park, near the village of
Ham' – more than likely the origin of Thatched House

Lodge. No replacement for Sir Daniel Harvey seems to have been appointed, nor was any successor appointed for Colonel Panton when he died some twelve years later. Somerville and Burford were, in effect, working keepers, predecessors of the head and under keepers of the eighteenth and nineteenth centuries. The office of Keeper of a Lodge and Walk fell into disuse a few years later.

After the king had enquired into the reduced strength of the deer herds in 1669, attempts were made to increase their number. In February 1671 a payment of £350 was authorised, in favour of a Mr Baker, for the provision of good upland hay at 35 shillings a load 'for 2,500 deer [to be kept] in New Park Co. Surrey'.[45] The intention was clear and commitment confirmed. On 17 November 1676 the Master of the Toils was instructed to

> remove the toils to Hyde Park and take thence 150 deer and carry them to Greenwich Park and the Great Park at Windsor and from thence to the Little Park at Windsor and take from thence 60 deer and carry them also to Windsor Great Park or as he shall receive further directions and from thence to Albury Park near Guildford belonging to the Earl of Warwick and there take 200 deer and carry them to Richmond Park there to be disposed of as Thomas Delmahoy shall appoint who has presented them to the King.[46]

Treasury Books from May 1680 describe

> The hay that was mowed in the meads starved all the deer that winter [1678], and will do so again for the ground is one-third overgrown with rishes this spring ... the meadows in the park will never be good for hay except they be scoured, the bushes grubbed up, the mole hills cut and the trenches cleared.[47]

In June of the same year, grass in the paddocks was considered to be of an inferior quality and not fit for feeding the deer. It

was ultimately cut and sold, and the subsequent revenue used to buy hay of a much higher quality for the deer.

The winter of 1678 was a difficult one for the deer in the park, with over 600 fallow and seven brace of red having died. Despite these losses, the deer herds remained viable, and it is highly likely that the number of deer in the park was greater than recorded in 1669, although whether the target figure of 2,500 was reached is unlikely. Either way, it was clear that the condition of the park was deteriorating. On the death of the Duke of Lauderdale in 1683, the duchess surrendered her rights to the keepership of the park and it was granted to Laurence Hyde, Earl of Rochester. Hyde's sister Anne was married to the Duke of York, later to be James II, and this may well have influenced the king's decision to favour him at the expense of the Countess of Dysart. The office then attracted a salary of six shillings a day, an entitlement to three bucks and three does in due season each year, and certain other perquisites, including the right to graze cattle and pigs in the park, providing that this did not conflict with the interests of the deer.[48] In 1684 and 1685 the earl made various improvements, including some on the agricultural side, where mossy and overgrown areas were ploughed up and sown with corn. In May 1686, James, now James II, granted Petersham Lodge, vacant since Panton's death, and the ground called the Green and Garrett's Orchard – a total of 15 acres on the north-west corner of the park – to Edward Hyde, Viscount Cornbury, and Charles Boyle as trustees for the Earl of Rochester.[49] Twelve years later the earl's grounds were extended by a grant, in October 1698, of just under 38 acres of woodland on the hillside between the grounds of Petersham Lodge and King Henry's Mound.[50] The woodland contained 300 oaks and sixty elms.

Rochester rebuilt the old lodge, and laid out new gardens, walks and avenues in the woods; his fine new house was designed by Matthew Banckes and built in 1692–3, with additions made by John Yeomans in 1699. It was simply called

'New Park', and as keeper he may well have regarded it as his own property. Neither James II nor William III seem to have made much use of the park. William was more interested in shooting than hunting, and seems to have found the Old Park more suitable for his purpose. Nor were Queen Anne and her consort Prince George keen hunters. Hartleton Lodge (at this time referred to as the 'Great Lodge') was left to one of the salaried keepers, Theophilus Westwood; his colleague Mr Aldridge resided in the house 'on the hill near Ham'. Accounts for 1699 show that the staff also included a mole catcher, whose name was Henry Badger, and a bailiff called Thomas Satchfield.[51] 'Aldridg' is first mentioned in Treasury Books of 1699. In 1714 a record of wages paid to park staff for the half year shows that 'Waldritch', a keeper, earned £12 10s 0d. Two years later £40 was spent on the repair of Aldridge's Lodge, which stood on the site of Thatched House Lodge. As one of four keepers, in 1733 his duties included 'watching, keeping and preserving the game of all kinds within and for the district of 10 miles about the Palaces of Richmond and Hampton Court'. The name Aldridge was associated with the park for at least the period from 1699 to 1754.

# Eighteenth-Century Developments

By 1702, Queen Anne had granted Rochester and his heirs
the keepership for another two generations in succession; so
on his death in 1711 Henry Hyde, his son, succeeded him
not only as Earl of Rochester but as keeper of the park. He
was given permission to sub-grant the keepership jointly to
Francis Gwyn and Richard Powys. Whether Gwyn and Powys
were ever in fact appointed is doubtful, for their names do
not appear in any Treasury Papers, while that of Rochester
appears frequently in the context of the park, and it was to
him that regular payments were made for the salaries of the
park staff. In June 1716, he also managed to petition the king
concerning the condition of the park. According to the earl,
'The Great Lodge (Petersham Lodge) in Richmond Great
Park, the wall and the ponds in the said Park and several other
places are [in] very ruinous and decayed condition.'[1] That his
petition was successful, at least to some degree, is evident
from a warrant issued later that year to Edward Young,
Surveyor General of Woods, detailing the cost of repairs to
walls, gates, etc., Aldridge's Lodge, the Great Pond Head and
drains 'being about 16 miles'. In 1726 some further land was
granted out of the park to an adjacent proprietor. The Duke

of Argyll was rebuilding Sudbrook, and obtained a grant of
an extra 30 acres for thirty-one years at a rent of £6 a year. In
1731 he was able to purchase 5 acres of freehold land from
the New Park grounds.[2]

On 1 October 1721 the mansion in the New Park was
destroyed by fire with an account of the events that night
printed in *Reed's Weekly Journal*. Not only the Earl and
Countess of Rochester and their family but also their daughter
and son-in-law, the Earl and Countess of Essex, were asleep
in the house. The fire was believed to have been started by
a spark from a fire setting light to some linen, which was
airing in the nursery. By the time a maid found the fire and
raised the alarm, the whole room was ablaze. The Earl of
Essex meanwhile, 'hearing a crackling noise, which was no
other than the burning of the wainscot', thought that thieves
were at work and leaped out of bed, clutching his sword,
to investigate. Then he and the countess heard the ringing
of a bell and shouts of fire. The Essexes, the Rochesters and
their son Lord Hyde got out of the house without danger.
However, those on the upper floor were trapped. Four
servants jumped for it; one was killed by the fall and another
severely injured. Lady Charlotte Hyde, the youngest daughter,
'had the presence of mind to let herself down by tying sheets
to the window bars and a servant standing underneath, when
she could come no lower, bid her jump and he would catch
her'.[3]

Rochester did not rebuild the mansion but sold the site
and his lease of the 52 acres in 1725 to Thomas Martin and
Nathaniel Halkeld. By April 1731, Martin and Halkeld's
executors sold 5¼ acres to the Duke of Argyll to add to
the Sudbrook estate, and they sold back some 25 acres to
the Crown.[4] The remainder was first leased, and then sold,
to William Stanhope, later created Earl of Harrington and
Viscount Petersham. Stanhope got the Earl of Burlington
to design a new house for him. It was a long, low building,
dignified and certainly very classical. Although it had a

basement and two storeys facing the courtyard and the road, the back facing the gardens, which were at a higher level, showed only a single storey above a line of very small windows at the ceiling of the floor below. In 1734 he was able to lease back from the Crown the land that Martin had sold.[5] In 1750, colonnades terminating in octagonal pavilions were added to the house by Edward Shepherd (an architect and developer, who, among other things, built and owned Shepherd's Market in Mayfair).

It was this disaster that foreshadowed an end to Lord Rochester's interest in the park, although it appears he was still sufficiently concerned to protest in 1723 at a proposal to raise money by felling trees in the park, pointing out that 'the wood in Richmond Park is rather for ornament than for profit'.[6] In 1727, with the agreement of his son, he surrendered the keepership to King George II for compensation of £5,000. The king then bestowed it on Robert Lord Walpole, the eldest son of his Prime Minister, Sir Robert Walpole. (Horace Walpole later wrote that, while his brother Robert was the nominal ranger, in reality it was his father, for he wanted to hunt there once or twice a week.)[7] It is likely that Sir Robert had already been hunting in the park with George I, for in the last year of his life the king had taken a new initiative. The Old Park with its lodge was in the hands of his son, the Prince of Wales. The Great New Park was his to hunt in, but there was no suitable accommodation in which to eat, rest or spend the night if so desired. Hartleton Lodge had degenerated to the status of a keeper's cottage. Petersham Lodge, where he might perhaps have called on Lord Rochester to provide hospitality, was no more. So the king embarked on building a new lodge for his own use. The site chosen was just to the north of Hartleton Lodge. The design was commissioned from Roger Morris, protégé and collaborator of Lord Herbert, later Earl of Pembroke, who perhaps put Morris's name to the king. By February 1727 the plans had been approved by Herbert and the king, and submitted to the Treasury. Having worked

out the cost at £5,780 2s 3½d, the Treasury then proceeded to suggest economies that would bring the cost down to £4,450, which expenditure they authorised, together with the appointment of Roger Morris as clerk of works and of Daniel Garrett, 'labourer-in-trust', as his assistant.[8]

The king died in June 1727 with the house only just started, but work was continued for George II and Queen Caroline. The elegant Palladian villa was completed in 1729 at a final total cost of £7,659, considerably more than the agreed budget after the attempted economies of scale by the Treasury. This included the facing of Portland stone, which the Treasury had tried to have replaced and substituted with brick in their attempts to find economies. So the 'New Lodge' acquired the name 'Stone Lodge' or 'White Lodge'. It was a small building, with only four rooms on the main floor, and a few bedrooms above, intended rather as a banqueting house than as a place to stay. An avenue of trees was planted from the lodge to Richmond Gate, then in 1736–7 the queen's private road was made to link White Lodge directly with Richmond Lodge (the buildings of Richmond Park are further discussed in Chapter Six).

Sir Robert Walpole was attentive to further improvements in the park and in particular to the other buildings in the park, and is said by his son to have spent £14,000 of his own money on improvements (descriptions of some of these are also in Chapter Six). He repaired and enlarged, by the addition of wings, Hartleton Lodge (henceforth known as the 'Old Lodge'), and constructed the pond beside it. This house was allotted for the use of his son as a ranger, and was of course available for Sir Robert's own use. Another building which Sir Robert enlarged was Aldridge's Lodge, whose namesake had died in 1734. Horace Walpole had mentioned that 'the thatched house' was one of his father's improvements, and he annotated the British Library copy of Robertson's *Topographical Survey* to the effect that his father had built the 'thatched room' or summer house in the grounds, from

which the house derives its present name of Thatched House Lodge.[9]

John Rocque's *Survey of the Country Ten Miles round London* in 1746 and E. J. Eyre's plan in 1754 are the earliest plans of Richmond Park in the eighteenth century. Both these plans show a number of other buildings in the park, whose origins may date from the Walpole era. There appear to be gatekeepers' lodges at the Richmond, Ham, Robin Hood, Roehampton and Sheen Gates. There are also cottages at the sites of Pembroke Lodge (called the Molecatcher's), White Ash Lodge, Bog Lodge (called Cooper's Lodge) and Sheen Cottage (called 'Dog Kennels' – but probably where the master of the hounds lived, as well as his dogs). The Eyre plan also shows a farmhouse and paddocks in the south-east corner of the park, an area which appears to be merely woodland and scrub on the Rocque map. The summer house, later called Princess Amelia's, near Richmond Gate on the brow of the slope overlooking Petersham, was already there by 1746.[10]

Walpole went regularly to the park at weekends to hunt and to stay at Old Lodge where, he claimed, he could 'do more business than he could in town'. His business at Old Lodge would not always bear close inspection. According to Lord Hervey, he was caught out in 1736 when Queen Caroline wanted to tell him that the king was safe in Holland after a storm at sea, but found that he had retired to Richmond Park with his mistress and eventual second wife, Molly Skerrett. Such was his interest that he was also reputed to open and read any letters from his gamekeepers before attending to official business. It was also said that the closing of the House of Commons on Saturdays dates from this time, because the Prime Minister wanted to be able to attend the Saturday meets of the Royal Buckhounds.

Hunting was extremely well organised, and the king, the court and Sir Robert Walpole hunted regularly during the season. George II had hunted at Richmond while still Prince

of Wales, as in 1725 Lady Mary Wortley Montagu mentioned in a letter to her sister, the Countess of Mar:

> I spend many hours on horseback, and I'll assure you, ride stag hunting, which I know you'll stare to hear of. I have arrived to vast courage and skill that way, and am so well pleased with it as with the acquisition of a new sense. His Royal Highness hunts in Richmond Park, and I make one of the *beau mond* in his train.[11]

A further picture of these royal hunts can be seen from a report which was published in the *Stamford Mercury* in August 1728:

> On Saturday their Majesties together with their Royal Highnesses the Duke [of Cumberland] and the Princesses, came to the New Park by Richmond from Hampton Court and diverted themselves with hunting a stag, which ran from eleven to one, when he took to the great pond, where he defended himself for half an hour, when he was killed. His Majesty, the Duke, and the Princess Royal hunted on horseback, her Majesty and the Princess Amelia in a four wheeled chaise, Princess Caroline in a two-wheeled chaise, and the Princesses Mary and Louisa in a coach. Sir Robert attended as Ranger, clothed in green.[12]

These hunts appeared not to be without incident. Henrietta, Countess of Suffolk, wrote on 31 July 1730, 'We hunt here with great noise and violence, and have everyday a tolerable chance to have a neck broke,' and this seems to be no exaggeration as there are accounts of Princess Amelia being thrown from her horse when a stag turned on it 'and due to her Petticoat hanging on the Pommel of the saddle' dragged for some distance before being rescued. In August 1732, the unfortunate but Hon. Mr Fitzwilliam, Page of Honour to His Majesty, and his horse came to grief 'among the coney-

burrows'. Three days later, a chaise overturned, fortunately without injury to driver and passenger, and one of the king's huntsmen, a Mr Shuter, had a fall from his horse and received a slight contusion on his head. The following month Sir Robert Walpole was thrown from his horse 'but received no injury, yet her Majesty ordered him to be bled by way of precaution'.[13]

The number of hunts was considerable, and, in 1732 alone, the Royal Buckhounds met on no fewer than thirteen occasions in Richmond Park, the opening meet being 22 July and the final meet on 15 November. In years where there were fewer staged in the park, meets were arranged in other venues not far away, including Windsor Forest, Hounslow Heath, Sunbury Common and Putney Heath. With such excitement, including the chance of seeing the king break his neck, it is not surprising that many spectators crowded the park to watch or participate in the royal hunt. In 1735, before the opening meet of the Royal Buckhounds in the park on 9 August, a notice was issued:

> Upon account of the great Crowds and Throngs of People that have attended the Stag Hunting at New-Park, when the Royal Family were hunting there, which has Rendered the Riding there not only troublesome, but very dangerous, her Majesty has been pleased to order That no Person shall be admitted into the Park without a Hunting Ticket, prepared for that Purpose, with the Date of the Day, and the Seal of the Ranger; to be given Weekly, by the Ranger or his Deputy, upon proper Application.[14]

This restriction appears to have been directed only to the question of persons hunting in the park without permission. Shortly afterwards, however, further steps were taken to control and restrict entry. Previously, although the park had gates, keys had been provided liberally to any persons who had reason to use the roads through the park. At various

points around the wall, ladder stiles had been erected to give access to pedestrians without their having to use the gates. Now lodges were built at the gates to control the vehicular traffic. Tickets were to be required for carriages to enter the park. On the pretext that there were now keepers available to open the gates whenever required, so the ladder stiles were no longer necessary, many were removed. The locks on the gates were changed, so that the keys previously issued were now useless.[15]

According to Horace Walpole, the gatekeepers were instructed 'to open to all foot passengers in the daytime and to such carriages as had tickets, which were easily obtained'. Nevertheless, these measures constituted a considerable restriction on public right of entry to the park, and a good deal of resentment was aroused in the communities that lived around it. Another source of complaint was the additional restriction of 'Fence Month', originally two weeks each side of Midsummer's Day, but soon extended to the whole months of May and June, when almost nobody, ticket holders or not, was allowed into the park, on the grounds that the young calves and fawns were then at their most vulnerable. The extent to which these measures had affected the local communities even in the time of the Walpoles is brought out by a letter, said to have been written on 1 October 1748, quoted by the anonymous author of *Two Historical Accounts*.[16]

The Absence of the Royal Family this Year, and the almost total prohibition of entering the New Park, have driven away many worthy Citizens and others, who used to resort here for the Benefit of the Air ... I apprehend we shall soon become a deserted Village ... There is something so unnatural in the shutting up our Park, that it is as hard to assign a Reason for it, as it would be to show by what Authority it is done: The Thing however is a Matter of Fact; and merits both Enquiry and Redress.

It has often been suggested that Sir Robert Walpole was anxious to curtail public access to the park for more personal reasons, too, and he seems to have come to regard it more as a private estate than a park. With the removal of some of the ladder stiles that were set up against the boundary wall at various points, and the building of the many lodges for gatekeepers, this would seem to have been the case. Sir Robert's impact on the development of the park is summarised in the *Victoria County Histories*, Surrey edition: 'The Prime Minister, although he effected improvements and spent much money on the Park, made several infringements on the rights of the public by shutting up gates and taking away stepladders on the walls.'

Hartleton Lodge had been extended and improved, and White Lodge to the south was under way. On 9 June 1736 the Surveyor General of Woods was authorised to spend £600 for making new roads 'for the convenience of the Royal Family in their passage from the Royal Gardens at Kew to and through Richmond New Park'. At the same time a private entrance was created for the royal family on the northern boundary of the park, known as Queen's Gate, later becoming Bog Gate. Queen's Ride, a broad, tree-lined avenue leading away from the west elevation of White Lodge, first comes to notice in Rocque's *Survey of London*, published in 1746, and was named as such after Queen Caroline, wife of George II. The survey gives the impression that the woods on either side of the ride were mature, so the avenue may have been hewn out of existing woodland, perhaps in 1736 or the following year, to complete the route between the royal residence at Kew and the king's new hunting lodge in the park.

The office of deputy ranger was created in the 1730s, probably to take over the responsibilities of the day-to-day management and administration of the park, which were becoming increasingly complex. On 21 June 1733, 'Captain Edward Jackson, deputy ranger of Richmond New Park' successfully petitioned the Surveyor General of Woods for

£922 12*s* 8¾*d* to pay for 'works and repairs' in the park.[17] In this case the money was found from the proceeds of wood sales from the park, with this seemingly occurring three years later to defray the costs of other works in the park, and it was likely that the costs of maintaining the park were further funded by the sale of wood and other produce along with other sources.

Joseph Cooper, 'late keeper of Richmond Park' who died on 7 February 1735, is found in Petersham graveyard along with his son Augustine, who died on 3 July 1775 aged sixty-three. They are likely the very same family who occupied Cooper's Lodge – eventually Bog Lodge – and it is likely that Augustine Cooper was the head keeper of his day – as was probably his father before him. It was not uncommon for several members of one family to follow the same trade or profession, and for son to follow in father's footsteps. Of the remainder of the staff in Richmond Park during the period there is little record. One post that was certainly occupied was that of mole catcher, with the mole catcher's lodge shown on Rocque's survey near the site of Pembroke Lodge. The other post that was unlikely to have been vacant was that of bailiff, as there was always a considerable amount of work to do in the park. A keeper by the name of Lucas was recruited, early in the eighteenth century, from the Duke of Newcastle's estate at Claremont, near Esher, with his main attributes appearing to be his skill in fighting with the quarterstaff, useful for dealing with poachers no doubt. Lucas was probably employed in a relatively junior capacity, but his appointment is worthy of note since his family was to be closely involved with the affairs of the park for the next 150 years.

The absence of detailed records at this time do not give any details of the condition of the herds, and it can only be assumed that they were in satisfactory condition during the earlier years of the eighteenth century simply because of the popularity of the park as a royal hunting ground. In 1732 one Charles Howard was paid £87 for catching up and

transporting red deer from Horton, Northamptonshire, to 'Richmond New Park'. Two years later deer were brought to the park from the Earl of Salisbury's woods at Hoddesdon, Hertfordshire. There were outgoings too. In 1742, George Lowan, Chief Huntsman to the king, was paid £78 for taking red deer to Epping Forest. The following year he received £128 for catching up red deer and transporting them to Windsor Forest. The stock of deer is unlikely to have been particularly large; too many could well have interfered with the hunting. The introductions of red deer recorded above may have been designed to improve the quality of the red deer by bringing in 'new blood, and the deer removed to Epping and Windsor to reduce the herd size to manageable proportions *vis-à-vis* hunting'.[18]

In 1740 a re-grant of the position of ranger was made, by which Sir Robert was given the reversionary right to the post if he should survive his son. In 1742 Sir Robert finally retired as Prime Minister, and was created Earl of Orford. Three years later, he died, and his son, now the 2nd earl, of course continued as ranger. In February 1749 George II granted the reversion of the position of ranger, after Orford's death, to his youngest daughter, Princess Amelia. When Lord Orford died on 1 April 1751, Princess Amelia immediately assumed the role of ranger. At once she started to tighten still further the restrictions on entry to the park. The first incident occurred on Ascension Day, 16 May 1751. It was the regular custom to 'beat the bounds' of the parish on that day, and in the past the bound-beating party had been accommodated by having ladders placed against the wall at the point, not far from the gate where the queen's private road passed out onto East Sheen Common, where the wall crossed the parish boundary – some 70 acres of the parish, of course, lay within the park. The churchwardens, led by Thomas Wakefield, the Anglican vicar of Richmond, sent due notice to the park authorities, presumably the deputy ranger, but this time

when they came to the Place they saw three or four Men sitting upon the Park Wall, but found no ladders: So that with Difficulty the Minister and other Parish Officers with some of the principal Inhabitants got into the Park, where they soon found the same Men mounted on Horseback placed there, as is presumed, to see what was transacting. After the Minister, Church-Warden, etc, had asserted the Rights of their Parish, by marking the Boundaries thereof in the Park, they proceeded to the Gate upon Richmond-Hill, thro' which they returned from doing their Duty.[19]

The frontispiece illustration to *Two Historical Accounts* shows the bound-beating party pouring through a breach made in the wall. If they did in fact make this breach, it seems strange that no direct punitive action was taken. It is possible that the wall had already part crumbled, taking into account its build quality and ongoing problems with it, and therefore allowing a 'difficult' means of access. The park staff may also have acted without authority in trying to deny access, and the deputy ranger was unsure of his legal ground. It is, however, likely that it was this incident, just six weeks after she had become ranger, that determined Princess Amelia to take much firmer steps to keep out both those on foot and those with carriage passes. She now denied access to all but her guests and friends. Carriage permits were issued only on a very restricted basis; pedestrians were refused right of entry altogether. As a result, the complaints escalated. Horace Walpole wrote to George Montagu on 27 July 1752:

Discontents of the nature of those about Windsor Park are spreading about Richmond. Lord Brooke, who has taken the late Duchess of Rutland's at Petersham, asked for a key; the answer was (mind it, for it was tolerably mortifying for an Earl), 'that the Princess had already refused one to my Lord Chancellor'.[20]

Petitions to the princess were continually rejected. On 28 July 1752, a 'Memorial' to the princess from the 'Proprietors of Estates in the several Parishes' was published in the *Post Boy*. This claimed public rights of way on the roads in the park, for those on foot or mounted, or with cattle and carriages, the right to ladder stiles at convenient points for pedestrians and to doors for bound-beating parties, the rights to dig gravel, to use the water and watercourses, and to gather firewood. They offered evidence, both oral and written, to prove the validity of these rights; and concluded with a suitable amount of flattery.

> That from the Time of making and inclosing the said Park to the time that the present Earl of Clarendon parted with the Rangership, your Memorialists enjoyed an uninterrupted Possession of the several Rights and Privileges aforesaid, but soon after that Period, your Memorialists were, by Degrees, deprived of most of them, and had almost despaired of ever having them restored, till their drooping Hopes were at length revived by the Coming of Your Royal Highness to the Rangership, whose eminent and unbounded Goodness gives them the greatest Reason to believe That Your Royal Highness wants only to know their Grievances to Redress them.[21]

The result was abject failure, so the next step was to try the issue in the courts. The first case was *Rex* v. *Deborah Burges*, heard at Croydon Assizes on 12–13 November 1754. It is described in detail in one of the anonymous booklets possibly attributable to John Lewis, *Merlin's Life and Prophecies*, published in 1755. Merlin was a cult figure at this time, and most of the booklet rehearses the old verses and their application to British history – or legend. Significantly, then follows a page of evidently new verse, 'prophesying' exactly what would happen in Richmond Park – but ending with the prophecy that Her Royal Highness would graciously restore

the ancient rights of the people. The last ten pages are devoted to an account of the court hearing:

> Some time last Summer some Gentlemen went to Mrs Deborah Burges, Gatekeeper of Richmond Park, and demanded Admission, which she refused. Upon which an Indictment was brought against the said Deborah, and came to be tried before the Rt. Hon. Sir Dudley Ryder Kt., Lord Chief Justice of the King's Bench, Mr Justice Foster [on Tuesday 12 November].

The trial lasted two days with both sides producing an impressive array of counsel and witnesses. Opening for the prosecutors, Mr Clark claimed that there had always been and should be 'a high road through Richmond Park from Richmond to Croydon for horses, coaches, carts, carriages and people on foot'. The witnesses for the prosecution were mostly elderly inhabitants who affirmed the existence of the road, even dating back to 1699. A lot of time was spent discussing the Coombe Gate, which Walpole was said to have bricked up; how there was no lock on it at all until Lord Rochester's time and how even when a lock was fitted 'there was no denial of passage – and there was always a footway'. The defence was, however, formidable, producing no less than thirty-seven witnesses, several of them titled, led by Lord Palmerstone. The burden of their evidence was that the gates had always been locked since the park was formed, and that, even if keys and tickets had formerly been more readily available, there was no public right of way. One of those called was Joseph Austin, a locksmith, who said he had been employed by Lord Rochester to make the park keys. He remembered that he had had to change the locks and keys twice because unauthorised ones had been made. It was generally accepted that the 'Fence Month' had been instituted only by the 2nd Lord Rochester. When counsel for the defence summed up, he taunted the prosecution for having 'cunningly' failed to distinguish in their case between

the rights relating to a footway, a highway and a cart way – the implication being that the case for a right of footway alone might have succeeded. The jury returned a verdict for the defendant.[22] The argument about a highway was pursued in the next of the anonymous pamphlets, *A Tract on the National Interest*, published in 1757, which argued that the signs of the existence of ancient highways were there for all to see who were not deliberately blind. There was a lane in Roehampton, Dunditch Lane, which now stopped short of the wall, because a gate that had formerly stood there had been closed. The road from Dorking through Malden and Coombe stopped short where the Coombe Gate had once been; the route was picked up again by the highway on Richmond Hill. The author of the pamphlet was careful not to lay any blame at Princess Amelia's door: 'The Right of the people to a free passage through Richmond Park was a privilege they always enjoyed until the late Sir Robert Walpole audaciously divested them of it.'[23] Whether John Lewis, a local brewer, was the author of these tracts or not, it was he who had taken steps to bring a case himself to try to establish the pedestrian right of access into the park. Gilbert Wakefield, the son and brother of the two Wakefields who were ministers of Richmond church from 1767 to 1806, wrote in his *Memoirs* how Lewis set about it:

> Lewis takes a friend with him to the spot (the East Sheen Gate); waits for the opportunity of a carriage passing through; and when the door-keeper was shutting the gates, interposed and offered to go in. 'Where is your ticket?' 'What occasion for a ticket: anybody may pass through here.' 'No, not without a ticket.' 'Yes, they may, and I will.' 'You shan't.' 'I will.' The woman pusht, Lewis suffered the door to be shut upon him, and brought his action.[24]

The case of *Rex* v. *Martha Gray*, the gatekeeper, was finally heard at Kingston Assizes on 3 April 1758 before two of

the three Justices who had previously heard the case against Deborah Burges – Denison and Foster. The verdict this time was given against the gatekeeper. Lewis was asked by the bench, says Wakefield, whether he wanted step-up ladders or doors. He opted for the ladders on the basis that they would probably proclaim their message more clearly than a door, which would have to be kept shut because of the deer. They were duly set up at East Sheen Gate and at Ham Gate on 12 May, and opened to the public on 16 May, when 'a vast concourse of people from all the neighbouring villages climbed over the ladderstiles into the Park'. However, the dispute was far from over. The ladders were made with such wide spaces between the steps that old people and children could not use them. Lewis complained to one of the Justices, who was empowered to have them altered.

As a result, John Lewis, the brewer, became a local hero, and had his portrait painted and engraved to illustrate Gilbert Wakefield's book. When severe floods destroyed his brewery by the Petersham Road, and he had fallen on hard times, the Revd Thomas Wakefield organised a collection for his benefit, and he survived on a small annuity until his death in 1792, in near poverty. The right of pedestrian access having been established, a further attempt was made to bring a case to establish the right of carriage- and bridleway. This was again heard on 26 January 1760, and once again failed.

As was to be expected, the succession of legal cases had brought a great deal of widespread unpopularity on the head of Princess Amelia and had attracted far more attention than the previous complaints of the local inhabitants. The subsequent unrestricted admission of pedestrians had made the park less attractive to her, and by 1761 she gave up the position of ranger. She surrendered it to her nephew, the new King George III, allegedly for an annuity of £1,200, and moved across the river to Gunnersbury. It has always been assumed she resided at the Old Lodge while she was the ranger of the park, as that was available and had been used by the previous

ranger. However, as she was George II's favourite daughter, it is also quite likely that she would have had the use of the White Lodge. It was certainly repaired and redecorated at her expense in 1751–2 under the direction of Stephen Wright, then clerk of works at Hampton Court.[25] In 1754, Wright was also appointed as clerk of works for 'Richmond New Park Lodge'. The princess then got him to provide plans for the addition of wing pavilions to the house, which were to be connected by low, curving corridors at basement level. This work, according to Cloake, was said to be still incomplete when the fourth volume of *Vitruvius Britannicus*, in which the design was illustrated, was published in 1767, although Cloake quite rightly questions this. The pavilions and curved linking sections are quite clear on both versions of John Eyre's plan of 1754. Also, Horace Walpole, writing with first-hand knowledge, states that the lodge was 'enlarged' by Princess Amelia.[26] The addition of the wings was the only enlargement of the house that took place at this period. If indeed some feature of the work was not completed by 1767, it must have been quite a minor one.[27]

On 23 June 1761 George III bestowed the position of ranger on Lord Bute. The close collaboration of Bute with the king's mother, and then with the king himself, at Kew seems also to have extended to an active cooperation in the management of the park. In 1761, repairs and works were carried out under the king's own personal supervision. Some £6,000 were spent altogether on repairs between 1761 and 1764.[28] The king and Bute did relax the restrictions on entry to Richmond Park, and though tickets were still issued for carriages they were again made more readily available. George III also instructed that wild turkeys should no longer be raised and kept in the park. The wild turkey, a North American bird brought to England by Turkish traders in 1521, may have first been introduced in the park during the later years of the seventeenth century; William of Orange was reputedly 'a good shot at winged game, preserved pheasants, wild turkeys and "such small

deer" at Hampton Court, Windsor, Richmond and other royal manors'.[29] Early in the eighteenth century, flocks of up to 3,000 were to be found in the park, and they were shot by George II and others. They were large, heavy birds, some of the old cocks weighing as much as 30 lb.[30] Edward Jesse, writing in 1834, said,

> One of the keepers in Richmond Park informs me that he has often heard his father, who was also a keeper, mention that, in the reign of George the second, a large flock of wild turkies, consisting of not less than three thousand, was regularly kept up as part of the stock of the park ... They were hunted with dogs, and made to take refuge in a tree where they were frequently shot by George the second. I have not been able to learn how long they had been preserved in the park before his reign, but they were totally destroyed towards the latter end of it, in consequence of the dangers to which the keepers were exposed in protecting them from poachers, with whom they had many bloody fights, being frequently overpowered by them.

Another decision was to give up stag hunting in the park; and the royal hounds were transferred to Windsor. Henceforth the deer were, apart from their ornamental role, to be regarded rather as a source of venison than of sport.

After Bute's resignation as Prime Minister, his successor George Grenville made a bid to obtain White Lodge. The king, however, was determined that he should not have it. He wrote, on or around 20 April 1764, to Bute, his 'dear Friend':

> I told him [Grenville] ... that I owne I did not chuse to let any one inhabit my own houses, and that, as to that, I had already prepared an apartment where I might drink tea or shelter myself in riding from a shower, that the whole floor consisted but of four or at most five rooms and that it would therefore be impossible for me to grant his request.[31]

Thereafter, Bute and the king and queen in effect shared White Lodge. Bute could use it when he wished, but did not reside in it permanently, and the king and queen used to go there quite often. Lady Mary Coke was not very impressed when taken to see it in September 1766 by Miss Medows, the daughter of the deputy ranger:

> The chief curiosity is an Indian paper in the great Room, which cost three guineas the sheet; it looks like japan, but being on a dark blue ground makes the room appear very dismal. The chimney pieces are, I think, very paltry. The King and Queen has [*sic*] drank tea there every Sunday evening all this summer.[32]

Also at this time, it appears that the park was occasionally used for military manoeuvres. In the British Library there is a plan of 'the country between Richmond Hill and Wimbledon' drawn by Sir David Dundas for an exercise of the Light Dragoons in 1770. A more intriguing exercise is mentioned by Lady Mary Coke in her writings 'of the bush fighting Review they performed yesterday, previous to His Majesty seeing them this morning in Richmond Park'.[33] Old Lodge was henceforth the residence of the deputy ranger. Philip Medows held that post from 1761 until his death in 1781, when Lord Bute's son James took over. In March 1792 Lord Bute died. The king decided to assume the position of ranger himself, with the Hon. Stephen Digby as deputy. The king had ambitious plans, which reflected his interest both in agriculture and in estate management. Writing in 1792, Daniel Lysons said of them,

> His Majesty ... has it in contemplation to cause all the swampy parts to be effectively drained, the rough banks to be levelled, and the roads turned where beauty and advantage may be gained by so doing. The open parts, especially the large tract of ground towards East Sheen, are to be ornamented with plantations properly adapted to the elevation of the surface;

and the valleys opened so as to carry the appearance of greater extent, and to give additional grandeur to the old plantations. Within the walls of the park is an eligible and compact farm of 225 acres. To this, it is said, that [*sic*] His Majesty, who has shown a very laudable zeal for the encouragement and improvement of agriculture, will pay particular attention, by the application of the soil to the purposes most apposite to its nature, and in particular by introducing the Flemish system of husbandry.[34]

This ambitious programme was not entirely or even largely carried out, but in *Malcolm's Agriculture of Surrey*, 1794, it is stated that very shortly after the death of the Earl of Bute an attempt was made to grow cereals in the park. At first the land yielded good crops, especially of oats, but later the thin, hungry, gravelly soil, inroads of deer, etc., made it advisable to lay it down again as permanent pasture.

In September 1792, shortly after the king had taken over the job as ranger, a report on Richmond Park and 'proposed alterations' was submitted by Nathaniel Kent, a land valuer and agriculturalist, who also seems to have been the senior partner in a firm of builders and was for a short time bailiff of the king's farm at Windsor. It seems likely, according to Cloake, that he was the source of these ideas for improvement of the agriculture in the park, as he had made a study of Flemish agriculture when serving as a diplomat in the Netherlands in the 1760s, and had published a report on the subject in 1766. He then abandoned diplomacy and became an acknowledged expert consultant on the management of landed estates. One improvement to the park, in which Kent is recorded as having played an important part, was made in the 1790s and still exists. This was the erection of new gates and a lodge at the Richmond Gate. As there has been much incorrect speculation about the designer of these, some detail of the story, which seems to emerge from surviving documents, may be of interest. In August 1793, Nathaniel Kent, writing as

a member of his firm Kent, Claridge & Pearce, submitted a
'plan and elevation for a new gate and lodge on Richmond
Hill, approved by His Majesty', together with an estimate for
this work and for repairs to the other gate lodges. These were
promptly forwarded to the Treasury for authority, but no reply
was forthcoming, and they resubmitted in August 1795. The
plan, but not the elevation, remains attached to the papers.
It shows a carriage gate, a side gate and a stile, with a small
square lodge.[35] It was at this time that John Soane, the newly
appointed deputy surveyor of woods and forests, entered
the act. A plan is preserved in his museum that portrays at
the top a design for the gates (without lodge) 'as delivered
to His Majesty in the Richmond Journal for April 1795 by
Kent, Claridge and Pearce'. Below this appear front and side
elevations and a plan of a gate lodge, which is very similar
to the building that was actually erected. This is described
as 'the intended lodge on Richmond Hill as approved by His
Majesty'. Despite the attribution of the gate design, neither it
nor the lodge appear to bear any close similarity to the Kent
plan.[36] It seems highly likely that Soane, in his official capacity,
had tinkered with Kent's original design in order to get the
king's approval. There seems to have been a further delay of
some two and a half years, but finally the work, entrusted to
the firm of Kent, Claridge & Pearce, was started. Mr Kent
wrote on 18 May 1798, 'The lodge and gate is begun.' By
September 1799 it was finished, but Kent was reminded that
it had to be approved by the deputy surveyor of woods. James
Wyatt had just taken over this post from Soane, and it was he
who was to carry out the survey.[37] Payment of £1,140 was
finally made to Kent's firm in April 1802.

By the end of the century, those lands that had been granted
out of the western slopes of the park to enlarge the grounds
of Petersham Lodge and Sudbrook House appeared to have
been lost to the park for good. The Sudbrook ground, some
30 acres, the lease of which was twice renewed, in 1750 and
1766, to Lady Dalkeith (later Baroness Greenwich), was

granted to her in freehold when the lease expired in 1784.[38] At Petersham Lodge, the lease of about 50 acres, renewed in 1764–5 to William, 2nd Earl of Harrington, was sold by his heir Charles in 1780 to Thomas Pitt, Lord Camelford. In 1781–2, Pitt had some repairs and decorations carried out by the young John Soane. On 16 October 1787, Camelford bought the freehold of the estate from the Crown for £1,294. Then, on 6 April 1791, Camelford sold the estate to William, Duke of Clarence (the future William IV). Clarence obtained an extra 15 acres, including King Henry's Mound, by grant from the Crown. Clarence had many homes in the Richmond area, but the lodge in Bushy Park was the only one he kept for any length of time. After four years, he sold Petersham Lodge on 3 April 1795. A total of 6 acres of the grounds were resold to the Crown; all the rest of the estate – the house and 59 acres of land – went to Sir William Manners, Bt (later Lord Huntingtower), the eldest son of the Countess of Dysart.[39]

With the cessation of deer hunting, pressures on the deer herds were relieved, but this was short-lived. With the continuing disafforestation of the royal forests, those who were responsible for the administration of the Royal Venison Warrant were becoming increasingly reliant on the fallow deer herds of the royal parks for the large quantities of venison required to satisfy the needs of the warrant. As the eighteenth century drew to a close, so the demands on the fallow deer herds of the parks multiplied – so much so that by 1789 the deputy ranger, the Hon. James Stuart (son of the ranger), reported that the park was in 'great Want of a Supply of Deer'. Subsequently, £273 was spent on the purchase of 76½ braces of fallow deer 'for his Majesty's Service'. There is also evidence of an importation of red deer from Germany, possibly in the early years of the reign of George III, because on 10 January 1790 W. Harris, a gardener at Thatched House Lodge, shot an old stag, 'the only one left that came from Hanover'.[40]

The salaries and emoluments of the park staff in the later years of the eighteenth century are not well documented, but one record, dated 1788, shows that the ranger was paid a salary of £109 10s 0d a year, the head keeper £69, the first underkeeper £20 and the second £25. This was by no means the keepers' only source of income, for they had entitlement to certain fees and other payments. The first underkeeper's income from those sources was presumably greater than that of the second; hence the disparity in their salaries. A mole catcher was still employed, receiving an annual salary of £14. The bailiff received £10 a year. All, with the possible exception of the bailiff, lived in the park rent free, and enjoyed perquisites such as an allowance of firewood, and the right to graze a specified number of cattle. On 1 June 1806 there were eighty-nine cows and oxen at large in the park, the property of the ranger and staff.[41]

Two major factors mark the end of the eighteenth century in Richmond Park. One was the end of an era and the other was the end of hunting in the park, followed by greater venison production. By the end of the eighteenth century, public access had been re-established more firmly than ever. Building activity in the park was now considerable, ranging from the provision of staff lodges to the statelier White Lodge. A hint of formality was introduced by way of Queen's Ride and the short tree-lined avenue leading eastward from King Henry's Mound. Nevertheless, at the close of the century the fundamental medieval flavour and character of the park remained intact.

# The Nineteenth Century

By the beginning of the nineteenth century, George III was now rarely using White Lodge. While he was still at Kew recovering from an attack that had overwhelmed him in January 1801, he decided that Henry Addington, his new Prime Minister, needed a new residence nearer to London than his own house at Woodley near Reading. Addington and his family were lodging temporarily in Henry Dundas's house on Wimbledon Common. George decided to give him White Lodge, which was now virtually abandoned since Lord Bute's death, and wrote to him from Kew: 'The appearance of the morning makes the King hope the evening will be dry. He therefore trusts Mr Addington will bring his family in his sociable to the Lodge in Richmond Park; but hopes among the number that the lively and engaging youngest daughter will not be omitted.'[1]

The royal party set off to meet the Addingtons at White Lodge, but last-minute business detained the Prime Minister so the king was kept waiting for an hour. However, nothing was going to be allowed to interfere with his pleasure in personally showing the Addingtons round their intended home. Wanting to impress, the king proposed to ensure

the Addingtons privacy by fencing off a 60-acre enclosure around the house, even allegedly marking it out personally. Addington, however, protested that this was far more than he needed or wanted, and he persuaded the king that 5 acres would be quite sufficient.[2] A number of alterations were ordered that would transform what was still no more than a hunting lodge into a comfortable residence. James Wyatt, in his capacity as deputy surveyor of woods and forests, was responsible for the works, with the pavilions linked to the main building by curved, two-storey, quadrant corridors, which took the place of the open curved colonnades of the 1750s plan. As Wyatt used the services of Robert Browne as clerk of works and of Office of Works tradesmen for the job, there was some confusion over the responsibility for payment, but the bill of some £20,000 was eventually met by the Office of Woods and Forests. Humphrey Repton was responsible for the landscaping of the 5 acres, and substituted 'the neatness and security of a gravel walk' for the 'uncleanly, pathless grass of a forest, filled with troublesome animals of every kind, and some occasionally dangerous'.[3] His method of illustrating his proposals using his hinged-plate device probably exaggerated the 'troublesome animals' by showing in his 'before' scene half a dozen cattle and a group of deer all within about 1 yard of the walls of the house.

Within the park were a number of distinguished residents when the Addingtons moved into White Lodge on 15 October 1802. Louisa, Countess of Mansfield, who had married the king's equerry, Robert Fulke Greville, in 1797, was appointed deputy ranger in 1801, and was living in the Old Lodge. Hill Lodge, the former 'Molecatcher's cottage' in which the king's beloved 'Eliza', the Countess of Pembroke, had first rented rooms from the gamekeeper Trage in 1780, was subsequently granted to her as a residence. Never totally rebuilt, but enlarged and altered piecemeal over the years, it grew into a large, rambling villa. The first major enlargement has not been precisely dated according to Cloake; it was the

addition of four spacious rooms at the southern end of the
old cottage, probably the work of Sir John Soane, whose
accounts show him as visiting the lodge and drawing plans
of it for Lady Pembroke as early as 1785.[4] Soane continued
to be associated with the property, to advise Lady Pembroke
and to design new improvements for her, on and off, for the
next ten years. More works were actually carried out by him
in 1796, and most of Pembroke Lodge as it stands today can
be attributed to Soane's designs. Soane was also involved
with improvements to Thatched House Lodge for General Sir
Charles Stuart, one of Lord Bute's sons, in 1798.

One other house in the park had been upgraded from the
status of staff accommodation to that of a residence for the
gentry. The former 'Dog Kennels', by the Sheen Gate, were
granted in 1787 to the Rt Hon. William Adam, a nephew of
the architect Robert Adam, a lawyer and Whig politician, who
was a close associate of the Prince of Wales. He retained the
house, renamed Sheen Pond Lodge, until his appointment as
Lord Commissioner of the Scottish Jury Court in 1816, after
which it was occupied in turn by three of his sons: William
George Adam, Admiral Sir Charles Adam, and Lt-Gen. Sir
Frederick Adam. The name of Adam's Pond commemorates
the 65 years of this family's continuous occupation of the
house nearby.[5]

The main houses in the park during this period, apart from
the main gate lodges, were six in total. The head keeper lived
in what was called Cooper's Lodge in 1754, Lucas' Lodge in
1771, and later Holly Lodge or Bog Lodge. This stood at the
southern side of the bog near the northern wall of the park.
The second keeper lived at White Ash Lodge, overlooking
the Pond Slade. The date of this is unknown, but is shown
on Eyre's map of 1754. Also dating from this time was the
farmhouse in the Paddocks, south-east of Beverley Brook.
The two gamekeepers lived in Bishop's Lodge near Richmond
Gate, and in Ladderstile Lodge near the old Coombe Gate,
built in the 1780s. In 1852–3 a new house was built for the

park bailiff near the southern end of Sidmouth Wood, and is now called Oak Lodge.

By the time Henry Addington moved into White Lodge, much of the park was still in a semi-wild state. In the south-east corner, beyond Beverley Brook, was the Ranger's (or King's) Farm, with cultivated fields and meadow pastures for large flocks of sheep. The cattle from the farm ranged at large in the park with the deer, and were captured in some of the artwork from the time. There were, however, two pens into which the deer could be gathered for winter feeding. There were stretches of fairly open land inside the Richmond and Roehampton Gates, and another stretch west of the Sheen Gate that was under cultivation. The land round the White and Old Lodges, and the valley of the Pen Ponds and Pond Slade, was also largely open ground. Over the rest of the park the trees grew scattered or in natural groves; almost the only deliberate planting was the avenue to White Lodge, known as the Queen's Ride, and some fairly thick planting along the ridge bordering the Petersham Lodge and Sudbrook grounds.[6] How much of the king's programme of agricultural improvements was carried out is not known. As he became much more ill and increasingly blind, he became less effective in his role as ranger for Richmond Park. Addington had given up the premiership in 1804, and in 1805 he accepted a peerage as Viscount Sidmouth, although he returned briefly to ministerial office in Pitt's new administration. Though Sidmouth continued to play an active role in politics, he was given another interest in 1813; his continued friendship with George III was certainly beneficial to him. The Countess of Mansfield gave up the role of deputy ranger, and the Prince Regent granted it to Lord Sidmouth. A year later, the prince appointed his sister Princess Elizabeth as ranger. She married in 1818 and went to live in Germany, installing in Old Lodge, to act as her local agent, General Sir Henry Campbell. Whatever the real impact of this was, the effective charge of the park was now in the hands of Lord Sidmouth as deputy ranger,

and he took his job very seriously. He had sold Woodley after moving into White Lodge, so it was now his only home. He continued to live there and to hold the post of deputy ranger until his death in February 1844. During his tenancy at White Lodge, an imposing *porte cochère* was added to the rather plain east front.[7]

From 1819 onwards, the new deputy ranger's impact was considerable. He developed a policy of making new plantations in the park, enclosed with fences to protect them from the deer. His first venture was the south-eastern part of the Spanker's Hill Plantation in 1819, which was extended to the west almost up to the site of the Old Lodge in 1824. It was followed by the northern half of the Sidmouth Plantation in 1823, Ham Cross Plantation in 1825, Kidney Plantation in 1828, Conduit Plantation in 1829, the southern part of the Sidmouth Plantation in 1830, and the central and north-western parts of the Isabella Plantation in 1831.[8]

In the 1830s and 1840s, the park recovered the land that had previously been lost. Lord Huntingtower died in 1833; Mr Edward Jesse, who, as 'Itinerant Surveyor of Woods and Works' in the newly established combined Office of Woods and Works, was responsible for the royal parks, persuaded the commissioners to purchase the Petersham Lodge estate from his executors for £14,500. The house, which had not been regularly occupied for twenty years, was condemned as damp and full of dry rot. It was demolished in May 1835 and its 59 acres of land were reincorporated into the park. The high fence that had separated Petersham and Richmond Parks was pulled down, and the heavy planting along it was thinned out. A new terrace walk was made from Richmond Gate to the stables of Pembroke Lodge.[9] In 1842 Sudbrook Park was put on the market by Lady Horton, widow of Robert William Horton, who had bought the property from the trustees of the Duke of Buccleuch in 1825. Again at the urging of Edward Jesse, the whole property was purchased by the Crown. It was not practicable to restore all the land

that had been granted out of Richmond Park, for the mansion built by James Gibbs for the Duke of Argyll stood right across the original boundary. However, some 20 of the 'so-called 30 acres' purchased by Lady Greenwich in 1784 were restored to the park, leaving just over 12 acres on the east side of the house.[10] The house itself and the rest of the park, which had never been part of Richmond Park, were then rented out as a hydropathic establishment. Today it is the home of the Richmond Golf Club.

At the same time, the population of the deer in the park was reinforced. Earl Spencer presented his entire herd from Althorp Park to William IV, and 269 of them were safely transferred to Richmond. Eight years later, in 1843, Lord Sidmouth offered the deer herd of Stowell Park in Gloucestershire, the home of his second wife, provided that they were added to the Richmond herd; 179 animals were duly moved. There were other gifts, and transfers between the various royal deer parks, and by mid-century the total number of deer in the park was about 1,500. It was the Sawyer family who were instrumental in many of the exchanges of deer. On the death of the deer keeper in Bushy Park, Rowe Sawyer was promoted to the deer keeper's position there. The Sawyer family were represented in other deer parks, too, including Woburn, Bedfordshire and Cassiobury in Hertfordshire. The family association was to be useful in a series of introductions and exchanges of deer involving Richmond and other royal parks between 1833 and 1853. This vast movement of deer – large numbers were involved, all fallow – was in direct response to Jesse's survey of 1831, the object being to build up the herds of the parks to a degree that would enable the requirements of the Royal Venison Warrant to be comfortably met. Deer were exchanged with Woburn and Cassiobury Park. James Sawyer noted in his diary that Friday 1 March 1833 was a 'very fine morning', and he spent part of it catching 'three brace of deer sorels and sores for Woburn Park'. Tuesday 16 April that year started with 'a dull morning' and saw John Lucas,

the second or under keeper, returning from Cassiobury with 'eight brace in exchange'. Catching live deer for transporting elsewhere was not a simple task. One method used involved two or three keepers, on horseback and each with a dog, riding down and cutting out from the herd a selected animal. As soon as it had been cut out, the dogs were sent in pursuit, supported by younger dogs, which were 'slipped' as soon as the keepers' dogs had been laid on. Once the animal had been brought to bay, the dogs seized it by throat and ears, holding it until the keepers arrived. The deer was then immobilised by strapping hind and forelegs together, and loaded onto the horse-drawn van following behind. The dogs were trained to pull deer down and detain them without causing injury, and they are described as a 'large rough sort of greyhound, and very powerful and sagacious'. An alternative method used the reward of food to entice deer into paddocks. 'Toils' were erected at selected openings in the paddock rails, the nets being supported on stout poles about 2 metres high. Dogs were then introduced into the paddocks, their job being to drive chosen animals into the nets, in which they became entangled, thus enabling them to be quickly immobilised. To assist, the two old deer pens were replaced by five new ones. For many of the moves, however, a professional was employed, such as W. Herring who was in business as an 'Importer of red and fallow deer to Her Majesty and dealer in all sorts of Pheasant, Fancy Poultry, Swan and Waterfowl, Gold and Silver Fish, Sporting and Fancy Dogs' and operated from 'The Menagerie, New Road, near Regent's Park'. Despite this large influx of fallow deer, there was little increase in the size of the park herds. Jesse's survey of 1831 revealed the presence of 1,400 animals; in 1848 a census put the numbers at '1,500 or thereabouts'. The 1848 census, made by Sawyer, was detailed, identifying the deer by age and sex. Excluding fawns, there were 700 males and 550 females. The commissioners had laid down a policy in 1843 that required the keepers to achieve a ratio of five males to three females, having been advised that, in some

of the best-managed herds in the country, the number of male deer was nearly double that of the female. This policy was pursued with some vigour, even to the extent of killing off 'such proportion of female fawns dropped ... as shall tend to produce the object in view'. There were about four deer for every 5 acres of open parkland. Although the pastures were sufficient to sustain that stocking rate, plus a limited number of cattle from spring to autumn, supplementary winter feeding was a regular feature of herd management. Hay, beans, corn, carrots, potatoes and acorns were all part of the winter diet. Only the hay was produced – in the large paddocks on the east side of the Beverley Brook – and the acorns gathered in the park, with small boys employed – including the head keeper's sons.

In 1835 Princess Elizabeth died, and the Duke of Cambridge, her brother, was appointed as ranger. He, too, was an absentee in Germany, being still Viceroy of Hanover. However, General Campbell's position, and his occupation of the Old Lodge, had been a personal arrangement between him and the princess. Accordingly, Old Lodge was vacant when Cambridge returned from Hanover in 1837. It was offered to him, but he and the duchess said they would be happier at their house on Kew Green. The lodge was in poor condition and it was estimated that it would cost £6,000 to repair, which was deemed unjustified taking into account its condition. So, between 1839 and 1841, it disappeared as had Petersham Lodge previously.[11]

Lord Sidmouth died in February 1844, so in essence the Duke of Cambridge would have been entitled, by the terms of his appointment, to White Lodge, but again he declined, as they preferred to live in Kew. As a result, the house was granted to Princess Mary, Duchess of Gloucester, who occupied it from 1844 until her death in 1857, but as ranger from 1850 in succession to the Duke of Cambridge. After the death of Princess Mary, the position as ranger was given to the 2nd Duke of Cambridge, who also preferred to live at Kew.

For a while Queen Victoria retained White Lodge in her own hands. In 1858 the Prince of Wales was sent there, with his tutor, for some serious studying, then in 1861 the queen and Prince Albert stayed in the lodge for a while after the death of the queen's mother in March – and, as it transpired, only months before the death of Albert. White Lodge was then lent for a short time to Lady Phipps, and in 1867 and 1868 it was again used occasionally by the Prince of Wales. In 1869 it was granted to Princess Mary of Cambridge and her new husband the Duke of Teck.

For eleven years after the death of Lord Sidmouth no deputy ranger was appointed. The head keeper, or superintendent, reported directly to the ranger. However, in 1855 the post was revived. The three holders of the appointment between then and 1922 – Colonel Augustus Liddell (1855–70), Major-General T. H. Clifton (1870–98) and Admiral Sir A. FitzGeorge (1898–1922) – had no homes in the park, for the mansions were all occupied.[12]

At Thatched House Lodge, Lady Stuart outlived her husband by forty years. On her death in 1841 it was granted to General Sir Edward Bowater. Again there was a long occupancy by a widow, Lady Bowater, who died in 1892. The Stuarts and the Bowaters occupied the house for over 100 years.

It was, however, Pembroke Lodge that had the most fascinating occupants. It had been the home of the Earl of Erroll for fifteen years from 1831 until 1846. Then, after a brief occupancy in 1846 by the Countess of Dunmore, the house was given in 1847 to Lord John Russell (1792–1878). The Russells were also long-term residents. Lord John (later Earl Russell) lived there until his death in 1878, and his widow for a further twenty years after that. Russell had made his name championing the passage of the Reform Bill of 1832. He came from an aristocratic family (the dukes of Bedford) noted for its public spirit. His own liberal inclinations were probably also due to a private education rather than attendance at a

public school and, eschewing Oxbridge, his attendance at Edinburgh University, where he imbibed the philosophy of the Scottish Enlightenment. He championed the cause of religious freedom for English Dissenters and Irish Catholics, but as Prime Minister his attempts to end civil disabilities for Jews, extend the franchise to urban workers and guarantee security of tenure to Irish farmers were frustrated by party disunity. Thwarted in public life, he retreated to Pembroke Lodge where he wrote copiously – poetry, biography and history – till his death. Their daughter Lady Mary Agatha Russell continued to occupy Pembroke Lodge until 1903. Bertrand Russell, the philosopher, Lord John's grandson, spent much of his childhood here. He arrived at the age of four, and the opening sentence of his autobiography reads, 'My first vivid recollection is my arrival at Pembroke Lodge in February 1876.' Both parents had died before he was four. Contrary to his parents' wish for him to be brought up by atheistic friends, he became the ward of his grandmother, Lady Russell, a woman of strict personal conscience and Puritan views, and so grew up at Pembroke Lodge, where,

> throughout the greater part of my childhood, the most important hours of my day were those that I spent in the garden ... I knew each corner of the garden, and looked year by year for the white primroses in one place, the redstart's nest in another, the blossom of the acacia emerging from a tangle of ivy. I knew where the earliest bluebells were to be found, and which of the oaks came into leaf soonest.

One of his great childhood friends was Annabel Grant Duff, who lived at York House, Twickenham. In a memoir of her early life, she wrote,

> My only boy friend was Bertrand Russell ... Bertie and I were great allies and I had a secret admiration for his beautiful and gifted elder brother Frank. Frank, I am sorry to say,

sympathised with my brother's point of view about little girls and used to tie me up to trees by my hair. But Bertie, a solemn little boy in a blue velvet suit with an equally solemn governess, was always kind, and I greatly enjoyed going to tea at Pembroke Lodge. But even as a child I realised what an unsuitable place it was for children to be brought up in. Lady Russell always spoke in hushed tones and Lady Agatha always wore a white shawl and looked down-trodden ... They all drifted in and out of the room like ghosts and no one ever seemed to be hungry. It was a curious bringing up for two young and extraordinarily gifted boys.

Visitors to Pembroke Lodge were also rather exciting, and included Garibaldi in 1864 as well as Nasir ud-Din, Shah of Persia, who paid a state visit to England in 1873 and recorded it all in his diary. On Sunday 29 June he was driven down past Chiswick and Kew to Richmond:

It has some pleasant avenues and a beautiful view over the surrounding country – especially over the River Thames. On the lawns here, also, there were many deer of the kind we saw at Windsor. As rain was still falling, and it was impossible to go about, it was proposed to proceed to the house of Lord Russell – one of the olden English ministers of celebrity, which was near at hand. I experienced a desire to go. We went, alighted, and entered. He and his wife came to meet us. He is an old man, nearly eighty years of age. He is short of stature. In spite of his years, he is in possession of a fine intellect and understanding. He is of the Whig party ... Well, we sat for a while. Dr Beust, the Austrian Ambassador, and other diplomats were there. After a few minutes we mounted again, and drove to the hotel of Richmond [the Star and Garter] which is a very beautiful establishment ... The view was very fine, but the haze and clouds prevented its being seen properly. The rain fell unceasingly; so we sat there a little, took some tea and fruit, and then drove home.[13]

At Sheen Lodge, too, sixty-five years of the Adam family was followed by sixty-nine years' occupation by the Owen family. When Sir Frederick Adam gave up the lodge in 1852 it was granted to Professor (later Sir) Richard Owen, a botanist who had just been appointed the first director of the Natural History Museum. He, and then his daughter-in-law and his granddaughter Mrs Ommanney, lived there until 1921.

There were further changes in the 1850s in relation to the administration of the park. The merged Office of Woods and Works was split up again in 1851, and the responsibility for royal palaces and parks was now firmly placed with the Office of Works. However, the ranger, or in practice the deputy ranger, still had a considerable say in the administration. Directly under their control were the head keeper, second keeper, three under-gamekeepers, a carpenter, a mole catcher, the five gatekeepers, and a number of labourers. The park bailiff, a direct employee of the Office of Works, was responsible for the maintenance both of buildings, roads and trees in the park, and of the Richmond–Kew road. He had his own staff – a foreman of roads and three workmen, a carter and a part-time carpenter. Four uniformed constables were placed under the bailiff's control after a luncheon guest of the Russells' had been robbed by a youth with a pistol. At the same time, the five gatekeepers on the ranger's establishment were also clothed in constable's uniforms. In the summer months, three extra police constables were attached to the bailiff's force. In 1875 the park police were transferred from the bailiff's department to the rangers'.[14] During the latter years of the eighteenth century, after the court of George III had been established at Kew, and the first half of the nineteenth century, the 'Kew Cart' made regular journeys along the Richmond–Kew road, travelling between Richmond, Kew and Windsor Castle. On the cart was carried produce from Richmond Park, destined for the royal table. Pheasant, partridge, hares and leverets, and sometimes fish were sent. A substantial quantity of game was then shot in the park. Not all went to the royal table;

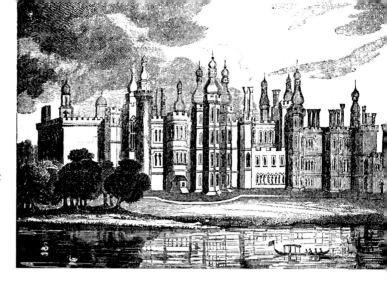

1. View of Richmond Palace (engraving) in the seventeenth century. It was built by Henry VII in 1501 and became a show palace of considerable repute to show off to foreign guests.

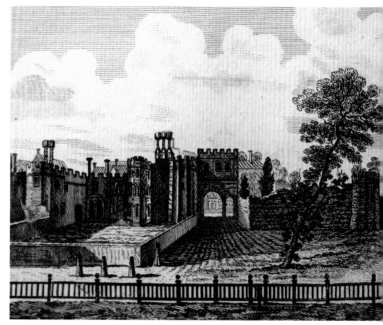

2. Anne of Cleves (1515–57), the fourth wife of Henry VIII, had a long association with Richmond Palace, and used it as her main residence from 1540 until 1547. The palace was the scene of Anne's divorce, and was where she established herself in the anomalous position of a wealthy and unmarried great lady.

*Below:* 3. Richmond Palace's west front, drawn by Antony Wyngaerde, dated 1562. Once Elizabeth became queen, she spent much of her time at Richmond, as she enjoyed hunting stags in the 'Newe Parke of Richmonde'. She died there on 24 March 1603.

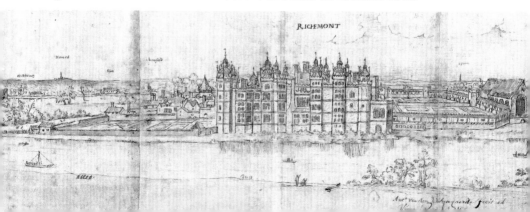

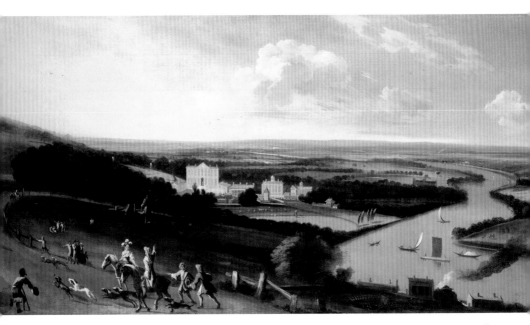

4. The Earl of Rochester's House, New Park, Richmond, Surrey, between 1700 and 1705, artist unknown. Rochester rebuilt the old lodge, then laid out new gardens, and walks and avenues in the woods, with his fine new house designed by Matthew Banckes and built in 1692–3 with additions by John Yeomans in 1699. It was simply called 'New Park', and as keeper he may well have regarded the park as his own property. (Yale Center for British Art, Paul Mellon Collection)

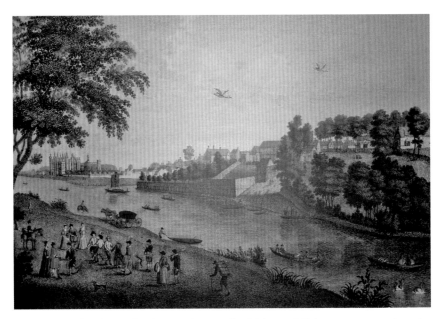

5. Painting of Richmond Palace and riverside. Richmond Palace was granted to the divorced queen, Anne of Cleves, Henry's fourth wife, who entertained the king and his daughters there on several occasions. (Courtesy of London Borough of Richmond upon Thames)

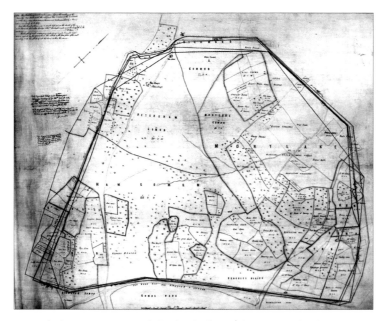

6. Nicholas Lane's map of the lands for enclosure in Charles I's New Park, showing several different boundaries that were considered. This pre-enclosure map of Richmond Park, surveyed in 1632 but completed in 1637–8, depicts the mixture of common land and private holdings, and shows the route of the projected wall to surround the new park.

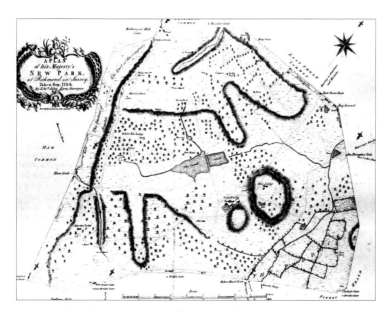

7. Plan of Richmond Park, made for Princess Amelia in 1754 by John Eyre, a surveyor. John Rocque's 'Survey of the Country Ten Miles round London' in 1746 and Eyre's plan in 1754 are the earliest plans of Richmond Park from the eighteenth century. Both these plans show a number of other buildings in the park, whose origins may date from the Walpole era.

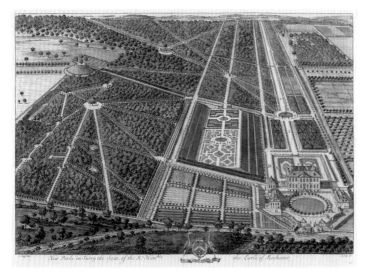

8. Engraving by Jan Kip and Leonard Knyff for *Britannia Illustrata*. Henry VIII's Mound can be seen on the left of the image, and Hatch Court, the forerunner of Sudbrook Park, at the top right.

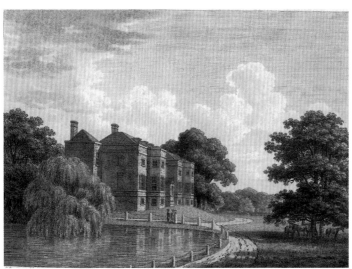

9. The Lodge, in Richmond Park, the residence of Phillip Medows, Esquire, West Suburb, 1780, by William Watts. (Yale Center for British Art, Paul Mellon Collection)

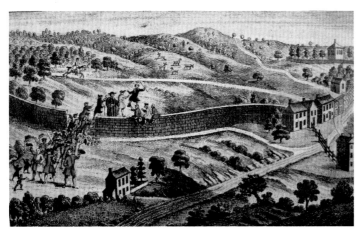

10. The frontispiece of *Two Historical Accounts ... of New Forest and Richmond New Park*. This shows the bound-beating entering the park through a breach in the wall on 16 May 1751.

11. Henry Addington, later 1st Viscount Sidmouth, by Francis Wheatley. Addington maintained homes at Up Ottery, Devon, and Bulmershe Court, in what is now the Reading suburb of Woodley, but moved to the White Lodge in Richmond Park when he became Prime Minister. However, he maintained links with Woodley and the Reading area, as commander of the Woodley Yeomanry Cavalry and High Steward of Reading. (Yale Center for British Art)

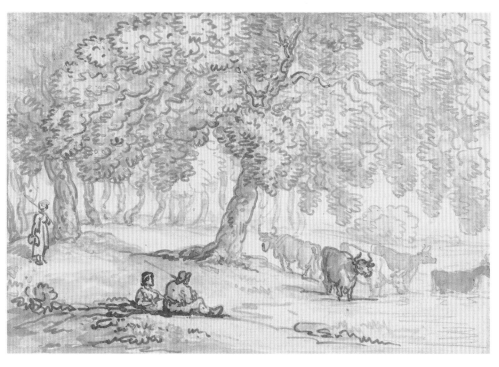

12. Richmond Park by Thomas Rowlandson. (Yale Center for British Art, Paul Mellon Collection)

13. In August 1793, Nathaniel Kent, writing as a member of his firm of Kent, Claridge & Pearce, submitted a 'plan and elevation for a new gate and lodge on Richmond Hill, approved by His Majesty', together with an estimate for this work and for repairs to the other gate lodges.

*Left and below:* 14 & 15. Two nineteenth-century engravings of feeding deer in a severe winter. Supplementary winter feeding was a regular feature of herd management. Hay, beans, corn, carrots, potatoes and acorns were all part of the winter diet. Only the hay was produced – in the large paddocks on the east side of the Beverley Brook – and the acorns gathered in the park, with small boys employed for these tasks – including the head keeper's sons.

16. Pembroke Lodge in the nineteenth century. In 1847, Queen Victoria granted the lodge to Lord John Russell, then Prime Minister, who conducted much government business there and entertained Queen Victoria, foreign royalty, aristocrats, writers and other notables of the time, including Garibaldi. Lord John was much taken with the lodge, calling it 'an asset that could hardly be equalled, certainly not surpassed in England'.

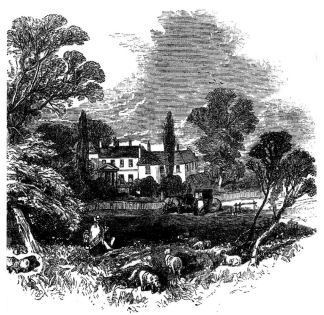

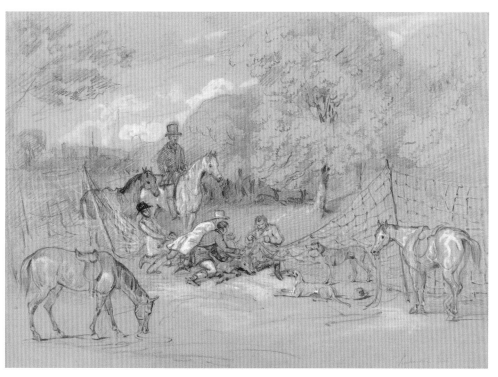

17. Netting deer in Richmond Park, undated, by George Hayter. An alternative method used the reward of food to entice deer into paddocks. 'Toils' were erected at selected openings in the paddock rails, the nets being supported on stout poles about 2 metres high. Dogs were then introduced into the paddocks, their job being to drive chosen animals into the nets, in which they became entangled, thus enabling them to be quickly immobilised. (Yale Center for British Art, Paul Mellon Collection)

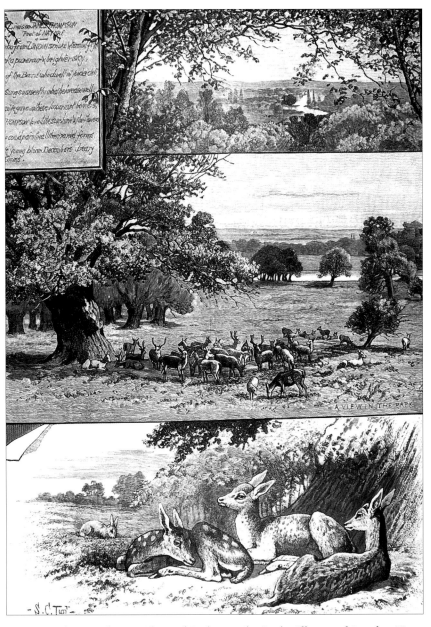

18. Pastoral scenes from Richmond Park, popular in the *Illustrated London News* in the nineteenth century.

19. Kingston Gate dates from around 1750. In 1898, the gates were widened and the present cradle gate erected. Later, the iron gates were replaced by low timber ones, but the cradle gate and iron piers remained. The present gates were erected 1954–7, and consist of two carriage gates with pedestrian gates on either side.

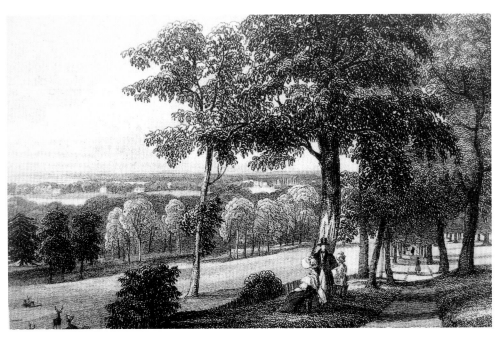

20. The new terrace in Richmond Park, made after Petersham Park was recovered in 1835. Engraving by Frederick Smith, *c.* 1838.

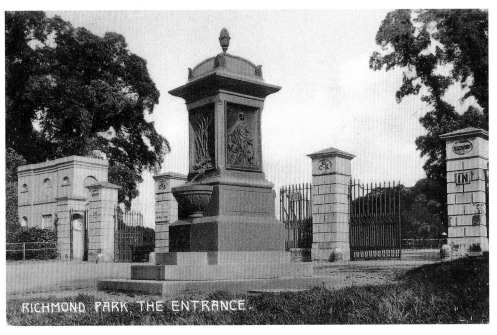

RICHMOND PARK. THE ENTRANCE.

21. Richmond Gate is one of the original six gates, and has the heaviest traffic. The gates were widened in 1896. According to Collenette, a drawing dated 1782 shows the gates to have been of timber with a ladder stile for pedestrians. These were replaced in 1798, when new iron gates and lodges for the gatekeepers were erected. Their design has formerly, but incorrectly, attributed to Capability Brown.

*Above left:* 22. Sheen Gate (one of the original six gates in the boundary wall when the park was enclosed in 1637) was where the brewer John Lewis asserted pedestrian right of entry in 1755 after Princess Amelia had denied it. The present double gates date from 1926.

*Above right:* 23. Roehampton Gate is also one of the six original gates. The present wrought-iron gates were installed in 1899. Roehampton Gate Lodge dates from 1901, with the initials V.R. set in stone in the brickwork of one of the main elevations. The earlier lodge was built on the opposite side of the gates in what is now the rest garden, and is shown on Rocque's plan of 1741. The present lodge, with its mock-Tudor timber and decorative tile hanging, reflected the architectural style of the time.

24. The land on which the Star and Garter Hotel was later built was owned by the Earl of Dysart, and is located on the river-facing side of Richmond Hill, next to the Richmond Gates of Richmond Park and overlooking Petersham Common. The land, initially only enough for the building of a small inn in 1738, was leased from the earl by a John Christopher (died 1758). This inn bore the name 'Star and Garter', a name that was and still is common among inns and hotels around Britain

25. White Lodge. The house was built as a hunting lodge for George II by the architect Roger Morris, and construction began shortly after his accession to the throne in 1727. Completed in 1730 and originally called Stone Lodge, the house was renamed New Lodge shortly afterwards to distinguish itself from nearby Old Lodge, which was demolished in 1841.

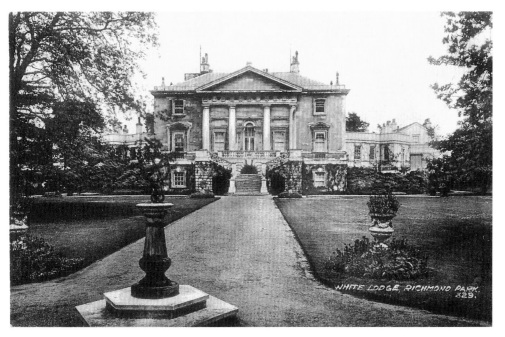

26. After restoration of the house following disrepair in the late eighteenth century, George III gave the house to another Prime Minister, Henry Addington, 1st Viscount Sidmouth, who enclosed the lodge's first private gardens in 1805. Although the king (affectionately called Farmer George because of his enthusiasm for farming and gardening) made himself ranger, Lord Sidmouth was made deputy ranger. Among the more famous visitors to White Lodge during this period was Horatio Nelson, 1st Viscount Nelson, in the month before the Battle of Trafalgar. He is said to have explained his battle plan to Lord Sidmouth by drawing lines on the table with a wine-moistened finger.

27. Edward VII developed the park as a public amenity by opening up almost all the previously fenced woods, and making public those gates that were previously private. He was popular with local people.

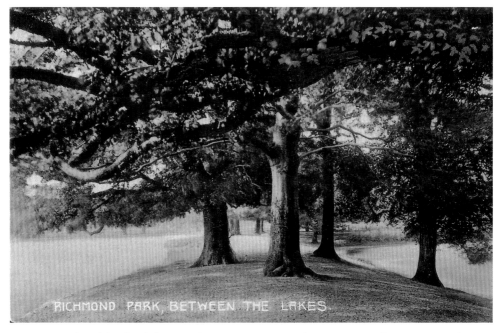

28. Pen Ponds, a lake divided in two by a causeway, was dug in 1746 and is now a good place to see waterbirds. John Rocque's 'Map of London', of 1746, shows Pen Ponds for the first time, named 'The Canals'. Between 1855 and 1861, new drainage improvements were constructed, including drinking points for deer.

*Above left:* 29. Another feature of the medieval deer park, the fishpond, remained evident in the shape of the Pen Ponds; fish were no longer being 'cropped' from the ponds by the end of the century, but they were still fishponds and not used for any other purpose.

*Above right:* 30. A large number of ponds were dug as watering points for the deer and cattle throughout the park, and in the late nineteenth century as part of Josiah Parkes' drainage scheme.

31. Queen's Ride, a broad, tree-lined avenue leading away from the west elevation of White Lodge, first comes to notice on Rocque's 'Survey of London', published in 1746, and was named as such after Queen Caroline, wife of George II. The survey gives the impression that the woods on either side of the ride were mature, which suggests that the avenue may have been hewn out of existing woodland, perhaps in 1736.

32. Many of the veteran oaks predate the enclosure of the park, and are at least 500 years old. From historical records it is known that funds were raised to repair the wall in 1659 'by felling and cutting of ... pollards and under woods', so 350 years ago the trees must have been 150–350 years old.

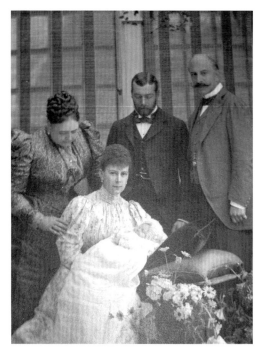

33. The royal christening of Prince Edward of York at White Lodge, Richmond Park, on 16 July 1894.

34. When Henry Addington moved in to White Lodge, much of the park was still in a semi-wild state. In the south-east corner, beyond Beverley Brook, was the Ranger's (or King's) Farm, with cultivated fields and meadow pastures for large flocks of sheep. The cattle from the farm ranged at large in the park, a practice which continued into the twentieth century.

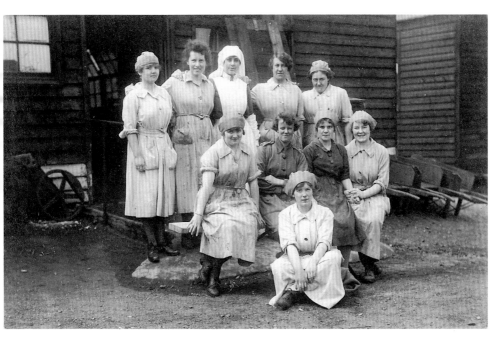

35. The Women's Auxiliary Army Corps in Richmond Park in 1917. A hospital, the South African War Hospital, was built on the parkland between Conduit Wood and Bishop's Lodge, and a second pedestrian gate, Cambrian Gate, was provided specifically to serve this unit.

36. The impact of the Second World War on Richmond Park was significant. This image shows an inspection on 22 May 1941 by HRH Duke of Kent, accompanied by actor David Niven and Colonel Hopkinson. (© The Hearsum Collection – donated by Colonel D. T. W. Gibson of the Phantom Squad)

37. Anti-aircraft gun emplacements were set up in a number of locations, and as a further defensive measure the Pen Ponds were drained and camouflaged so as to deny bomber crews the sight of an obvious landmark. A facility for disabling unexploded bombs operated between Isabella Plantation and Ham Cross. This was the first mixed (sex) HAA (heavy anti-aircraft) battery in the UK. (© The Hearsum Collection)

*Above left:* 38. 3/2 London Field Ambulance, Richmond Park Camp, Putney SW.

*Above right:* 39. The South African War Hospital. The hospital facilities were said to be the most advanced of their kind in Britain, and included 'bath-beds' – unique in this country – for those with bad shell wounds or advanced septicaemia.

*Top:* 40. Dispatch riders training just to the South of Pembroke Lodge under the watchful eyes of General Sir Allan Brooke and Colonel Hopkinson. (© The Hearsum Collection – donated by Colonel D. T. W. Gibson of the Phantom Squad)

*Above:* 41. The park in 1972. Richmond Park has about 1,200 'veteran' trees, over 800 of which are English oaks. Many of them date from before the enclosure of the park in 1637, and some are approximately 700 years old.

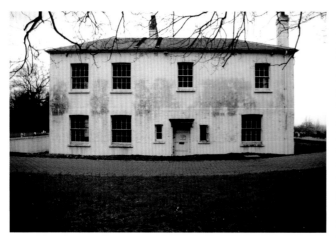

*Top:* 42. After the Second World War, Pembroke Lodge became a government-run tea room with flats for staff. Its conversion to either a restaurant or a country club had been considered earlier in 1926, but it was decided that the income from letting it as a residence would be a better source of revenue. However, in the early 1980s the upper floor was unused, as was part of the ground floor, and much of the building was damp.

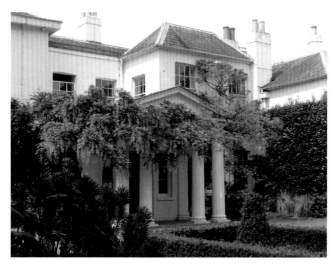

*Middle:* 43. The Hearsum Family Limited, a private company, entered a partnership with the Royal Parks Agency, in which the company ultimately restored Pembroke Lodge to its former glory at their own expense in exchange for the grant of a long-term lease. After significant investment, some 250,000 people a year now visit the lodge.

*Bottom:* 44. One of the best views in London is from the terrace of Pembroke Lodge.

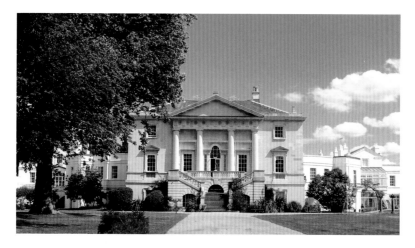

45. In 1955, the Sadler's Wells Ballet School was granted the use of White Lodge on a permanent basis. The school was later granted a royal charter, and became the Royal Ballet School in 1956. It is now recognised as one of the leading ballet schools in the world.

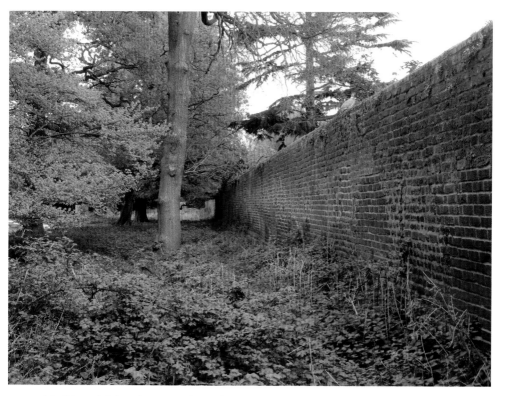

46. Edward Manning was given the contract to construct the wall, but found it hard to recruit local labour for the task. With royal press-ganging, 'mayors and kings' officers' were instructed to assist Manning in 'taking up the required bricklayers, labourers, carts and carriages'.

47. In 1736, Bog Gate (also then known as Queen's Gate) was opened as a private entrance by which Queen Caroline could enter the park on her journeys between White Lodge and Richmond Lodge, a royal residence in Old Deer Park. Public access, twenty-four hours a day, was granted in 1894 and the present 'cradle' gate installed.

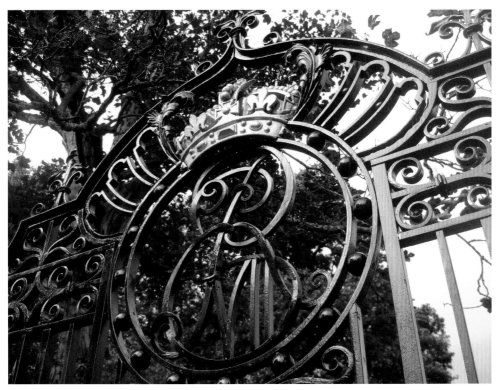

48. Robin Hood Gate, another of the six original gates, takes its name from the nearby Robin Hood Inn, and is close to what is called the Robin Hood roundabout on the A3. Widened in 1907, it was closed in 2003 as part of a traffic reduction trial and remains permanently closed. Alterations commenced in March 2013 to make the gates more suitable for pedestrian use, and to return some of the hard surface to parkland.

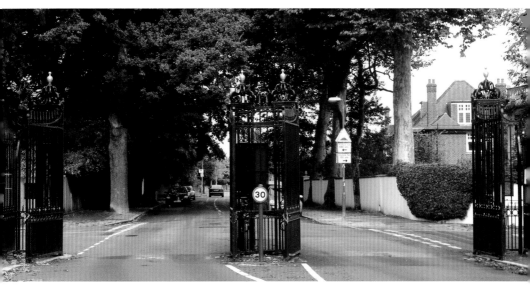

*Above and below right:* 49 & 50. Sheen Gate (one of the original six gates in the boundary wall when the park was enclosed in 1637) was where the brewer John Lewis asserted pedestrian right of entry in 1755 after Princess Amelia had denied it. The present double gates date from 1926.

*Below left:* 51. Distance plates in Richmond Park allowed the gatekeepers to accurately inform park users of the distance to the next gate – a frequently asked question.

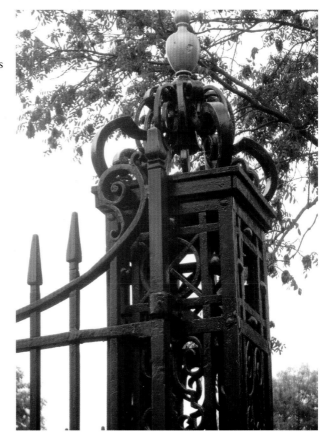

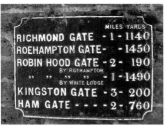

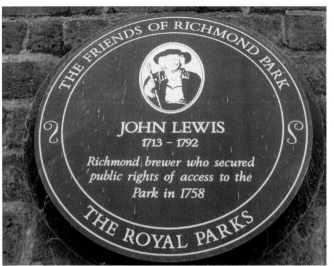

52. The dedication at Sheen Gate to local brewer John Lewis, who took the gatekeeper who stopped him from entering the park to court. The court ruled in favour of Lewis, citing the fact that, when Charles I enclosed the park in the seventeenth century, he allowed the public right of way. Ranger Princess Amelia was forced to lift the restrictions.

53. The Teck Fountain is located on the edge of the freeboard at Richmond Gate. Constructed of polished pink granite and green slate, it no longer functions and is in poor condition. It is inscribed 'HRH Princess Mary Adelaide Duchess of Teck, 27 October 1879'.

54. New gates, which can be viewed through the King Henry's Mound telescope, have been installed on the edge of Sidmouth Woods to mark the tercentenary of St Paul's Cathedral. St Paul's is connected to Richmond Park through the protected 10-mile view of the cathedral from King Henry's Mound.

*Above left:* 55 Lady Agatha Russell left a memorial, still standing in the rose garden: 'Pembroke Lodge 1847–1902 – In loving memory of my Father and Mother, Lord and Lady Russell and of our supremely happy home at Pembroke Lodge.'

*Above right:* 56. James Thomson (1700–48) was a Scottish poet and playwright, known for his masterpiece *The Seasons* and the lyrics of 'Rule, Britannia!' In later years, Thomson lived in Richmond upon Thames, and it was there that he wrote his final work *The Castle of Indolence*, which was published just before his untimely death on 27 August 1748. Johnson writes about Thomson's death that 'by taking cold on the water between London and Kew, he caught a disorder, which, with some careless exasperation, ended in a fever that put end to his life'. He is buried in St Mary Magdalene church in Richmond. This memorial, the successor of several earlier boards, was erected in 1895.

*Below:* 57. *Lovers in Richmond Park* (Windsor Park), 1864, James Smetham. (Yale Center for British Art, Paul Mellon Fund)

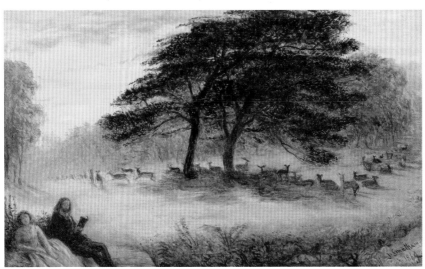

58. *A Group of Trees*, also known as *Trees at Richmond*, by Thomas Rowlandson. (Yale Center for British Art, Paul Mellon Collection)

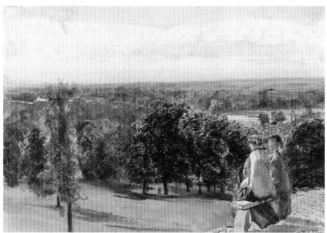

59. *In Richmond Park*, 1869, by John William Inchbold. (Yale Center for British Art, Paul Mellon Collection)

60. *Breaking Ice*, in Richmond Park, by artist Ruth Stage. (The New English Art Club)

61. *Icy Morning* in Richmond Park by artist Ruth Stage. (The New English Art Club)

62. *Richmond Park*, c. 1914, by Spencer Frederick Gore. Gore's hard work in Richmond Park and great devotion to this series were to lead to his destruction. He followed a regime of painting outdoors, directly before the subject, and in March 1914 he got wet and contracted pneumonia. Within just a few days he was dead.

63. *Winter Morning* in Richmond Park, by artist Ruth Stage. (The New English Art Club)

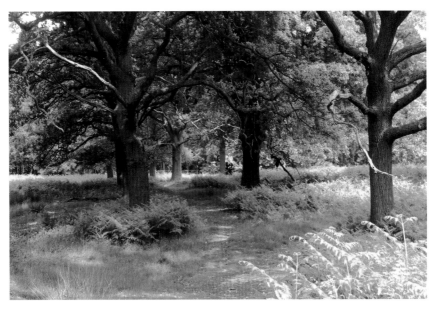

64. The veteran trees are perhaps the park's most outstanding feature, dotted throughout the parkland and woodlands. Some are in obvious lines, indicating very ancient field boundaries.

65. In Isabella Plantation, the garden has fifteen known varieties of deciduous azalea and houses the national collection of fifty Kurume azaelas – introduced to the West in around 1920 by the plant collector Ernest Wilson. There are also fifty different species of rhododendron and 120 hybrids.

66. Isabella Plantation, with its woodland garden, is one of several bird sanctuaries in Richmond Park. The main stream through the garden from Broomfield Gate was dug in 1960, and the plantation was enlarged to include Peg's Pond. More recently, in 1989, a wild stream was dug in the northern section and this has now been colonised by ferns, water plantains and brooklime. The Bog Garden was reconstructed in 2000.

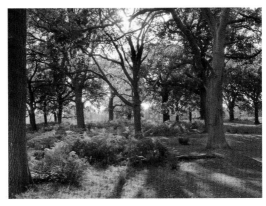

67. 'Occasionally when in London I visit Richmond Park to refresh myself with its woods and waters abounding in wild life, and its wide stretches of grass and bracken.' W. H. Hudson, *A Hind in Richmond Park*, 1922.

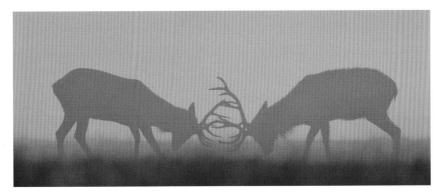

68. 'Stags are aloof and dignified, if not hostile in their manner, which prevents one from becoming intimate with them. When walking alone late on a misty October or November evening I listen to their roaring and restrain my curiosity. A strange and formidable sound! Is it a love-chant or a battle-cry? I give it up, and thinking of something easier to understand quietly pursue my way to the exit.' W. H. Hudson, *A Hind in Richmond Park*, 1922.

*Left:* 69. The definition of a veteran tree is 'a tree that is of interest biologically, culturally or aesthetically because of its age, size or condition'. Of the greatest significance is the number of trees the park supports – offering continuity of habitats by having several specimens in close proximity to one another.

*Below left:* 70. Richmond Park and Bushy Park are the first- and second-largest areas of acid grassland in the London area, with more than 280 hectares of this grassland community, including over fifty species of grass, rushes and sedges. Photograph by Tom Kenny.

*Below right:* 71. A visit to Richmond Park in the autumn reveals stunning colours and variations in foliage.

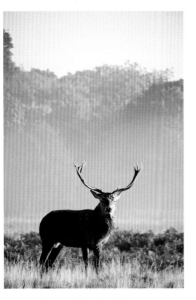

*Above left:* 72. There are accounts of Princess Amelia being thrown from her horse when a stag turned on it 'and due to her Petticoat hanging on the Pommel of the saddle' being dragged for some distance before being rescued. Formidable animals and certainly capable of looking after themselves!

*Above right:* 73. Autumn in Richmond Park.

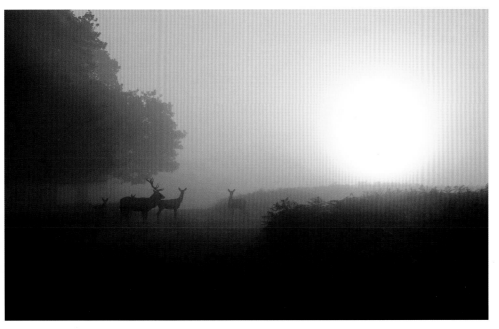

74. Sunrise on a cold autumn morning in the park. With few people around, it is often the best time to see the deer undisturbed. Photograph by Don Kiddick.

75. The largest ponds are the Upper and Lower Pen Ponds in the centre of the park; they are still fished today. Resident waterbirds include coots, moorhens, tufted ducks, mute swans, great crested grebes and grey herons.

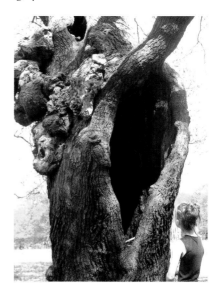

*Above left:* 76. The ancient trees, and the decaying wood habitat associated with them, support a huge diversity of wildlife, ranging from fungi to birds and bats. These fungi perform a crucial role in breaking down dead wood and creating habitats for other species.

*Above right:* 77. Veteran and hollowing trees support abundant wildlife, because of their decaying wood. In contrast, tall straight trees grown for sound timber are at an optimal stage for felling when they contain as much sound heartwood as possible – just before the decaying/hollowing process takes place.

*Top:* 78. Protection of the ancient tree resource is an important task for the Royal Parks. Richmond Park's veterans have individual management plans within a thirty-year programme of works.

*Middle:* 79. The chase often provided opportunities to develop 'courage, endurance, honour, discipline and horsemanship', proficiency in fighting on horseback being the mainstay of Norman military power. Today, much gentler 'horsemanship' is more common across the park's bridleways.

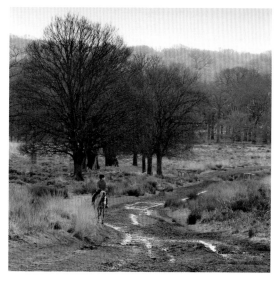

*Bottom:* 80. The invertebrate communities associated with decaying wood are of great conservation importance nationally and internationally, and the stag beetle is the species for which Richmond Park is designated a Special Area for Conservation.

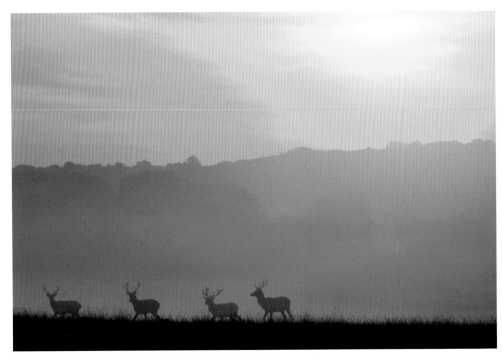

81. One of many stunning sunrises in Richmond Park.

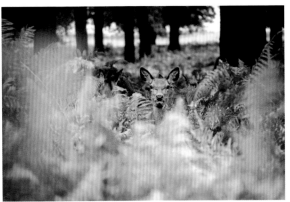

*Left:* 82. The parkland covers the less densely wooded parts of the park, usually with an understorey of bracken where deer are often found lurking.

*Below left:* 83. Very few fights occur during the rut, with most conflicts decided by posturing – who bellows the loudest, who smells the strongest, who has the most vegetation on their antlers? Fights only occur when the males are very evenly matched.

there were shooting parties organised by the ranger and others, hares were coursed, and no doubt the participants all had some share in the 'bag'. It was part of the head keeper's duties to arrange shooting, coursing and fishing for invited guests from time to time. The park ponds were maintained for fish production, just as they were in a medieval deer park. William IV had instructed Sawyer in November 1825 to ensure fish stocks were kept up. He was to obtain fish for stocking from unidentified sources, 'the sort and quantity of fish His Majesty leaves to your discretion'.[15]

During the latter years of his tenure as deputy ranger, Lord Sidmouth seems to have been content to let his head keeper take over much of the burden of managing the park. Sawyer was expected to report to Lord Sidmouth regularly, however, and he visited the deputy ranger's residence several times a month, usually at 10 a.m. Sometimes he attended to personal matters for his lordship, including decorating a local infant school on the occasion of their annual fete; it was a school in which one of Sidmouth's daughters, Charlotte, had a particular interest. Other less pleasant tasks included destroying one of Sidmouth's dogs after it had been attacked in the park by what was reputedly a mad rabid dog. Sawyer comfortably outlived Lord Sidmouth, who died at White Lodge in 1844.

Public access to the park had remained somewhat restricted during the first half of the century. Carriages were still admitted only with a 'card of admission', and though pedestrians might enter freely they were largely confined to the roads and defined footpaths. However, from the 1850s these restrictions were gradually abandoned. The Royal Parks and Gardens Regulations Act, passed in 1872, was indicative of a new way of thinking. The Act spoke of 'securing the public from molestation and annoyance while enjoying such parks, gardens and possessions'. The accounts for the park for the year 1870/1 include an item of £125 for 'sweeping and cleansing public conveniences'.[16] Lord Sidmouth's policy

of establishing plantations was continued, with additions to the Isabella Plantation in 1861 and 1865, to the Pen Ponds Plantation in 1865, to the Sawpit Plantations in 1874–5 and to the north-west part of the Spanker's Hill Plantation in 1877. In 1887 Queen Victoria's Golden Jubilee was commemorated by the establishment of Jubilee Plantation.[17] In 1855–61 a major drainage scheme was carried out over some two-thirds of the total area of the park. The work was supervised by Josiah Parkes, the pioneer of deep drainage of bogland. Among the areas drained was the bog that had given its name to Bog Lodge and the Bog Gate. A result of the drainage was the creation of nine small ponds to provide watering places for the deer. The area where the bog had been, between Bog Gate and Bog Lodge, was now granted to the Inns of Court Rifle Volunteers as a drill ground. In 1870 they were given permission to enter and leave the park by Bog Gate, which had previously been strictly a private gate. A number of new private gates had been constructed by the 1870s. One was at Sheen Lodge, made for Professor Owen. One, called the Pest House Gate, was near the workhouse; others were the Keeper's Gate (between Pest House Gate and Richmond Gate) and the Kitchen Garden Gate (between Bog Gate and East Sheen Gate). An old private gate, which had existed since the seventeenth century, was the Chohole Gate by the south-east corner of the park, which served the farmhouse in the paddocks beyond Beverley Brook.

Another gate, which had previously been private, was Petersham Gate. This was now used for foot access to Petersham Park, an area increasingly set aside for picnic parties, school outings and children's games. In 1856 Lord John Russell had to ask the head keeper to stop 'boys from playing cricket in all sorts of weathers in Petersham Park thus damaging the turf and greatly disturbing the deer'.[18] Interestingly, Lord John himself had set up, in this area four years earlier, a 'British School' for Petersham. He was granted a small plot of land by the Petersham Road, and built the

school entirely at his own expense. Named the Countess Russell School, it remained under the patronage of the family until 1891, when it was transferred to the direct authority of the British and Foreign School Society. The school remained on the site until November 1943 when it was destroyed by a bomb; the site now reverted back to parkland.

Even better known than the Russells to the population of Richmond – as supporters of local events, activities and charitable endeavours – were the ranger, the Duke of Cambridge, and his sister and brother-in-law, the Duke and Duchess of Teck, who lived at White Lodge with their daughter Princess May. They took the chair at charitable dinners, assisted in the establishment of the Richmond Royal Hospital, and opened fetes, new buildings and the Terrace Gardens. There was great delight locally when the Duke of York (son of the Prince of Wales – the future George V) married Princess May of Teck in July 1893; even more so when the new Duchess of York returned to her parents' home at White Lodge for the birth of her first child. The future King Edward VIII and Duke of Windsor was born there on 23 June 1894. Queen Victoria drove down to see her new great-grandson three days later, and came again to White Lodge on 16 July for the christening.

The Duchess of Teck died in 1897, and two years later, a year before his own death, the duke gave up White Lodge. It remained unoccupied during the last two years of Queen Victoria's reign. Very soon after King Edward VII's accession, he granted the lodge to his friend Mrs Emma Hartmann. Cloake quotes the lady's grandson, who wrote scathingly of the gift of the lodge and its consequences:

In 1901 an important but catastrophic addition was made to my grandmother's residences by King Edward VII, who bestowed on her for life the use of White Lodge in Richmond Park, a bestowal which, to quote *The Morning Post* of the day, was 'likely to be due to reasons of which the public knows

nothing...' Interior decorators descended on White Lodge like flies on a jammy opportunity. The house consists of a large central block from which extend two wings, each with its terminal block. Of all the interior decorators' accounts only one has survived, that of HJ Bertram and Son, who had secured one wing and the nursery block. This wing and block consisted of a curving corridor, three guests' bedrooms, the nurseries and the schoolroom, which had formerly been the sitting room of Princess May, later Queen Mary. By the time that Bertram and Son had finished with this end of the house it looked like a furniture depository, and the bill which was bound in red morocco, came to £56,784 19s 4d. King Edward found White Lodge a convenient, and I need hardly say, a comfortable hide-out. It was close to London, he could pop down – if a monarch can be said to pop – with or without giving notice of his arrival, and the press would not know where he had got to. And the food was so good that he appropriated the chef, a Frenchman named Menager ... The expenses of White Lodge ... combined with those of 39 Berkeley Square, which my grandmother ran concurrently with White Lodge, proved too much for even her means. Unknown to my father, she had recourse to money-lenders. The inevitable came in 1909, when my grandmother became a bankrupt. The bailiffs walked into White Lodge and sat on what they could. King Edward, who was not altogether without blame for this unfortunate turn of affairs, expressed to my father his strong disapproval of the failure of a person who had the privilege of occupying a grace-and-favour house, for which, I have always suspected, she had been paying a large rent. My grandmother promptly fell from both grace and favour and went to live with her sister in Paris ... No 39 Berkeley Square and White Lodge had between them cost every penny of £600,000.[19]

There were further changes in the day-to-day management of the park leading up to the end of the nineteenth century. Although the Parks and Gardens Regulations Act

suggested that the park was now managed as one unit by the Commissioners of Works, it seems that in practice, the situation was more complicated. On the death of Princess Mary in 1857, George, 2nd Duke of Cambridge, was appointed ranger. His warrant of appointment was much the same as that of Princess Mary, except that he was not given the sole right to appoint deer, game and park keepers; such appointments had also to be authorised by the queen or by the Lords Commissioners of HM Treasury (but not by the Commissioners of Works). Thus the management structure was to remain much as it had been, the ranger's department and that of the park bailiff (which was directly responsible to the Office of Works) having separate areas of responsibility until the turn of the century. As with previous rangers, day-to-day affairs were left in the hands of the deputy ranger, an office occupied between 1870 and 1898 by Major-General T. H. Clifton. James Sawyer retired in 1872 after forty-two years in office, and was succeeded by his son, Henry George Sawyer, who was, at thirty-one years of age, a junior gamekeeper in the park. John Lucas, who had in 1825 refused the head keeper's position in favour of James Sawyer, had died in the interim period, and his position as second keeper was filled by his son, also named John. His retirement in 1877 marked the end of the Lucas family's association with the park – an association which had continued, unbroken, since the reign of George I.[20] One of the other many changes which James Sawyer had witnessed in his long career was the erosion of the perquisites, some of them of considerable antiquity, which he and his predecessors had enjoyed. Their loss had been compensated for by increases in salary, and in the year of Sawyer's retirement his was £250 a year, plus allowances of £96 'in lieu of fees' and £12 for the purchase of powder and shot. The keepers still enjoyed rent-free accommodation, and the right to maintain a limited number of cattle, etc., for their personal use. One perquisite that was to survive for a few more years was that of selling rabbits. Reputedly, this was

so valuable to the keepers that the rabbits were assiduously protected, much to the annoyance of local equestrians, for whom rabbit warrens and burrows were a menace.

The term 'superintendent' is first mentioned towards the end of the nineteenth century, although this is misleading according to Baxter Brown. It was not formally introduced until 1904, but the grave of John Sherratt in Petersham churchyard carries the information that he was '28 years superintendent of Richmond Park' and his service, although not confirmed, was probably between 1850 and the late 1870s. It was the park bailiff who had the superintendence of the park, which included the duty of supervising the maintenance of the park's trees, and the policy of the systematic establishment of plantations, introduced early in the century by Lord Sidmouth. The southern sections of Isabella Plantation were planted in 1861 and 1865; the west and south sections of Pen Pond Plantation in 1865; the Sawpit Plantations, one on either side of the west end of Queen's Ride (thus extending the length of the Ride), were planted in 1874–5; and the north-east section of Spanker's Hill Wood in 1877. The beech trees flanking the terrace walk between Richmond Gate and Pembroke Lodge were probably planted shortly after Petersham Park was returned to the main park in 1834. Hornbeam Walk, which runs from the south of Pembroke Lodge to Ham Cross Roads, may have been planted at about the same time as a continuation of the terrace walk, but the first record of its presence is not made until 1875. A nursery for raising oaks was established in the park in 1824, but production was insufficient to cater for the large planting programmes, and young trees were acquired from other sources. A total of 3,000 Spanish chestnuts from A. Robertson of Dorking, and 500 English oak from Veitch & Sons, were purchased in 1875. In the same year, 2,000 oaks and 5,000 'firs' were received from the New Forest. The greater proportion of the trees planted were oak; not only are they the natural tree of the park but also their acorns made

an important contribution to the diet of the deer. Spanish chestnut were planted in some quantity for the same reason. However, other species were not neglected, and beech, hornbeam, sycamore, thorn and larch were all represented in the nineteenth-century plantings. Silver birch, the 'lady of the woods', may have been planted too, but it is more likely that the majority of birch trees established naturally.[21]

Towards the end of the nineteenth century, head keeper Henry G. Sawyer had few problems, apart from the perennial one of providing a sufficient supply of venison for the royal warrant. However, at the end of September 1886, things were to dramatically change. The unusual behaviour of some of the fallow deer near Sheen Gate, together with the discovery of a fallow carcass in the vicinity, warned the keepers that something was seriously amiss. The Agricultural Department of the Privy Council Office was consulted, and they sent their Chief Inspector, A. C. Cope, and Professor V. Horsley of the Brown Institute, London, to look into it further. The establishment of the presence of rabies was confirmed by Cope and Horsley. In their official report of the Richmond Park outbreak, they conjectured that 'the distemper' that had destroyed a large number of deer in Cassiobury Park in Hertfordshire in 1798, and 'which remained so long in Windsor Great Park', may well have been rabies. Baxter Brown found this especially interesting because Henry Sawyer, deer keeper at Petworth Park in Sussex in the late eighteenth century, refers to both outbreaks in a letter to his nephew James Sawyer (the first of the Richmond Park Sawyers, and Henry G. Sawyer's grandfather) dated 25 February 1798:[22] 'I am sorry to hear that the distemper has destroyed so many deer at Cassiobury Park and that it should remain so long in Windsor Great Park but I have not the least opinion that the sheep is the cause of it...' He then describes a similar outbreak of 'distemper' in Windsor Little Park, where he had probably worked earlier in his life (his father, John Sawyer, who died in 1732, was keeper of the king's Little Park at Windsor early in

the eighteenth century), in this instance blaming 'bad weeds' growing in cold, wet land in the north part of that park for causing the outbreak. Henry Sawyer had already discussed the Windsor Park 'distemper' in an earlier letter to his nephew: 'I never heard of exactly the same disorder among the deer as rages at Windsor Park, but some years past we had a disorder here among the deer, of which so many died or in consequence of which were killed, that I believe we had not above 30 left.'[23] However, the Petworth 'disorder' was unlikely to have been rabies. Although the symptoms shown by affected deer, as described by Sawyer, were in some respects similar to Cope and Horsley's description of the rabid Richmond Park deer, there was one major exception. Sawyer specifically stated that 'they never offered to bite each other nor do harm to other animals', whereas in Richmond Park they did. Indeed, this was one of the major findings of the Cope and Horsley investigation, for they were able to prove conclusively that the rabies virus was transmitted by diseased deer attacking and biting healthy animals, something about which there had previously been considerable doubt, with reference not only to deer but to herbivores as a whole.

The disease spread slowly throughout the herd during the winter of 1886/7, and by April 160 animals had died. At first, the greater mortality was among the does and fawns, because the bucks were able to fend off attack from rabid animals with their antlers. After they had shed their antlers, and when in velvet, the bucks proved to be just as vulnerable as the does and fawns. By September the outbreak had been brought under control, but 264 fallow had been lost, either because of the disease or from being shot because they displayed the symptoms. Thankfully the outbreak was contained in one area of the park – in the vicinity of Sheen Gate – because of the fallow deer's habit of remaining relatively static, in herds of about 100 or 200, in specific localities. As a consequence, only the one herd was decimated; outbreaks of the disease had occurred in an adjacent herd, but by confining this

second herd in hastily constructed paddocks, and shooting any animal that showed symptoms, Cope and Horsley were able to prevent further contagion. One final experiment completed their investigation. Four red deer were paddocked on pastures that had been grazed by rabid fallow. The red deer were given their freedom after a period of some months, during which they remained perfectly healthy, thus proving to the satisfaction of the two scientists that the rabies virus could not be spread via contaminated pastures.[24] Eleven years later, Henry G. Sawyer reported another epidemic, but of a much less dramatic nature. Following a succession of foggy weeks in late November and December 1897, a number of fallow deer, seemingly in good condition, were found dead. A post-mortem, carried out by the head keeper, revealed that the beast's intestines were inflamed, and in most cases the livers congested, but not the respiratory system. At the same time many deer were 'attacked with scour', which according to Sawyer was 'not uncommon among the deer in Spring when grass is early and white frosts occur but it is unusual to have scour in Autumn or early Winter'. The deaths continued into the new year, and between Christmas and mid-February twelve bucks, ten does and thirty-four fawns were lost. Many of the latter died of weakness, showing no signs of scour, and Sawyer attributed the greater loss of fawns to cessation of lactation by affected does.[25] The head keeper was cautious in his diagnosis of the cause of the outbreak but seemed to attribute it to atmospheric influence – the large deposit of London smoke on the grass during the foggy weather may have proved an irritant. Hares had died in the park during the same period, displaying the same symptoms, possibly as a result of grazing on pastures that had been heavily contaminated by deposits from London smoke.

The losses caused by the two epidemics were never to be made good. Prior to the rabies outbreak there were more than 1,400 fallow in the park; by the end of the century there were just over 1,000. However, numbers were no longer so

important. By this time it had been realised that the remaining fallow herds of the royal parks were just not sufficiently large to maintain the supply of venison required to satisfy the needs of the Royal Venison Warrant, so measures were taken to reduce the huge quantities that had been called for earlier in the century. Some recipients were unfortunate enough to lose their entitlement altogether; others found that the amount of venison they were accustomed to receive each season was reduced. Even the royal table suffered, and Queen Victoria agreed to accept a lesser number of carcasses in 1885, and again in 1893. No longer was it necessary to strive to keep the park herds at maximum strength, and the intensive management practices which had been followed for much of the century were gradually ceased.

# A Medieval Park
# into the Millennium

The beginning of the twentieth century saw Richmond Park enter a new phase in its history. King Edward, who had an interest in Richmond Park, quite apart from Mrs Hartmann, that dated back to his residence there in the 1850s and 1860s, decided that he would take the position of ranger himself when George, Duke of Cambridge, died in 1904. (He also took over the job as ranger of St James's, Green and Hyde Parks in London.) He decreed that the existing deputy rangers, both at Richmond and London, should remain in office, but when they died or retired no further such appointments should be made. 'The Commissioners of His Majesty's Works and Public Buildings will be charged with the general management of the said Park.' The king minuted, 'I hope that the two Deputy Rangers fully understand that they can give no orders without my permission and any suggestions from them for the well-being of the Parks should be submitted to me through the First Commissioner of HM Works.'[1] With this new dispensation, the separate departments of the ranger and the park bailiff were amalgamated, under a new superintendent directly responsible to the Office of Works. The posts of head keeer and bailiff were abolished, as were

those of the under-keepers. Henry G. Sawyer was retired on 1 July 1904. This was the end of a family association that had survived for well over a century and had produced three generations of head keepers. The first superintendent was Mr S. Pullman, who had been employed in the park for a number of years in the park bailiff's department as foreman. Benjamin Wells, who had been Henry Sawyer's assistant, was appointed assistant to Pullman. Two of the three gamekeepers were retained: George Wells and Earnest Buckley.

King Edward, as ranger, instructed that

> steps be taken to render all parts of Richmond Park more accessible to the Public than heretofore. With this object His Majesty has given directions that the preservation of game in the Park shall be discontinued and that woods hitherto closed shall be thrown open where possible without injury to the timber or without detriment to the preservation of order in the Park.[2]

The only exceptions were Sidmouth Wood, Pond Plantation and Teck Plantation. Already some steps had been taken to improve access to the park itself. In 1884–5 the last surviving ladder stile, by the one-time Coombe Gate, had been replaced by a normal pedestrian gate, which still bears the name of Ladder-Stile Gate. In 1894 the Queen's (Bog) Gate was opened to public foot traffic, and in 1896 the Keeper's Gate at the end of Chisholm Road was similarly opened. The carriage gates were all eventually widened, starting with Richmond Gate in 1896, then Kingston Gate in 1898 and Roehampton Gate in 1899. Robin Hood Gate was widened later, in 1907, Ham Gate in 1921 and East Sheen Gate in 1926. These are discussed further in Chapter Six.

Another change in the park was the slaughter of almost 2,500 rabbits, because, being game, they were no longer protected, and this in turn improved the pastures to the benefit of the deer and gave rise to the establishment of many

thousands of silver birch seedlings in the enclosed plantations, not all of which were to remain closed; some 40 hectares were opened up as a result of the royal command, and two years later a driftway bisecting Sidmouth Plantation was opened to the public.

Towards the end of the nineteenth century there was mounting public criticism of the practice of hunting the carted stag, and particularly of the royal connection with the sport through the Royal Hunt. In view of this, Edward VII, when he came to the throne, decided that it would be expedient to disband the Royal Hunt, despite its long and illustrious history. As a consequence, the number of red deer in the park, which had remained constant at between fifty and sixty throughout the nineteenth century because some were regularly sent to the Royal Hunt paddocks, had leapt to seventy-five by 1906.[3] Edward himself was not averse to field sports, especially shooting, so it is possible that the same public criticism may have had some influence on his decision to discontinue the preservation of game for sport in Richmond Park.[4] Baxter Brown describes the park as having been brought to a more advanced or highly organised state in response to the demands made of it. There had been no fundamental changes, as the basic structure remained virtually unaltered. As he states, the reasons for the park's continuing existence had changed – by 1904 it was no longer a hunting ground, its original *raison d'être*; but the change of use had little or no impact on its structure and character. It was still a deer park, and made up of varying and informally bounded areas of 'wasteland', pastures and 'launds', and woodland not intended for commercial timber production, whose proportions were influenced more by natural restrictions than by man's direction. The creation of the enclosed plantations was not out of character with the medieval deer park, for they too had their enclosures, albeit for differing reasons. Relatively large numbers of old, mature oaks, many of them 'stag-headed', still survived to contribute to the impression

of ancient parkland. That other feature of the medieval deer park, the fishpond, remained evident in the shape of the Pen Ponds; fish were no longer being 'cropped' from the ponds by the end of the century, but they were still fishponds and not used for any other purpose.[5]

It was only a few years since Edward VII had disbanded the Royal Hunt on account of adverse public criticism when, having also decreed that game should no longer be preserved for sport in Richmond Park, the red deer herd flourished; but the fallow herds were not prospering in the early years of the twentieth century. The size of the herds had reduced rapidly, and mortality among the fawns was high. To stop the accelerating deterioration, it was decided to introduce a number of bucks from elsewhere, most of them supplied by a Mr Richard Porter, who was apparently a professional dealer. He was associated with a number of transactions involving live deer and the royal parks between 1899 and 1916. The health of the fallow herds began to improve, probably because of the introduction of new stock and because of the lesser number of deer in the park. It was agreed that the strength of the fallow herd should remain at about 800 animals, and it soon became apparent that, in order to maintain this number, more deer than were required for royal warrant purposes would have to be culled. In 1911, for the first time, Richmond Park venison was sold in the marketplace, dressed carcasses fetching 5*d* a pound. In 1906 an attempt was also made to establish a roe deer colony, with five animals from Lord Ilchester's estates of Milton Abbas in Dorset being released in Sawpit's Plantation, on the edge of Queen's Ride. The introductions proved to be unsuccessful – most did not survive and were not seen beyond 1912.

Access to the park was becoming less restricted. In 1894 Bog (or Queen's) Gate (originally opened in 1736 to provide a private entrance for the royal family on their way to and from White Lodge) was opened to the public twenty-four hours a day. A new gate was made to facilitate easier access

(to foot traffic only). This was probably the first of the now familiar iron cradle gates, which allowed unhindered pedestrian use but prevented escape by the deer. Two years later, in response to public demand, a second cradle gate was constructed adjacent to Bishop's Lodge, but, unlike Bog Gate, Bishop's Gate was locked at night, an arrangement which was to persist for a few more decades. A new cradle at Ladderstile, already a public entrance for pedestrians, was built in 1901.[6] The accessibility to plantations was increased as a direct result of the king's command in 1904. Conduit Wood was opened up in 1905, and Sheen Wood a year later. In the same year the 'driftway', which bisected Sidmouth Plantation east to west, was opened to the public during the summer months. Creation of new plantations continued. The first of the Coronation Plantations, beside Dann's Pond, was planted in 1902 to commemorate the coronation of Edward VII; Teck Plantation, the enclosed woodland to the west of Sheen car park, dates from 1905.

As with many of the public parks and Royal Parks in the country, the impact of the First World War on Richmond Park was significant. A large military camp was established on what are now the golf courses and a fenced-off enclosure, known as the 'bombing compound', which appeared beside the carriageway 100 metres west of Sheen Crossroads. A hospital, the South African War Hospital, was built on the parkland between Conduit Wood and Bishop's Lodge; a second pedestrian gate, Cambrian Gate, was provided specifically to serve this unit. The hospital facilities were said to be the most advanced of their kind in Britain, and included 'bath-beds' – unique in the United Kingdom – for those with bad shell wounds or advanced septicaemia. The patient would recline on a cradle, suspended in flowing water at body temperature. This treatment, which normally lasted four to five days, greatly eased the pain otherwise incurred by changing dressings, as well as helping to drain septic wounds and making sleep easier. During the war, over 40

hectares near Sheen Gate were ploughed, and crops of oats and potatoes grown. Garden allotments, administered by Richmond Borough Council, were situated in the north-west corner.[7] The tradition of renting grazing for cattle continued, and in 1914 there were 143 head of cattle in the park, some of which belonged to park staff. Grazing was shared not only with the park's deer but with six agricultural horses, two saddle horses and two driving ponies, all of which were used by various members of staff as part of their daily duties. F. D. Ommanney, who spent his youth in Sheen Cottage, recalled of the First World War,

> Every holiday, when I returned home, the ugly evidences of war spread farther and wider over the green spaces around the house in the park. For several centuries it had looked out upon scenes of immemorial peace. Now, from the warlike clamour that increased around it, it seemed to shrink back among the trees. Rows of huts sprang up and the inevitable cookhouses and latrines that accompanied them. Guns pushed up their snouts among the trees. Army lorries, disregarding the sacred rules enforced upon us for years by stately old gentlemen in top hats with gold braid around them, careered across the green levels and scarred them with their wheels. In the plantations they stood in rows like prehistoric monsters asleep. Captive balloons hung above, obese shapes in our familiar sky. Columns of soldiers marched and drilled, attracting from the purlieus down the hill troops of raffish *vivandières*, who wandered about in groups and made sly giggling invitations. The sound of rifle fire and bursting grenades echoed among the copses.

Richmond Park was also the scene of wartime innovation. In November 1917 trials were carried out on H. G. Wells' 'aerial ropeway'. Far from being a wacky idea, Wells had evolved this way of moving rations, ammunition, equipment and wounded men, following the death of hundreds of men

carrying rations and ammunition up to the front line in the Third Battle of Ypres. Some had died under enemy fire; others had slipped off the duckboards and drowned in flooded shell craters. Wells' ropeway was designed to be erected after dark for night use. It was hung on 10-foot poles and could convey 10 tons per hour for a distance of ½ mile, but the generals turned it down. Wells commented, 'The tin hats did not like it, bitterly deriding them as "fine, handsome, well-groomed, neighing gentlemen" with "clear definite ideas of what war was."'

Despite the reduction in numbers of deer in the park, the war affected the deer herds. In 1916, to augment worsening meat shortages throughout the country, fifty fallow and twenty-four red deer were slaughtered and sold to the Central Meat Market.[8] Grazing was also restricted by military activity, and grain to supplement the winter diet was in short supply, which affected deer numbers in the park. In 1917, more venison was sold to the Central Meat Market, most of which was sent to supply HM ships of the fleet. Military activity also affected the herds in other ways, and in January 1918 three bucks managed to entangle themselves fatally in the army telephone lines which then festooned the park. By April 1918 there were only 413 fallow and 46 red deer left. It was in that year that the Royal Venison Warrant was suspended, the government being obliged to introduce general food rationing towards the end of the war, and, as official correspondence put it, 'Now that rationing is in force it certainly seems wrong to distribute deer by Warrant.'[9]

At the end of the First World War, the cultivated areas were returned to parkland, including the allotments, which Richmond Borough Council were required to vacate by Lady Day in 1920. The military camps were soon dismantled. Only the South African War Hospital, which had by then been taken over by the Ministry of Pensions, survived – but not for long, because it too was demolished in 1925. Military use of the park was to linger on for a number of years, though.

In 1922 some thirty 'Field Days' were held, involving large numbers of troops, and the Household Cavalry, with the Guards Regiments, were regular visitors.[10]

Public use of the park increased dramatically after the war with one example describing as many as 2,000 motorists entering by way of Sheen and Roehampton Gates alone one fine Saturday.[11] The effect on the deer herds was significant; once again they were in trouble. In early summer, visitors were picking up newborn fawns, imagining them to be abandoned, and handing them over to the park keepers. Though the fawns were returned as soon as possible to the place where they had been found, it was suspected, probably with some justification, that the does did not always return to their offspring.[12] The result was that the Commissioner of Works at the time, Sir Lionel Earle, wrote to a selection of historic deer-park owners, seeking fallow deer on either a purchase or an exchange basis: 'The public of London derive so much pleasure and interest from the deer that it would be a thousand pities if the two surviving herds (Richmond and Bushy Parks) were allowed to degenerate.'[13] The letter drew a good response, and a number of deer were sent from various deer parks, among them Ashridge in Buckinghamshire, Woodhall in Hertfordshire, Wonersh in Surrey, and Petworth. Some were purchased, others were on an exchange basis and a few were gifts. The Duke of Buccleugh donated four bucks from his estate at Boughton Park in Northamptonshire. The duke was to correspond with Sir Lionel on the subject of deer-park management for a considerable time; he even visited Richmond Park, conversing with park superintendent Benjamin Wells, who had succeeded Pullman in 1919. Wells was of the opinion that there had been a degree of mismanagement of the herds in the past few years, an opinion with which the duke was inclined to agree. Buccleugh also recommended that areas of bracken in the park could be beneficially reduced. He suggested that the quality of park fallow deer was dependent on the 'dams', and advised Sir

Lionel to introduce does rather than bucks. In the years that followed, there were generally more does than bucks in the herds, a reversal of the trend of previous years. By April 1928 there were more than 600 fallow in the park, and one in three adult does had successfully reared fawns, in contrast to only one in seven in the year 1921–2. For the second time within twenty years a deteriorating situation had been turned round, and the fallow herds were prospering, a situation which was to continue until 1939, when, once again, war intervened.[14] It was also thanks to Buccleugh that common sense prevailed when the Office of Works were considering the introduction of exotic deer species to Richmond Park in 1929. Advice was sought and the proposal was thrown out.

Further public use of the park was also marked by the provision of sports facilities. A cricket pitch was laid out near the Kingston Gate, and a whole block of pitches to the west of Bog Gate. Between the war years the number of winter games pitches was to proliferate, and they occupied virtually all level areas of parkland of sufficient area. More controversy was to follow with the opening on the east side of the Beverley Brook, also known as Crown Meadows or Great Paddocks – which had never before been open to public access – to the sport of golf. The idea of constructing a golf course in the park was first raised in 1921. Golfing facilities for the 'artisan' class, who were unable to afford membership of the several private clubs in the vicinity, were practically non-existent in south-west London, and Lord Riddell, 1st Baron of Walton Heath and President of the Artisan Golfers Association, enthusiastically took up the plight of the local artisans. A consortium was formed, comprising local businessmen and dignitaries, who came to the conclusion that the most suitable site for an artisans' golf course was in Richmond Park. The proposal aroused considerable public debate in newspapers locally and nationally. It was certainly controversial, but eventually agreement was reached between the consortium and the Office of Works: the consortium agreed to fund the

capital costs and to undertake financial responsibility for the future management of the course in such a way that green fees would be kept to a level that the artisan classes would find acceptable. George V was not at all keen when the proposal was put before him for royal assent, but eventually granted it after learning that the project would benefit those who could not afford to play golf. The course was designed and built by F. Hawtree and J. H. Taylor, a prominent golfer of the period, and was opened on 9 June 1923 by the Prince of Wales, who was born in White Lodge; it became known as the 'Princes Course'. Two years later a second eighteen-hole course was opened, such was the success of the venture. On this occasion the Duke of York (later George VI), who spent the early years of his married life at White Lodge, executed the ceremonial drive for what became known as the 'Duke's Course'. In 1927 the Office of Works bought out the consortium by agreement, and accepted responsibility for the management of the courses. The name of the club was changed from Priory Golf Club to its present title of Richmond Park Golf Club in 1953. In 1985, Martin Hawtree, grandson of the original architect, was commissioned to undertake a program of modernisation on the two courses. In 2014, significant further modernisation will be undertaken. The clubhouse has moved from Roehampton Gate to Chohole Gate on the south-east corner of the course, and has been designed by architects at William Saunders, who have a long-standing history of clubhouse development with Glendale Golf, the lessees of the two courses since 2004. Significant further course improvements were designed to provide experienced golfers with an enjoyable and challenging game in the historic surroundings of Richmond Park.

In many of the other royal parks, including Greenwich Park, Regent's Park, Hyde Park and Kensington Gardens, bandstands were a common feature. Yet it was only in the early 1930s that a bandstand appeared in Richmond Park, near Richmond Gate, and in the pre-war years it was very

popular with Sunday afternoon band concerts. The concerts were reintroduced after the war but did not have the same appeal; the bandstand fell into disuse in the mid-1950s and was eventually dismantled and re-erected in Regent's Park in 1975.[15]

It was the Second World War that was to disrupt Richmond Park more than any other event in its significant history. In many London parks, the impact of the war was dramatic, but it was more so in Richmond Park, not simply because of its unique nature but because of the fine balance between 'public park' and 'historic medieval deer park'. Military training was once more conducted in the park, and large areas were again ploughed up for crops. The previous Army camp on the Paddocks had been displaced by the golf club, and a large new camp was established in 1938 to the south and east of Thatched House Lodge, to house recruits for the East Surrey Regiment. Throughout the war, the camp was a military convalescent depot for 2,500 soldiers; then it was used by the women's Army unit, the Auxiliary Territorial Service (ATS), and after the war by its successor unit, the Women's Royal Army Corps (WRAC). After the war, it was used as an athletics village for the 1948 London Olympic Games, and housed the Royal Corps of Signals and repatriated service families from Suez in 1956. It was eventually demolished in 1965. Anti-aircraft gun emplacements were set up in a number of locations, and as a further defensive measure the Pen Ponds were drained and camouflaged so as to deny bomber crews the sight of an obvious landmark. A facility for disabling unexploded bombs operated between Isabella Plantation and Ham Cross.[16]

The ploughing up of the park was significant, with most of the pastures put to the plough, the agricultural operations being under the control of the County of Surrey War Agricultural Executive Committee. Public access was restricted; routine maintenance work suffered, and tree planting was more or less abandoned. At the same time, the

Office of Works decided that the deer herds should be reduced
to 150; by late 1942 there were only 100 left. Attempts were
made to drive the remaining animals into Petersham Park in
an effort to prevent crop damage, and to confine them there
with electric fencing. Disappointingly this didn't work, and
more surprisingly in the spring of 1943 the Agricultural
Executive Committee proposed that the deer herds should
be disposed of altogether. Thankfully the proposal came
to nothing, although the numbers in the herd continued to
dwindle and reached an all-time low of sixty-eight fallow
and thirteen red, which had to share what remained of the
grazing. By now, some 140 hectares were under cultivation,
with a flock of 350 sheep and fifty head of cattle; the then
park superintendent, A. E. Wilson, reported that the deer
were flourishing.

Richmond Park was also the base of the GHQ Liaison
Regiment known as 'Phantom' Squad. In November 1939,
at the very beginning of the Second World War, Air Marshal
Barratt, the Commander of the British Air Forces in France,
set up a special semi-secret unit, the 3rd British Air Mission, to
gather as much information as possible about the disposition
of the enemy and the terrain that they were rapidly occupying.
The code name for this unit was 'Phantom', and it was under
the command of Wing Commander J. M. 'Fairy' Fairweather
and Lieutenant-Colonel G. F. 'Hoppy' Hopkinson. Noting
the speed of the German 'Blitzkrieg' invasion of the Low
Countries, both men realised that the only way to get the
information that the Air Marshal needed was by actual
ground reconnaissance at the front line. Trying to pick up
small amounts of intelligence from behind the lines at GHQ
was not an option. Together 'Fairy' and 'Hoppy' put together
a mixed company of fifteen officers and 110 other ranks,
equipped with armoured cars and motorcycle units. There
was also a wireless section manned by troops from the Royal
Corps of Signals and 500 carrier pigeons. An official definition
of 'Phantom's' job was 'to transmit vital information from the

battle front, ignoring the usual channels, to the Commander able to dispose of the vital reserves'. In practice, this meant putting vehicles with trained observers as close to the fighting as possible. The information gathered would be coded and sent back either by radio or motorcycle dispatch rider. One officer at the time commented, 'The information coming out of France wasn't good – but at least it was accurate!' After the war, 'Phantom' was popularly described as 'the eyes and ears of the Commander in Chief'.

On 28 May 1940, during the evacuation from France, Wing Commander J. M. Fairweather and many of his 'Phantom' staff were lost when their ship, the SS *Aboukir*, was torpedoed by an E-boat about 8 miles off Ostend. Undeterred, 'Hoppy' Hopkinson, realising the vital importance of the work, quickly set up the 'GHQ Liaison Regiment' (Phantom) and a training unit at Pembroke Lodge in Richmond Park. At the same time 'Phantom' units were set up around the English coast to report back on the expected enemy invasion. In many ways Richmond Park and Pembroke Lodge were ideal locations for the rapidly expanding 'Phantom'. They were close enough to London to be in touch with the War Office and yet far enough away to be reasonably secure and discreet. The park was also large enough to accommodate all the men training there and their vehicles. Among them was the actor, Major David Niven, who commanded 'A' Squadron. He wrote of his time at Pembroke Lodge: 'These were wonderful days which I would not have missed for anything.'

During the war there were 'Phantom' patrols operating in Europe, North Africa and Italy, each consisting of an officer, an NCO and up to nine other ranks. They were typically equipped with Norton motorcycles, Jeeps, Morris 15-cwt trucks and Scout cars. Other patrols undertook parachute drops with the SAS to provide intelligence for SAS Brigade HQ. Before long, 'Phantom' was also supplying intelligence to the 12th US Army Group. 'Phantom' landed in Normandy on 6 June 1944, D-Day. Its job was to locate and constantly

update the ever-changing positions of all British, Canadian and American units, and report them back to HQ. In September 1944, during 'Operation Market Garden', a 'Phantom' patrol provided the only communication between the surrounded airborne troops at Arnhem and headquarters. This included the desperate message from General Urquhart that 'unless physical contact is made with us early 25 Sept, consider it unlikely we can hold out'. Two 'Phantom' officers were subsequently awarded the Military Cross for maintaining these vital communications during the operation. Although Field Marshal Montgomery described the work of 'Phantom' as 'indispensable', in January 1944 GHQ Liaison Regiment (Phantom) was absorbed into the Royal Armoured Corps. 'Phantom' was finally disbanded in 1945 but reappeared briefly as Army Phantom Signals Regiment (Princess Louise's Kensington Regiment). In 1961 the regiment reformed and became a 'Trunk Communications' Signal Regiment with squadrons in Portsmouth, Coulsdon and Hammersmith.[17]

By 1949 there were apparently only fifty deer remaining in the park, although twelve months later Baxter Brown reports that there were 179. At this time work was commenced to tackle the repairs that were needed as a result of the impact of the Second World War. Fencing around the plantations was repaired after it had become evident that many of the deer had sought refuge in them during the war.[18] The restoration works were slow, involving the transformation from farm and military encampment back to parkland. Areas were still under cultivation up until the early 1950s. In 1956 the wrought-iron carriage gates at Kingston, opened by Queen Victoria in 1861, had still to be restored, and the temporary wooden gates that had replaced them early in the war, by then in dilapidated condition, remained in position.[19] Buildings associated with the encampment were not demolished until the 1960s, but had been useful as the Olympic Village for the 1948 Olympic Games, as previously discussed.

With the re-enclosure of many of the plantations, there were now moves to return the park to its former glory in relation to the trees within it. The first post-war plantation, Queen Elizabeth Wood, was established in 1948. Three years later, Prince Charles Spinney, south-east of Isabella Plantation, was planted, each occupying 4 hectares. There have been further additions, including the 1953 Coronation Plantation, planted mainly with beech, and located close to the 1902 Coronation Plantation. Queen Mother's Copse was planted in 1980 to commemorate the Queen Mother's eightieth birthday, and lies between White Lodge and Roehampton Gate. It consists mainly of English oaks, the first planted by HRH Princess Alexandra, with the remainder donated by school groups, the Friends of Richmond Park and private individuals. However, it is the establishment of a woodland garden in the west section of the Isabella Plantation that really stands out in post-war Richmond Park. The Isabella Slade was originally planted by Lord Sidmouth in 1831, with subsequent additions, first on the north-east side in 1845, and then an enlargement of virtually the whole outer edge of the plantation in 1865. This planting was superimposed on some of the pre-enclosure oak pollards of 'Blacke Heathe'. It is not clear how it came by the name Isabella. It is possible it was named after the wife or daughter of a member of staff, but the name is at least 200 years old, appearing as 'Isabella Slade' on a map dated 1771. Lane's map shows the area was called The Sleyt (a slade was a greensward, open space between banks or woods, or boggy ground) in the early seventeenth century. Isabella may well be a corruption of 'isabel', which once meant a dingy or greyish yellow, and would have referred to the colour of the sandy clay topsoil. The word also has an unsavoury origin. In 1601 the Archduchess Isabella of Austria, Infanta of Spain and Governor of the Spanish Netherlands, vowed not to change her linen until Ostend had been recaptured from the Protestant Dutch. The siege lasted three years (1601–4), and her counsellors must have faced the routine noxious ordeal of

advising their unnecessarily malodorous governor. The name Isabel therefore became a byword for grubby discolouration. Prior to the development of Isabella Plantation in 1950, only a small pool existed, the Still Pond, which was fed by a spring, and a muddy wallow at the foot of the slope in open parkland (now Peg's Pond). Both ponds, dug in 1861, were for the watering of livestock. The woodland is largely the inspiration of Wally Miller, head gardener, and George Thomson, park superintendent, 1951–71; the former is now immortalised with Wally's Island in Peg's Pond, and the latter with Thomson's Pond in the centre of the plantation and also with the wooden stumps that line the carriageways of the park, known as 'Thomson's teeth'. Thomson cleared the *Rhododendron ponticum* which is so widespread in the park, and planted other rhododendron species and Kurume azaleas around Still Pond. The Main Stream running from Broomfield Gate was dug in 1960, the water initially pumped from the Sidmouth Plantation reservoir, and the plantation enlarged to incorporate Peg's Pond. Since 1976 the water has been pumped from the Pen Ponds to feed each stream. A third stream was dug in the early 1980s through the wilder northern section, where the stream banks have been colonised by ferns, water plantains and brooklime.[20]

Isabella Plantation, with its woodland garden, is one of several bird sanctuaries in Richmond Park. The importance of the park as a natural habitat is described in further detail in Chapter Seven. However, for well over eighty years the major enclosed plantations have been designated bird sanctuaries, as have the Pen Ponds. There are no exotics here as are found in most of London's Royal Parks.

The deer herds prospered after the war. However, during 1964–5 a poor crop of fawns was produced, and examination of culled fallow carcasses later in the year showed a high incidence of abscesses in the lungs and liver. Suspicion fell on the silage which was, at that time, fed to the herds to supplement their winter diet, and when the silage was replaced

with a mixture of locust beans, corn and maize the following winter, the health of the herd immediately began to improve.[21] However, a new threat faced the deer in Richmond Park – the motor vehicle. They had been a presence in the park since the beginning of the century, and they were clearly not compatible with the deer. As early as 1908, Mr W. Heaton Armstrong MP was fined £4 and costs for exceeding the 20 mph limit. During the winter of 1961/2 the gates were kept open until 8 p.m. in an attempt to ease rush-hour traffic congestion. However, so many deer were killed on the park roads between sunset and park closing time that this trial was quickly abandoned. For an eighteen-month period in 1979–80, the carriageway between Kingston and Richmond was kept open to traffic until midnight, on account of a major road closure outside the west boundary of the park. Despite attempts to discourage deer from approaching the main carriageway, there was again a dramatic increase in the number killed and injured on the road. The Friends of Richmond Park, at their inaugural meeting in 1961, raised serious concerns in relation to the impact of traffic on the park.

The Friends of Richmond Park celebrated their fiftieth anniversary in 2011, and it is interesting to see how the park has evolved and changed through their eyes since their inauguration in 1961. Their first meeting discussed the following:

> Current developments at the eastern end of Hyde Park and the north-western tip of Green Park – both now totally sacrificed to the needs of motor traffic, and more still to come – show all too clearly that the Royal Parks are now regarded as fair game for road improvement, and already there are ominous signs that Richmond Park is no longer safe from future extensive improvements.

At the time, there appeared to be real concerns from park users that the traffic situation would only become worse. The

speed limit on Richmond Park roads in August 1960 had been raised from 20 mph to 30 mph, and despite it not being part of the national highway there was a growing tendency for motorists to use Richmond Park as a shortcut. A bus strike at that time meant increased usage of the park by traffic, and the increase was significant, as were associated deaths to deer, and other environmental issues. The Minister of Works, Lord John Hope, ruled that the park gates should be opened after dark until 8 p.m., further increasing the risk of accidents.

Simultaneously, some areas of Hyde Park had been assigned to the main highway system to improve the flow of traffic in central London; this had a considerable impact on the parkland, with loss of trees and increases in pollution and noise. Concerns were aired that Richmond Park, too, would be threatened by plans to create a new road from Shepherds Bush Common, which would join the Kingston bypass by cutting through the east side of Richmond Park, and form part of the national highway network. Local people and park users decided that their concerns for the park must be acted upon before the threats became reality. Awareness was raised, and included lobbying MPs. Support was strong; representatives from twelve local bodies were sympathetic, including the Richmond Society, the Pedestrians Association for Road Safety, and the Cyclists' Touring Club. Richmond Park 'served as an oasis of peace to which thousands went each week for pleasure and relaxation' and concerns were expressed that 'the park should not be looked upon as a relief for the main traffic routes out of London'. It was resolved to press for the speed limit to be returned to 20 mph, and also for a speedy removal of the old Women's Royal Army Corps (WRAC) camp near Kingston Gate, which covered 53 acres and had been released by the War Department for return to parkland, though no action had yet been taken. Lord Hope was standing firm, but there was some success. The park was now to close at dusk once more with the support of the

minister, following numerous collisions with deer. Work had also begun on clearing the WRAC camp. Local concerns, often expressed through the Friends of Richmond Park, give an excellent insight into many of the pressures facing the park at the time, including representations to the Noise Abatement Society in relation to noise from aircraft and helicopters. Into the seventies, issues that were raised by the Friends included encroaching car parking, and toilet and refreshment facilities. Another major concern was the impact of Dutch elm disease in the early seventies. Traffic issues still continued to be a concern; there was talk of a Petersham bypass that would be built through the park from near Petersham Gate to Ham Gate and Ham Common, and it had even been bizarrely suggested that a solution to the increase in local traffic was to construct a tunnel under the park gates at Richmond Hill to emerge near Ham Common. There remained opposition to such schemes, which in essence would destroy large parts of the park and generate more traffic in the area. Certain restrictions were brought into place, and a number of entrances and exits restricted to traffic use, including Robin Hood Gate. Further improvements were made to the infrastructure of the park, including footpath and car park improvements and the enlargement of Peg's Pond in Isabella Plantation.

At the end of the decade Richmond Park came under further considerable pressure. In 1979, the main road at Petersham subsided, resulting in cars and motorcycles being diverted into the park. The gates remained open twenty-four hours a day, and casualties to deer caused by speeding vehicles increased. A second incident of subsidence in Petersham occurred just two months later, with the park again being open all night to aid traffic flow. There was great concern that the park was virtually split in two by the diversion of main road traffic through it. Problems existed for animals and humans trying to cross the frontier delineated by the Kingston Gate to Richmond Gate road, which was heavy with vehicles. By

November 1979 thirty-nine deer had been killed in traffic accidents, and the number rose to forty-seven by the end of December. Almost ten deer a month had been killed since cars started being diverted through the park. It was not until January 1981 – eighteen months after the subsidence first occurred – that the roadworks were completed and the park returned to normal, with the gates closing at dusk.

Another serious disadvantage raised by new park superintendent Michael Baxter Brown, appointed in 1971, was the disadvantage in the supplementary winter feeding method employed after the abandonment of silage feeding. The method involved shovelling out the 'rations' once a day, from a moving tractor and trailer, following a long line in two open sites regularly used for the practice. Although seen as something of a local spectacle, particularly as the deer quickly learned to respond to the call of the 'feed' man, it was the strongest and heaviest animals that won the majority of the feed, at the expense of the weaker stock, smaller and younger. Other problems had to be contended with; the best pasture lands were losing their vigour, having been under the plough during the war years. A pasture husbandry programme involving the controlled use of sewage sludge, supplied by Thames Water Authority, was introduced in order to restore the vigour of the good pasture lands. Over 80 hectares of land were treated, almost all of which had been utilised for agriculture during the war. Such a practice is unlikely to have been pursued or encouraged, and would have been distinctively disallowed today taking into account the ecological value of Richmond Park. The ecology and natural history of the park is discussed in Chapter Seven.[22]

Over the centuries, as has been described in detail, the park was required by royal warrant (along with other Royal Parks) to provide venison for the royal table and for many other offices. Protected over the centuries, at times the royal warrant required some 800 fallow bucks to be killed

to fulfil the entitlement. Suspended between the two world wars, it was again suspended in 1997, and it remains to be seen whether it will ever be reinstated. At the time of the suspension there was a list of some seventy-nine offices that were still entitled to claim a haunch of venison. These varied from titles such as the Grand Falconer of England, through the Archbishop of Canterbury to the Mayor of Richmond, as well as most senior government ministers and even senior civil servants. As Simon Richards, park superintendent in 2011, wrote,

> It is another long-standing tradition of this country which has fallen victim to our times. However, from a practical and economic point of view it made no sense whatsoever. Nowadays, all venison from the deer culls is advertised by public tender and sold onto the wholesale market.[23]

In the early 1980s, public concern about culling of the deer had been heightened. This event now takes place twice a year and is necessary to keep the number of deer stable (otherwise it would increase by a third every year), and the herd healthy by removing weak and sick animals. There is only a limited amount of food available within the park boundaries and, without natural predators, overpopulation would lead to deer starving to death. There has been continued local support for the park superintendent, in particular by the Friends of Richmond Park, in response to accusations in the press, and in informing the public of the reasons for the culls, so public unease has reduced. In 1983, a new arrangement was introduced, and involved closing the park completely at night during the cull; it remains to this day.

By 2000, the topic of traffic curtailment had again become a major issue. The Royal Parks Agency issued a consultation document regarding possible traffic restrictions within the park, and it seemed that the time had finally come to make some changes to reduce commuter traffic. Topics in the air

included better speed-limit enforcement, gate closures, and the introduction of pedestrian crossings. The local councils of Richmond, Kingston and Wandsworth vociferously opposed any gate or road closures in the park, largely on the basis that it would cause chaos on surrounding roads. The councils formed the Richmond Park Forum, nominally a discussion group assessing the impact on the local environs of potential traffic changes, but in practice more of a pressure group for the councils' views. Locals continued to be of the opinion that the conservation of the park – now a Site of Special Scientific Interest and a National Nature Reserve, as well as a Grade I listed Historic Landscape – was of the foremost importance, and reiterated the point that the park roads were private, and should therefore not be part of council traffic plans.

At the end of 2000, Richmond Council announced that the speed limit on the public road through Petersham was to be reduced to 20 mph. It seemed more appropriate than ever that the speed limit on park roads should also be 20 mph. The Royal Parks Agency finally issued its proposals on traffic changes in December 2001. These included the reduction of the speed limit to 20 mph; the closure of Robin Hood Gate to incoming traffic (it had been closed to outgoing traffic since 1973); and improvements to car parks and to pedestrian road crossings. Although considered in some ways flawed, the document was welcomed by many as a practical step towards protection. During 2002 little seemed to be happening about the decision on the Royal Parks Agency's traffic proposals. It was felt the Royal Parks were held back from making an independent decision by a legal obligation to liaise with the local councils, who were obstructing change. Expected improvements to public transport around the park had not been progressed by the councils at any speed, and it was felt at the time that the councils were whipping up public opposition. Public meetings to discuss changes had become confrontational. It was not until May 2004 that the amended

regulations governing the Royal Parks were published. The speed limit was reduced from 30 mph to 20 mph in order to 'increase visitor safety, protect the Park and its wildlife and improve the quality of visitors' experience'. In June, the reduction to 20 mph was debated in the House of Lords on two occasions. First it was proposed that the reduction should require the prior approval of local authorities; second that the management of the roads within the park should be transferred either to adjacent local authorities or to Transport for London. Fortunately both proposals were withdrawn, and the reduction in the speed limit went through. The traffic reduction measures implemented in 2003–4 marked the end of ten years of fierce debate and acrimony over traffic in the park. The issue had divided many, and consumed a lot of time and energy. Public opinion was also strongly divided, and local councils were at odds with the Royal Parks Agency. By 2004, all were exhausted, and the next five years saw little action on traffic. It still remains a big problem, however, and is still central to many people's concerns about protecting the park.

Former park superintendent Michael Baxter Brown, writing in 1985, describes Richmond Park in the twentieth century as follows:

Despite all, Richmond Park has not yielded up its historic character. The park deer species of old thrive, without adulteration. The informal mixture of woodland, wasteland and 'lawns' survive and flourish, as do the Pen Ponds, still fishponds, reminiscent of the fishponds of a medieval park. The plantations, even that containing the Woodland Garden, would not be out of place in a medieval park. Richmond Park is a national monument of outstanding character, one which preserves the grand cycle of nature to the best advantage and is, at the same time, an active and important ingredient of modern society. It is fitting to return to the 1961 Report of the Ministry of Works Advisory Committee on Forestry for

its excellent summary of the park. Richmond Park 'preserves a treasured example of the English landscape which, it is to be hoped, the public and the authorities will long continue in co-operation to protect and maintain.'[24]

The Friends of Richmond Park, also having looked back at the last fifty years, were looking forward to their next fifty. Three themes have dominated the Friends' time and energy over their first fifty years – setting up the society as an effective and influential group; resisting urbanisation of the park in all its forms; and, of course, traffic. The themes of the next fifty years are likely to be the ever-increasing visitor numbers and the increasing intensity of how they use the park. People have more leisure time, and spend it in the park, running, cycling, kiting, dog walking, playing informal games and so on – all high-impact activities on the delicate ecology of Richmond Park. The second is the decline in public funding for the Royal Parks. In 1961 it was 95 per cent of income; in 2011 it was below 50 per cent; by 2061 it could well be zero. Some of the decline could be made up by philanthropy, but the majority will have to come from commercialisation (concerts, restaurants, toll charges, shops, sports, parking charges – like many of the other Royal Parks, Hyde Park in particular, where criticism has been levelled at the Royal Parks, often unfairly). The third is changes in Richmond Park's ecology and wildlife, and the need to prevent the same decline in species that has happened in the last fifty years and the need to reverse it. Climate change will affect the park's ecology, eliminating some species, favouring others and causing new diseases to fauna and flora. While park management has the main responsibility for dealing with these threats, the Friends aim to continue to contribute volunteers, funding, and even management help.

However, the importance of the park in the twenty-first century must be understood in the context of the importance of its wider natural history and ecology. From the early

inspiration of W. H. Hudson to C. L. Collenette in 1937 and the current management of what is now a Site of Special Scientific Interest and National Nature Reserve, the ecology and wildlife of Richmond Park are just as important as its medieval history and ultimate enclosure as a royal deer park. The artefacts and architecture, although less dominant in the park, also need to be considered in the context of the wider park.

# Artefacts and Architecture of Richmond Park

The buildings and monuments of the Royal Parks have been described as a mixed bag. Their artefacts and architecture range from fine mansions to public lavatories and shelters, from war memorials erected in celebration of Britain's imperial might to drinking fountains. This rather bizarre mixture reflects the history of the Royal Parks, which all began as royal hunting preserves but gradually became public amenities. With most owing their existence to Henry VIII, the Royal Parks were acquired as vast tracts of land to satisfy his love of hunting; his most ambitious project was to create a hunting ground that ran all the way from Whitehall Palace to the slopes of Hampstead. Present-day St James's Park, Hyde Park and Regent's Park were the result. Hunting was seen as the sport of kings, a means of impressing foreign visitors and a source of fresh meat. Successive monarchs, from the Stuarts through to George II, continued to create and improve the royal hunting preserves. These parks were enclosed and stocked. Henry VIII stated in a proclamation of 1536,

As the King's most royal Majesty is desirous to have the games
of hare, partridge, pheasant and heron preserved, in and about

the honour of his palace of Westminster, for his own disport and pastime, no person, on the pain of imprisonment of their bodies, and further punishment at his Majesty's will and pleasure, is to presume to hunt or hawk, from the palace of Westminster ... to Hampstead Heath.

Over the following centuries this royal prerogative was whittled away. Local residents gained access to the outlying parks, while the upper classes paraded, duelled and flirted in St James's and neighbouring parks.

By the 1830s there was mounting pressure to create municipal parks in Britain. The urban population was growing at an alarming rate, conditions in the cities were miserable and insanitary, and there was a real fear of social unrest. The Royal Parks, which by now were more or less open to the public, were among the few green spaces available to Londoners. They were, however, totally lacking in any facilities. A foreign visitor remarked that, to enjoy the parks, 'it is necessary to be a man of fortune, and take exercise on horseback or in a carriage'. At this stage the only buildings in the parks were the hunting lodges and summer houses for the use of the royal family, rangers' lodges, game stores and so on. Following the example of the new municipal parks, the Royal Parks took on an increasingly complex role. Fresh air and gentle exercise were no longer sufficient: the public were to be educated and improved by their outings. Now, in addition to gatehouses and superintendent's lodges, the parks needed cafés, shelters, lavatories and drinking fountains; bandstands, boathouses and sports pavilions; horticultural, zoological or paleontological displays; uplifting statuary and memorials. All these artefacts, like the earlier ones, were simply dropped into place. The *ad hoc* nature of the buildings and monuments has meant that their quality is very variable. Some are mundane, some represent vernacular or pseudo-vernacular building styles, others are masterpieces; Inigo Jones, Wren, Vanburgh, Hawksmoor, William Kent,

John Soane and Nash have all contributed and left their mark. Many of the Royal Parks ingeniously combined formal or informal water features with the transport and storage of water. The provision of water to the royal palaces was always a problem. Richmond and Greenwich parks have labyrinthine underground conduit systems that are still not fully understood, but elsewhere the water is above ground. In Bushy Park an extensive artificial watercourse, the Longford River, culminating in a pool and fountain, was cut to supply Hampton Court. In the central London parks there were a number of reservoirs controlled by the Chelsea Waterworks Company. One of the tasks of an Office of Works architect was to design the service buildings for the water supply. The provision of food was more controversial. In 1883 the Duke of Cambridge, ranger of the central London Royal Parks, wrote, 'I have ... set my face against the erection of any places for Refreshment in the Royal Parks, as I consider that these Parks are for the enjoyment of fresh air, and are not to be turned into Tea Gardens.' He was quietly overruled. Water was frequently married to sculpture. Some of it was simply decorative, but other pieces had a higher purpose, to honour the heroes of the empire or those lost in the war.

All these buildings and monuments express the tastes and needs of the individuals who shaped the Royal Parks. Charles II, William and Mary, George II and his wife Queen Caroline, George IV and Prince Albert were responsible for major transformations, but their predecessors and successors all played their part as well; the rangers, too, were important. Although the post was to some extent a sinecure, even a hereditary one, there was plenty of scope for the more active rangers, such as Sir Robert Walpole at Richmond, to make changes. Nor must the public be forgotten; many of the memorials and statues have been donated through public subscription or individual generosity. Unfortunately, during the evolution of the parks many buildings have been lost, some thankfully, such as the acres of military huts in Bushy

Park, but others, such as Vanburgh's water tower or William Kent's revolving summer house in Kensington Gardens, are sad losses.[1]

Within Richmond Park, though, the great expanses of rolling grassland and clusters of ancient trees dominate, representing an ideal of untamed nature. Its buildings and monuments, although not numerous, are an eloquent witness of its history, and range from the many lodges, such as the grandeur of White Lodge and Pembroke Lodge, to the grandest of gates, such as Richmond Gate, and the architectural nonentity of the Ladderstile Gate. Then there is the boundary wall itself, which encloses the park. These artefacts and architecture make a significant contribution to the character and landscape of Richmond Park.

The boundary wall that surrounds the park is significant for many reasons. It all began with the wall. Even before Charles I had bought up the land he needed to create himself 'a great Park for Red, as well as Fallow Deer, between Richmond and Hampton Court', he started in 1635 to build a wall to define the boundary of his hunting park. It was an effective way of putting pressure on any landowners who were reluctant to sell up; they speedily changed their minds when they found themselves separated from their fields by a 9-foot-high wall. Even in an age used to the autocratic ways of monarchs, local people did indulge in considerable complaining about the wall, so much so that the builder Edward Manning, who was given the contract, found it hard to recruit local labour for the task. With royal press-ganging, 'mayors and kings' officers' were instructed to assist Manning in 'taking up the required bricklayers, labourers, carts and carriages'. So, with varying degrees of willingness, Manning's men went to work. The bricks were made on site from local London clay, and the sky over Richmond was smoky from the fires that heated the kilns. It has been estimated that some 5 million bricks were made and laid. The job was finished in 1637, in less than three years, and presumably Manning pocketed his promised

£2,500 – as it worked out, a pound per acre enclosed. The wall
has, however, been a constant problem, requiring continuous
repair and building. There is a reference in Wren's accounts
to 'Riding Charges' in Richmond New Park in 1684–5, an
indication that he inspected the wall and possibly supervised
repairs.[2] It is an average of 2.5 m high and 337 mm wide.
Along some sections, the base of the wall steps out to become
450 mm wide, with some parts of the wall strengthened by
piers, 450 mm square, but their disposition seems arbitrary.
Between Ham and Kingston gates, piers occur at about 6.5 m
centres. Records from the late eighteenth century refer to
'grey stocks' being used near Ladderstile Gate, and to the
clearing of old bricks for reuse, but most of the older sections
of the wall are built of red or London stock bricks. The wall is
generally in Flemish bond, but English bond and occasionally
what appears to be a mixture of the two are also used. The
wall was originally built without concrete footings, and has
no expansion joints. The newer sections have foundations,
but no expansion joints have been incorporated, as
movement is assumed to be taken up by the older parts of
the wall. Copings are either saddleback bricks (which are
generally used with red bricks) or brick on edge; recently the
latter has been more usual as it is more cost-effective. There
are variations in the coping, such as the raked soldier course
below the brick on edge at Kingston Gate. Where changes in
the ground level occur, the wall may be stepped or follow the
lie of the land. In essence, Edward Manning didn't, in truth,
do a very good job; a wall built without foundations soon
started crumbling. A large proportion of it had to be rebuilt
within twenty-five years – by which time Charles was in no
position to claim compensation. It was still causing problems
into the twentieth century. A report in 1928 described a
section of wall near Petersham Gate that had collapsed as
being of soft bricks with very little through bond, consisting
practically of three half-brick walls connected by mortar
and a few bonding bricks. This is reinforced by a report of

1976, when two further sections of wall collapsed, and it was found the outer skin had dropped away, the main reason for the bulging and eventual collapse being the deterioration of pointing and copings, subsequent water penetration and frost damage.

Where the wall has been rebuilt, the detailing is often crude and the brick colour varies from engineering red (Broomfield Hill) to pink (east of Bog Gate). The length of the wall has been debated for years and there appears to be no single source that agrees: from 6.3 miles to 8 miles to 'not less than ten miles'; one even claims 12 miles, but it is closer to 8 miles in reality. There are, however, a number of breaks in the wall, in the form of Charles I's six original gates and the further six gates added subsequently. There's also the gap near the car park at Broomfield Hill, where the handsome facade of the former Kingston Hill Place can be seen through an iron railing that runs above a deep ditch or ha-ha. The house was built in 1828 on land purchased by a builder from Dorset, Samuel Baxter, who presumably had enough clout to secure a view of the park from his mansion windows. He also had his own gate into the park; its piers are still visible, though the opening has long been bricked up. There's another short gap in the wall beside Richmond Gate, where railings reveal the garden of Ancaster House. Here again it was a landowner with clout, Sir Lionel Darell, who in the late eighteenth century secured himself an extension to his garden – in this case by a personal appeal to George III, whom he saw riding past one day and asked; the king instantly granted his modest request.[3]

The wall has two main features of interest apart from the gates – the drainage outlets and the ha-has. The drainage outlets have a distinct raised section on top of the wall above each outlet. No reason has been found for such a construction or record of any date. Some outlets show a much more extensive raised section of wall at the Russell School, above two entrances, and above the stream outlet at Sheen

Cemetery, where there also seemed to be a gate, possibly bricked up. It is in the approximate position of Pest House Gate, which is clearly marked on a plan of the freeboard in around 1880–90. The stream itself was culverted at the turn of the twentieth century. All houses backing on to the park pay a feudal fee known euphemistically as 'Richmond Park Freeboard'; it ranges from about £2 to £200 per annum. When Richmond Park was first enclosed, by King Charles I, the Crown also commandeered a strip of land 16 feet and 6 inches wide outside the park wall. The primary purpose of this strip – the so-called freeboard – seems to have been to allow passage along the wall for maintenance purposes. Over the course of centuries, much of the freeboard has been encroached upon, so that there are now few places where it is still constitutes a public passageway.

There are also three sections of a ha-ha, one of which is mentioned in 1794 as being south-east of Roehampton Gate and is probably that on the boundary with Manresa House (built in 1760). It is described as 'a stretch of park wall lowered to ground level' with a sunk pale fence. There is also reference to a ha-ha west of East Sheen Gate, which is no longer in existence. The other two sections of ha-ha are on the boundary with Kingston Hill House (another mansion) and the south-east corner of Sudbrook Park Golf Course. They do not appear on plan until the 1867 ordnance survey, but are mentioned in works in 1928. They are 1.5 m deep with a brick retaining wall along the boundary side, and since before 1928 have all had a fence running along the top.

It is, however, the gates that are of significant interest to the boundary of Richmond Park. One of the six gates left open at the time of the enclosure of the park, Richmond Gate has always admitted the greatest volume of traffic. According to Collenette, a drawing dated 1782 shows the gates to have been of timber with a ladder stile for pedestrians. These were replaced in 1798, when new iron gates and lodges for the gatekeepers were erected. Their design has formerly been

attributed to Capability Brown, but he died in 1783, and according to Dorothy Stroud, the biographer of Brown and Sir John Soane, the latter is more likely to have been responsible, as discussed previously. Soane was appointed deputy surveyor of woods and forests in 1795, and there is a drawing in the collection of the Soane Museum of the 'intended lodge and gate on Richmond Hill'. It certainly bears a definite relationship to what was actually constructed. The early drawings of 1819 and 1841, and a photograph from the end of the nineteenth century in the Richmond Library collection, show a single carriageway and double gates flanked by two tall central piers (in earlier illustrations the central piers were surmounted by lamps), with railings infilling between the outer lower piers and pedestrian entrance. In 1896 the gateway was modified to accommodate three carriageways, and the piers probably rebuilt, as the four central piers are now the same height and their spacing has been altered. The iron cradle gate was probably also added at this time (they allowed free passage to pedestrians but prevented deer from escaping).[4] One of the attractive features of the pedestrian gates is the curved alcoves in the outer piers. The design of the wrought ironwork has remained largely unchanged except that the design of the gates was simplified. Ironwork is all black painted. The piers are of Portland stone, with the initials GR and CR and date of erection.

From before 1877 the foot gate was left open at all times. During the early part of the Second World War, the park was closed, but public access was allowed to limited areas in 1941, and the gate reopened to pedestrians; nevertheless, it was closed at dusk until 1949. From then until 1983, during the autumn cull all the foot gates remained open at all times except for three – Roehampton, Robin Hood and Kingston Gate – which were closed for one night a year to prevent the establishment of rights of way through these gates.

Bishop's Gate pedestrian gate was opened as a result of a petition by local inhabitants in 1896, when an iron cradle

gate was erected. It is similar to those at Cambrian and Bog Gates, and allows free access for pedestrians but prevents the escape of deer. Collenette describes it in 1937 as still closed at dusk until 1949. Since then it has been left open at all times until the autumn deer cull in 1983, during which time it was closed again at night.

There is also a private gate at Bishop's Gate. Called the cattle gate on plans of 1850 and 1851, a reference dated 1854 also records that the keeper had had access to the lodge via the freeboard for the last fifty years (the lodge, however, does not appear on the plan of 1813). There is also reference to a cattle gate 12 feet wide. It was also known as Keepers Gate and later as Chisholm Gate, and has always been private. The current gateway gives access to the garden at Bishop's Lodge, and appears to be in exactly the same location as in 1850.[5]

The Cambrian Road pedestrian gate was originally constructed during the First World War for access to the South African War Hospital, which was demolished in 1925. The gate was opened to pedestrians in 1925 and became the main access gate to the park for people coming from London by bus or train. Like Bishop's Gate, it is a safe access point, being at the end of a cul-de-sac. In 1938 the existing carriage gate, which had been closed for some time, was widened and a new pier constructed to form a bridle gate, for which keys were issued. The bridle gate is no longer used. The design of the cradle gate is the same as for Bishop's Gate. It was closed originally at night, and also closed at night up to 1949.[6]

Records of the Bog Gate date from 1736 when Queen Caroline was issued with a licence to make a road across Sheen Common to a new gate into the park. It is marked, but not named, on Rocque's plan of 1741–5; on Eyre's plan of 1754 it is marked Bog Gate, but on the 1794 plan by Richardson, it is known as the Queen's Private Gate. By the 1850s it is known again as the Bog Gate. It remained a private gate until 1894 when, in response to public pressure, it was opened to pedestrians, and a cradle gate was erected, again of the

standard type previously described. The timber maintenance gates are now rarely used, except for access to the freeboard. The appearance of the gate has remained unchanged since the beginning of the twentieth century. According to Collenette, the Inns of Court Rifle Volunteers were allowed to use the gate to enter and leave the park. From 1894, it remained open all night. It was closed between 1939 and 1941, then closed at dusk until 1949.

There has probably been an entrance to what was the kitchen garden and buildings for White Lodge Cottage since the mid-eighteenth century. The gate is marked but not named on the plans of 1850 and 1851 but is referred to as the Kitchen Garden Gate on a plan of 1877. The present gates are to the outbuildings or garages and to White Lodge cottage itself, and are private.

East Sheen Carriage Gate is one of the six original gates left open at the time of enclosure. It was known briefly as Goudge Gate during the second half of the eighteenth century, after Edward Gooch, a gamekeeper. It is probable that the original gate was timber with a stepladder for pedestrians, and was removed at the time of the dispute over the rights of way. According to Collenette, the gate at that time was 6 feet high, 3 feet wide and 2 inches thick. In 1758, the ladder stile was replaced after the successful action to establish the right of access for foot passengers, but the steps were placed so far apart that children and old people found them difficult to climb. After further complaints to the courts, the steps were modified. The stepladder remained in position until 1848. Between this time and the end of the century, a timber five-bar gate for carriages and a smaller gate for pedestrians were erected. This was replaced by a wrought-iron carriage gate with a single carriageway, and a pedestrian gate with brick piers. The gates were adjacent to Sheen Gate Lodge with the remains of the wide opening filled with a low wall and railings. These gates were replaced in 1926, and consist of two carriage gates with pedestrian gates on either side,

and a cradle gate and infill railings on the western side of the opening. The four main piers are iron, and the side piers brick. The ironwork is of a robust design and painted black, with gold embellishments on the columns. It was also open until dusk between 1941 and 1949.[7]

Also one of the six original gateways, Roehampton Carriage Gate was initially a private entrance used by the royal family and people connected with the park. The road to the gate was private and an annual fee of a buck paid for the right of way. The gate was opened to the public in 1844[8] but the road remained in private hands. In 1864, as the result of an argument between the Office of Works and owner of the road, the First Commissioner refused to pay the gatekeepers' salaries and the gate was again closed. There has never been a right of way through this gate, and it has been closed for one night a year to prevent the establishment of any such right, though the gate was normally left open at night for pedestrians. It was one of the gates closed between 1939 and 1945, and, like all the others, closed at dusk until 1949. The present gates were erected in 1899 and consist of two double-leaf carriage gates, with pedestrian gates, one of which is a cradle gate, on either side, and infill panels of railings on either side of these.[9] There are stables just outside the gate, and this is one of the main gates used by horse riders. The wrought-iron gates and columns are ornate, and painted black with gold-painted crowns and the initials VR in the centre. The ironwork of the cradle gate matches the rest and was probably an integral part of the design.

First mentioned in 1680 in a warrant for cutting grass near the gate, the Chohole Gate has always been private, used to gain access to the farm, which stood within the park on the site of Kingsfarm Lodge. It was first named on Eyre's plan of 1754. It is now the access gate for Hyde Park Nurseries and the two gate lodges. The gates are timber and are frequently open during the day. An inner set of iron railings and gates prevent public access to the golf course.

Another of one of the six original gates is referred to as the 'gate on the side of Wimbleton'. It is unnamed on Rocque's plan, but on Eyre's plan of 1754 it is marked as Robin Hood Gate. The gates were rebuilt in 1907 when the road was widened. It has two carriageways with pedestrian gates on either side, one of which is a cradle gate in a style matching the rest. They are wrought iron, of an elaborate design, with the initials ER and gold crowns highlighted with red in the centre of the main gates, and the date 1907 above the pedestrian entrances. It was open at all times for pedestrians, but closed one night a year to prevent the establishment of a right of way through it. It was closed in 2003 as part of a traffic reduction trial, and remains permanently closed. Alterations commenced in March 2013 to make the gates more suitable for pedestrian use and return some of the hard surface to parkland.

The Ladderstile Gate is also one of the six original gates left open in 1637 and was known as Combe Gate until 1850, when the name Ladderstile first appears; it had one of the last remaining ladder stiles in the park. According to Collenette, there was originally a bridle gate, great gate and stepladder. These were bricked up between 1735 and 1740, and only the stepladder remained, which was also subsequently removed. On Eyre's plan of 1754 the gate appears as a bridle gate. The stepladder was not replaced until 1758, after John Lewis's successful action to restore the right of pedestrian access. It is shown on a plan of the freeboard from 1880–90, and was replaced by a timber foot gate in 1884–5.[10] In a table of distances from the middle of the nineteenth century, the bridle gate at Ladderstile is described as being private, but the footpath is described is public. The present cradle gate (similar to those at Bog and Cambrian Gate) was erected in 1901, and photographs show that it and the bridle gate have changed little since that time. The maintenance gates were in existence at that time, but were opened up for military use during the First World War and used during the Second World War and

until the WRAC Camp was demolished. The present bridle and maintenance gates are varnished timber, and the cradle gate black-painted iron. The cradle gate remained open at night for pedestrians, but the gates were closed to the public from 1939 to 1945, and then closed at dusk until 1949.

Kingston Gate became the carriage gate in the southern corner of the park after Ladderstile was closed. It is not marked on Rocque's plan of 1741–5 and first appears on Eyre's plan of 1754. In 1861, Queen Victoria opened a new pair of iron gates, erected at the expense of the British Land Company and known locally as Queen's Gate. They were not used until 1870, and from 1877 the foot gate remained open at all times. In 1898, the gates were widened and the present cradle gate erected. Subsequently the elaborate iron gates were replaced by low timber ones, but the cradle gate and iron piers were retained. The present iron gates were erected between 1954 and 1957, and consist of two carriage gates with pedestrian gates on either side, one of which is the original cradle gate. This gate was closed one night a year to prevent the establishment of a right of way through it. Like all the other gates, it was closed between 1939 and 1941, and then closed at dusk until 1949.

Ham Gate carriage gate is one of the six original gates at the time of the enclosure. According to Collenette, a ladder stile was put up in 1758; it was still in existence in 1850 and is shown on a plan of the freeboard from 1880–90. Photographs from 1903 show timber carriage gates with brick piers and an iron pedestrian gate (possibly a cradle gate). This was replaced by the existing wrought-iron gates when the entrance was widened in 1921. It is the narrowest entrance, with only a single carriageway and one pedestrian entrance. The iron gate piers are surmounted by lanterns, and all ironwork is painted black. The gate was left open all night for pedestrians, and was probably one of those left open until dusk between 1941 and 1945. An application was made to widen the gates in 1935.[11]

The park is also home to many other artefacts that are often overlooked, including drinking troughs, fountains, memorials and shelters. These are numerous and spread throughout the park, but are nevertheless an important aspect of the history of the park.

Two drinking troughs are located in the park. The first is located at Roehampton Gate and is inscribed 'presented by the Metropolitan Drinking Fountain & Cattle Trough Association'. Installed in 1903, it is constructed of grey unpolished granite of a standard design with tap and pewter cup on a chain. The other was originally installed in 1903 at Sheen Gate by the Association, but removed in 1920; it was later rediscovered in the paddock at Bog Lodge. It was subsequently relocated and plumbed in at Ladderstile Gate in 1983, with both fountains thoroughly restored again in 2013.

A drinking fountain, located near Kingston Gate and constructed of pink polished granite with dog trough and children's step at the base, has been very popular with park users. It is inscribed 'Presented by Thomas Stewes-Cox Esquire MP 1899'. The fountain was selected for restoration and, in addition to general refurbishment, needed a replacement lid. The fountain was dismantled so that the material used to dowel the cup to the bowl could be checked and the overflow drainage reinstated. The urn was then found to be badly cracked and needed to be replaced. The drinking fountain was successfully installed with a new paved surround in February 2002. A further drinking fountain was located at Sheen Gate and constructed of grey polished granite. It was inscribed on the bowl 'Presented by the Metropolitan Drinking Fountain & Cattle Association'. No records of this fountain have been found, but it probably had taps, and this would date its construction to pre-1930. After that date, 'bubble' fountains were introduced by the society as being less susceptible to vandalism. It has been knocked over by cars on several occasions, and as a consequence damaged numerous times.

An iron pump fountain is located at Robin Hood Gate, cast iron and restored but no longer working. No records of this have been found.

The much more interesting Teck Fountain is located on the edge of the freeboard at Richmond Gate. Constructed of polished pink granite and green slate, it no longer functions and is in poor condition. It is inscribed 'HRH Princess Mary Adelaide Duchess of Teck, 27 October 1879'. Records held by the Metropolitan Drinking Fountain & Cattle Association are not clear, but do refer to a fountain erected in 1879 by Lady Piggot opposite the Star and Garter Hotel, and funded by public subscription. The description of that fountain does not fully tally with the Teck Fountain, and as no further records have been found as to whom the responsibility for it rests with, its decrepit condition continues.

Of similar interest is the Thomson Memorial located at the north entrance to Pembroke Lodge; a simple timber board with its rustic surround, it is inscribed with lines composed by John Heneage Jesse, the son of Edward Jesse, one of the Deputy Surveyors of the Royal Parks. A brass plaque at the base of the board contains the following information:

> J. Thomson 1700–1740 Author of 'The Seasons' resided the last twelve years of his life in Richmond and is buried in the Parish Church. This memorial, the successor of several earlier boards, was erected in 1895. It was repainted and re-lettered for the bicentenary of Thomson's death, on 27 August 1948. The inscribed poem is by John Heneage Jesse.

YE, WHO FROM LONDON'S SMOKE AND
TURMOIL FLY,
TO SEEK A PURER AIR AND BRIGHTER SKY
THINK OF THE BARD WHO DWELT IN YONDER DELL,
WHO SANG SO SWEETLY WHAT HE LOVED SO WELL,
THINK, AS YE GAZE ON THESE LUXURIANT BOWERS,

HERE, THOMSON LOVED
THE SUNSHINE AND THE FLOWERS.
HE WHO COULD PAINT ALL THEIR VARIED FORMS,
APRIL'S YOUNG BLOOM, DECEMBER'S
DREARY STORMS.
BY YON FAIR STREAM,
WHICH CALMLY GLIDES ALONG,
PURE AS HIS LIFE, AND LOVELY AS HIS SONG,
THERE OFT HE ROVED.
IN YONDER CHURCHYARD LIES
ALL OF THE DEATHLESS BARD THAT EVER DIES,
FOR HERE HIS GENTLE SPIRIT LINGERS STILL.
IN YON SWEET VALE – ON THIS ENCHANTED HILL,
FLINGING A HOLIER IN'TREST O'ER THE GROVE.
STIRRING THE HEART TO POETRY AND LOVE.
AND VIEW IN NATURE'S BEAUTIES NATURE'S GOD.

Two boards containing the lines by Jesse and others by either Jesse or Thomson were, before 1851, attached to two trees near Pembroke Lodge stables, and renewed periodically. In 1895, the present board and framework were erected by Mr T. F. Wakefield, a member of the local branch of the Selbourne Society, but sadly they are now only visible through fencing.[12]

One of the more unusual artefacts that remains is the wrought-iron bell pull fixed to the stone pier at Richmond Gate, which is said to be the remains of the bell that was rung to get the attention of the gatekeeper in order to gain admission to the park. On all the main gates are also black-painted metal distance plaques, with raised white lettering in various positions, either inside or outside the gate on piers or the park wall. No record has been found of the date of their installation, but they are based on tables of distance which were compiled in 1857–9 to enable the gatekeepers to give accurate information on the distance between particular points in response to frequent requests.

As well as artefacts associated with memorials, boundaries and entrances, there are others in the park, although architecturally moribund, that are also historically important. Within these are included conduits, reservoirs, wells and well-houses. A good example, located in the south-west corner of Conduit Wood, is the conduit that is said to be on the site of one of three which supplied water to Richmond Palace. It is marked as the White Conduit on the plan of 1637. An account in 1877 states that the spring supplied Richmond workhouse, situated on the boundary of the park to the north-west, with water. Its appearance has changed little since Collenette described it, in 1937, as a brick-built structure with a skin of render, and water emerging from its base.

Another unusual structure is the reservoir located in the north-east corner of Sidmouth Wood; it is probably on the location of the springhead marked on Eyre's plan of 1754 and subsequent maps. The present structure is covered by a shallow single-brick dome with holes in it, now moss covered. On the Ordnance Survey Plan of 1890, it is marked as covered, but this is not the case on earlier plans. An account of 1877 refers to a spring with a conduit for the supply of water to White Lodge, and notes that the supply had recently been insufficient, so that water was laid on from the Kew reservoir and Vauxhall waterworks. A plan of 'Fire Services and Water Supplies for Richmond Park', dated 1923, shows a connection from the reservoir to a tank in the kitchen at White Lodge.[13, 14]

To the north-west of King Henry's Mound is located an artesian well house. Little is known of the history of this structure, but its distinctive octagonal domed superstructure is shown on plans from 1835. According to the 1877 account of springs in the park, it was fed 'by an ordinary brick well about 12' deep from which water flows through a brick channel to a receptacle (the cistern) in Petersham Park'. The source springs for the well are shown on a plan of 1733 (for the conveyancing of Petersham Lodge) and marked as

the 'four springs in the Park use of which is intended to be granted to Lord Harrington'. A well is shown on this location (north-east of King Henry's Mound) on a plan of 1850. The 1877 account of the springs makes it clear that the structure was part of the system that originally supplied Petersham Lodge before it was demolished. The spring was known as the 'Lion's Mouth', and was located opposite the Dysart Arms (near the present gate) and fed by a conduit from the cistern or artesian well house. The water was said to possess medicinal properties. A conduit is shown near Petersham Gate on the 1851 plan. The spring also supplied a drinking fountain for the thousands of children who visited the park in the summer to quench their thirst, as well as providing a supply to the school built in 1852. The account mentions the concern felt by some that during the building of the Richmond reservoir the supply of water to the existing well would be affected, but this was not the case. A plan of water services in 1923 marks a supply pipe from a spring reservoir to the Russell School, which passes under the site of the old stables, just north-east of King Henry's Mound.

Located just within the western boundary of Sidmouth Wood, a reservoir is clearly shown on the Ordnance Survey Plan of 1867 as a low, square, flat-topped mound with a timber fence around the base. It originally stored water pumped directly from the Thames, holding up to 350 billion gallons, and in 1929 it supplied Kew Gardens with untreated water. It is now disused. The 1877 account of the springs in the park refers also to what was probably a second reservoir under construction at that time for the 'supply of Richmond with pure water'. The Fire Service water supply plan of 1923 shows a second reservoir belonging to Richmond Corporation, first south of Kidney Wood, near the location of four wells shown on earlier plans of 1733 and 1783, which were the source of supply to Petersham Lodge. Again, according to Thames Water Authority, two further reservoirs were constructed in the 1930s, approximately on this site. They have a capacity of

about 753 billion gallons, and were damaged during the war, but are still in use.

The park, however, has a number of historical artefacts and buildings that are more apparent to the visitor, and less hidden away from the casual eye. These include the more unusual King Henry's Mound, and the lodges, which remain in the park to this day.

King Henry's Mound has caused great debate over many years and Collenette acknowledges this, saying, 'Much has already been written concerning this earth mound', but it is generally agreed that it is a barrow. Edward Jesse, writing in 1835, says, 'It has been opened, and a considerable deposit of ashes was found in the centre of it.' On Charles I's map of 1637, it is marked as 'The King's Standinge', and in a conveyance of Petersham Lodge in 1686 it is styled 'King Henry's Mount'. In a conveyance of 37 acres 3 roods 7 poles to the Earl of Rochester in 1698, the boundary is defined as 'up to the mount called Henry the VIIths Mount', and in subsequent documents concerning the same land, down to 1834, the same description is given. On Eyre's plan of 1734 it is 'Henry the 8th Mount', and on Richardson's plan of 1771 'Henry 8th Mount'. Its connection with Henry VII seems to be of an earlier date than with Henry VIII, but whether legal documents or early plans are more likely to be correct is still an open question that even Collenette could not answer.[15] Edward Jesse wrote,

> This mound has long been celebrated as the spot on which Henry VIII stood to watch the going up of a rocket to assure him that the death of Ann Bolyn would enable him to marry Lady Jane Seymour. This is the tradition of the park, and it has been handed down from father to son by the several park-keepers.

However, this story has been hotly debated for decades, and most cast doubt on its authenticity. Anne Boleyn was beheaded

on 19 May 1536, and accounts show that on the evening of the same day Henry attended a revel at Wolfe Hall, Wiltshire, some 60 miles away, which would have been a difficult or impossible day's ride for a monarch in those days.

The mound is on the highest ground in the vicinity, and its first title of 'The King's Standinge' was, with very little question, used in its old sense of a stand for a hunter, to which game would be driven up to be shot. As we know that royalty hunted in the vicinity before the enclosure of the park by Charles I, this seems to be the obvious explanation of the term and the real connection of the tradition with Henry VIII. Collenette highlights that an interesting feature on many of the old maps – such as John Rocque's map of London, 1741–5 and in Kip's engraving of Petersham Lodge and grounds of about 1720 – is the existence of an avenue of trees leading from the mound in the direction of London, with 'Oliver's Mount' at its termination over 700 yards away. This avenue was evidently replanted in around 1830, and can still be plainly seen. When Petersham Park and the mound were separated from Richmond Park, a high wooden fence to keep in the deer was in existence between them both. In 1792 a brick ha-ha 171 feet long, 7 feet and 6 inches deep, and 22 feet and 8 inches broad was constructed on the eastern side of the mound, and that section of the fence was removed to open up a view of London. The rest of the fence was taken away after the repurchase of Petersham Park, but the ha-ha still remains. During the planting up of Sidmouth Plantation in 1823, it was foreseen that the view would be interfered with. Edward Jesse wrote, 'A vista was cut through it, which opens a fine view of London and St Paul's.' This path is still open, and the view open to St Paul's Cathedral from a spot some distance down the path.[16] Planning restrictions are now in force to ensure the view is not obliterated by tall buildings.

Along with King Henry's Mound, other traces of early man have been found in the park, and the following quoted from *Neolithic Man in North-East Surrey*:

Men and rabbits, jointly and severally, cleared away two or three roods of turf near the Pen Ponds, leaving a bare, sandy waste. As we had long suspected would be the case, the sandy soil yielded an arrow-head, a saw, two scrapers, and a tolerable abundance of cores and chips, with scraps of pottery. From another corner we obtained a well-wrought honey-coloured scraper of the orthodox horseshoe form. A close scrutiny of rabbit burrows gave more specimens.

To the south of Pembroke Lodge, in the vicinity of John Martin's Oak, there is more than one artificial hillock resembling King Henry's Mound. Again, Edward Jesse says of the former, 'Two or three ancient British barrows are seen near the fence, in which broken pottery and deposits of ashes have been found.' One of them has been called 'Charles II's Mound', but this title has never been in general use and is not shown on any plans. In *The Handbook of Richmond Park* this mound is referred to as 'said to have been used by King Charles II, who had a hunting box near Ham'.[17] A further mound existed near the north-eastern corner of Sidmouth Plantation, and is marked in Eyre's plan of 1754 and Richardson's of 1771 as 'Oliver's Mount'. Brayley, in 1850, says that labourers digging for gravel found three skeletons in this mound at 3 feet from the surface, laid side by side. Jesse, writing at the time (1835), does not seem to have regarded these skeletons as ancient, as he says, 'In digging gravel lately in the plantation several human skeletons were found. The earth had been heaped over them, and the spot was known in the park as Oliver's mound. I have not been able to ascertain on what occasion they were likely to have been deposited there.' Others later have regarded these as evidence of a barrow. The origin of the name 'Oliver's Mount' is also unknown according to Collenette. It has been connected with Oliver Cromwell, but most writers deny that he was ever near the spot. It has been mentioned that in November 1647 there was a great assembling of the parliamentary army under Lt-

Gen. Cromwell at Ham. In the operation of digging for gravel, all traces of this mound have long since disappeared.

Within the park, there are also a number of distinctive buildings of significant historical context, these primarily being a number of lodges of varying size, quality and architectural merit. By the reign of George I, the Ranger's Lodge (Old Lodge) was falling into disrepair. The king therefore had no suitable base for hunting in the park, so he ordered that a new lodge should be built, which was to become White Lodge. In 1726–7 the design was approved and expenditure authorised. Its design was ascribed by Walpole to the Earl of Pembroke, though Roger Morris, who was in charge of the building operations, is described as the architect by the authors of *Vitruvius Britannicus*. The central block is of Portland stone, three storeys high with basements at ground level on the west side, and the main floor at ground level on the east side. The original accommodation was intended only for brief informal visits. The west elevation, with its Tuscan columns and portico, is the focus of the vista along Queen's Ride, which suggests that both the ride and lodge were created at the same time and are interrelated. The lodge was originally known as Stone Lodge, and subsequently called the New Lodge to distinguish it from the neighbouring Old Lodge. The first mention of the name White Lodge occurred in 1760. Between 1744 and 1758 the two flanking brick pavilions, known as the Queen's and King's Pavilions, were added. These were probably designed by Stephen Wright. An illustration of 1767 of the west elevation shows them linked to the main block by basement corridors – on the east side, they would have been below ground level. Between 1764 and 1792, the Office of Woods and Forests spent £20,888 on the park, including a large sum on White Lodge. Between 1801 and 1806 James Wyatt, deputy surveyor of woods and forests, was responsible for the addition of the *porte cochère* and other modifications on the east side, which then became the main entrance, and by 1816, illustrations show the semicircular linking corridors

to be two storeys high on the west elevation, and as now existing.

In 1801, as we know, White Lodge was offered to Henry Addington (later Lord Sidmouth). The lodge at that time was open to the park. The stable block and servants' quarters were extended in 1846, constructed of stock brick with slate. In 1922 a monumental flight of stone steps was added to the west elevation, the finest feature of White Lodge. Later changes have been necessary to adapt the lodge to its present function as part of the Royal Ballet School. The stables were converted to classrooms and residential accommodation for staff, and a studio added in around 1954–5. In 1963, there were further additions on the north side, and a sunken garden on the south side was built over. Another studio and garages were constructed in 1970 overlooking the lily pond.[18]

The Thatched House is first mentioned in a warrant dated 1673, which referred to 'a brick building lately erected … On a hill near Ham'. In a Treasury paper of 1716, it is known as Aldriche's Lodge after one of the keepers (who died in 1736). It is shown but not named on Rocque's plan. On Eyre's plan of 1754 it is called Aldridge's Lodge, but for a short period at the end of the century it was referred to as Burche's Lodge. The name Thatched House Lodge first appeared in 1771. At the beginning of the eighteenth century a considerable sum was spent on improvements. The projecting bays on the north side appear on the plans of 1741 onwards, and from descriptions of the interior these would appear to be the oldest parts. In 1798, Sir John Soane was involved in further alterations, with the central part of the house little altered until the end of the nineteenth century. A wing was then added on the west side, which destroyed the symmetry of the elevations. The house was then again altered in the early 1960s with the present gates and wall on the northern boundary erected and minor modifications made to the north elevation. In the gardens, which are approximately 4 acres in size, is the thatched summer house, from which the

lodge takes its name. It is said to have been built in 1727 by Sir Robert Walpole, and that George II was entertained there during a hunting expedition. It is on two levels, and its thatched roof can just be glimpsed from the park. It is built into a slope and seems to have combined the functions of an ice house on the lower level and summer house on the upper level. Ice would have been contained within the circular brick chamber on the lowest floor. The interior of the upper floor was decorated with paintings based on mythical themes, both on canvas and on the walls themselves. The paintings are generally attributed to Angelica Kauffman, or possibly her husband Antonio Zucchi, and date from around 1780. The paintings were removed and restored in 1974.

The main house was used by various members of the royal household including General Sir Edward Bowater, and General Lynedoch Gardiner, respectively equerry to the Prince Consort and to Queen Victoria. Sir Frederick Treves, 1st Baronet, retired to the house after he successfully operated on King Edward VII's appendix in 1902. Later, Thatched House Lodge became the home of Wing Commander Sir Louis Greig (equerry to King George VI, when he was Duke of York), and then the Duke of Sutherland. It was also the London home of US General Dwight D. Eisenhower during the Second World War. Since 1963 Thatched House Lodge has been the residence of Princess Alexandra, The Honourable Lady Ogilvy (born Princess Alexandra of Kent), having been acquired by her husband, Sir Angus Ogilvy, who predeceased his wife in 2004, on a lease from the Crown Estate Commissioners following their marriage.

Pembroke Lodge is found on the site of the Molecatcher's Lodge (also known as the Vermin Killers Lodge) and appears but is not named on Rocque's plan of 1774–5. It is referred to as Hill House on Rocque's plan of 1775, but the name Molecatcher's Lodge appears on plans up to 1813. In around 1780, George III granted the lodge 'in the wilderness' to the

Countess of Pembroke, and another lodge and stables built towards the present northern entrance of the garden to the gamekeeper Trage, who had been the previous occupier of the Molecatcher's Lodge. In 1788 Sir John Soane was asked to make alterations and extensions to the existing cottage, and four rooms were added. The southern part of the house is the earliest section, and externally this still corresponds closely with Soane's original drawings, which show the stepped gable, part of the west elevation. It was constructed of brick and has long been painted white. The house was again extended between 1792 and 1796, and the kitchen wing added. Both Henry Holland and Soane were involved in the works. It became known as Pembroke Lodge after the countess's death in 1831. After the death of the countess, at the age of ninety-three, William IV granted the lodge to the Earl of Erroll, the husband of one of his daughters. Between 1831 and 1846, the earl completed most of the remainder of the north wing. The Countess of Dunmore lived here during 1846. In 1847, the lodge was granted to Lord John Russell, the Prime Minister. He was visited by several famous contemporaries, including Dickens and Queen Victoria, and spoke of it in glowing terms. He and his wife both died there, and a memorial remains in the garden, erected by their daughter, Lady Agatha Russell. Lord John's grandson was Bertrand Russell, and he spent twenty years at the lodge, later writing, 'I grew accustomed to wide horizons and to an unimpeded view of the sunset.'[19] Georgina Countess of Dudley took up occupation in 1903 and made further alterations including the decorative friezes in the ground floor of the Georgian wing, the mahogany doors and floor. A wealthy industrialist, John Scott Oliver, took up residence in 1929 and also carried out many alterations, mostly in the north wing. He suffered large financial losses in the recession and put the lodge on the market in 1938. However, before it could be sold, it was requisitioned for services during the Second World War, by the GHQ Liaison Regiment. There were some very illustrious members of this

regiment, including David Niven, who remarked in a letter,
'These were wonderful days which I would not have missed
for anything.' After the Second World War Pembroke Lodge
became a tea room with flats for staff. Its conversion to either
a restaurant or a country club had been considered earlier,
in 1926, but it was decided that the income from letting it as
a residence would be a better source of revenue. In the early
part of the twentieth century, gatekeepers were allowed to
serve teas at the gate lodges. The restaurant was opened in
1953 and the flats were occupied by the park staff. In the
early 1980s, the upper floor was unused as well as part of
the ground floor, and much of the building was damp. Park
superintendent for the Royal Parks, Simon Richards, was
quoted in 2005,

> There was a risk in the early 1990s that it would not remain
> public, because there was not enough money around to put
> the building in proper order, or enough people to invest the
> time to do that. The Royal Parks really were committed to
> Pembroke Lodge continuing as a building in the public realm.

Pembroke Lodge was under significant threat as it headed
towards the millennium. To take on the project, Hearsum
Family Limited, a private company, entered a partnership
with the Royal Parks Agency, in which the company would
faithfully restore Pembroke Lodge to its former glory at the
company's expense in exchange for the grant of a long-term
lease. Throughout the restoration, which began in 1998 and
ended in May 2005, Pembroke Lodge never closed. This
meant that the work had to be done in stages, which naturally
lengthened the process. Since the start of the transformation,
which slowly 'recovered decades of institutional neglect',
traffic at the lodge has grown fourfold. Some 250,000 people
a year now visit the lodge. Hearsum described it as a shell,
with the ground floor of the Victorian wing in much worse
condition than the Georgian wing.

We held up the first floor with steel to create the banqueting room. And to give you an idea we are not talking about a coat of paint ... All we have done is take it back to what the early clever people did. Sir John Soane, he was the clever part in this process. The plans are kept in his museum in Lincoln's Inn Fields, I trekked up there regularly to have a look.

Now a huge success after significant investment, Pembroke Lodge is unrecognisable from the early 1980s. In 2005, Daniel Hearsum said, 'It got to two-and-a-half million and I stopped counting. The investment has been huge, but it's about the long term and doing it right.'[20] Without doubt, it was done right.

On the site of Hill Farm, shown on the 1637 plan of the park, Bog Lodge was known as Coopers Lodge (on Rocque's plan of 1741–5), Lucas's Lodge (on Richardson's plan of 1771), and by the early nineteenth century was referred to as Bog Lodge or the Head Keeper's Lodge. For a brief period at the beginning of the twentieth century it was called Holly Lodge, and was formally renamed such in 1993. The name of Bog Lodge came from the bog to the north of the lodge, which was drained in 1855. The existing lodge probably dates from the mid-eighteenth century. Engravings from 1823 show the south elevation of the lodge and its eastern extension have remained largely unchanged. It was extended in the nineteenth century, and was for many years the home of the head keeper. It now contains a visitors' centre, the park's administrative headquarters and a base for the Metropolitan Police's Royal Parks Operational Command Unit.

Whiteash Lodge first appears and is named on Eyre's plan of 1754. It is one of the oldest buildings in the park, and normally the residence of the second keeper. It originally had extensive outbuildings, which included a deer house, kennels, chicken houses, cattle food store, three pigsties, three stalls for horses, a brewing house and a separate venison house. These have been reduced to a stable within its grounds, but the

whole complex retains a rural air. A Grade II listed building, it was restored in 1978.

Oak Lodge was built between 1850 and 1853 for the bailiff in the southern part of Sidmouth Wood. The building shows a departure from the traditional vernacular style of the smaller lodges in the park – up until that time built of stock brick, with a slate roof and yellow brick trims to the windows.

Bishops Lodge takes its name from a gamekeeper who was on the staff in the first half of the nineteenth century. A reference dated 1854 said that the keeper had had access to the lodge for the last fifty years. The lodge does not appear, though, on the 1813 plan of the park, but appears on the plans of 1850, and its layout seems to have changed little from that time. It forms part of a view over the park, and beyond, that is much favoured by amateur painters.

Sheen Gate Lodge is on the site of one of the original gate lodges and is shown on Rocque's plan; the present building dates from the early twentieth century, and replaced a brick building very similar in style to Bog Lodge. Roehampton Gate Lodge dates from 1901, with the initials V.R. set in stone in the brickwork of one of the main elevations. The earlier lodge was built on the opposite side of the gates in what is now the rest garden, and is shown on Rocque's plan of 1741. The present lodge, with its mock-Tudor timber and decorative tile hanging, reflected the architectural style of the time. Chohole Lodge was shown on the 1926 Ordnance Survey but not the 1911 version, so was probably built in the early 1920s and known originally as the Gardener's Cottage. Like Sheen and Kingston Gate Lodges it has a tiled roof, and red-brick and rendered walls. The original Robin Hood Gate Lodge was built on the opposite side of the gate, and is first shown on Rocque's plan. The present lodge was constructed between 1867 and around 1880. Ladderstile Gate Lodge dates back to the end of the eighteenth century and originally housed one of the gamekeepers; it had stables, a cowshed and a large compound for grazing domestic stock. Also shown on

Rocque's plan of 1741, Kingston Gate Lodge predates the construction of the road and gates in that part of the park. It was originally on the west side of the gate, on the site of the present lavatories and rest garden, and was in existence in 1903. The present lodge first appears on the 1911 Ordnance Survey, and is similar in style to East Sheen Gate Lodge. Ham Gate Lodge is the only original lodge still in existence, built in 1742. It is a simple white-painted brick building, built along the boundary wall, with stables and a paddock in the large garden.

# The Ecology and Wildlife of Richmond Park

In 1922, just before he died, W. H. Hudson, the renowned naturalist, wrote *A Hind in Richmond Park*, which starts with a description of a visit to the park rather than the natural history of this fascinating landscape.

Occasionally when in London I visit Richmond Park to refresh myself with its woods and waters abounding in wild life, and its wide stretches of grass and bracken. It is the bird life that attracts me most, for it is a varied one although so near to the metropolis, and there are here, at least two of England's few remaining great birds – the great crested grebe and the heron. The mammals are of less account, but I have met here with at least two adventures with the red deer which are worth recording. Stags are aloof and dignified, if not hostile in their manner, which prevents one from becoming intimate with them. When walking alone late on a misty October or November evening I listen to their roaring and restrain my curiosity. A strange and formidable sound! Is it a love-chant or a battle-cry? I give it up, and thinking of something easier to understand quietly pursue my way to the exit.

He continues describing a specific incident he recalls in great detail.

One afternoon in late summer I was walking with three ladies among the scattered oak trees near the Pen Ponds when we saw a hind, a big beautiful beast, rearing up in her efforts to reach the fully ripe acorns, and on my plucking a few and holding them out to her, she came readily to take them from my hand. She invariably took the acorn with a sudden violent jerk; not that she was alarmed or suspicious, but simply because it was the only way known to a hind to take an acorn from the branch to which it is attached with a very tough stem. To her mind the acorn had to be wrenched from me. My friends also gave her acorns, and she greedily devoured them all and still asked for more. And while we were amusing ourselves in this way, two ladies accompanied by a little girl of about eight or nine came up and looked on with delight at our doings. Presently the little girl cried out, 'Oh, mother, may I give it an acorn?' And the mother said 'No.' But I said, 'Oh, yes, come along and take this one and hold it out to the deer.' She took it from me gladly and held it out as directed. Then a sudden change came over the temper of the animal; instead of taking it readily she drew back, looking startled and angry; then slowly, as if suspiciously, approached the child and took the acorn, and almost at the same instant sprang clear over the child's head, and on coming down on the other side, struck violently out with her hind feet. One hoof grazed her cheek and dealt her a sharp blow on the shoulder. Then it trotted away, leaving the child screaming and sobbing with pain and fright.

Hudson then goes on to describe at length a further encounter with a hind in the park, this time much less dramatic, but nevertheless in such detail that he takes you to where he was stood and observing at the time.

Seeing a hind lying under an oak tree, chewing her cud, I drew quietly towards her and sat down at the roots of another tree about twenty yards from her. She was not disturbed at my approach, and as soon as I had settled quietly down the suspended vigorous cud-chewing was resumed, and her ears, which had risen up and then were thrown backwards, were directed forwards towards a wood about two hundred yards away. I was directly behind her, so that with her head in a horizontal position and the large ears above the eyes, she could not see me at all. She was not concerned about me – she was wholly occupied with the wood and the sounds that came to her from it, which my less acute hearing failed to catch, although the wind blew from the wood to us. Undoubtedly the sounds she was listening to were important or interesting to her. On putting my binocular on her so as to bring her within a yard of my vision, I could see that there was a constant succession of small movements which told their tale – a sudden suspension of the cud-chewing, a stiffening of the forward-pointing ears, or a slight change in their direction; little tremors that passed over the whole body, alternately lifting and depressing the hairs of the back – which all went to show that she was experiencing a continual succession of little thrills. And the sounds that caused them were no doubt just those which we may hear any summer day in any thick wood with an undergrowth – the snapping of a twig, the rustle of leaves, the pink-pink of a startled chaffinch, the chuckle of a blackbird, or sharp little quivering alarm-notes of robin or wren, and twenty besides. It was evident that the deer could not see anything except just what I saw – the close wood a couple of hundred yards away from us on the other side of a grassy expanse; nor did she require to see anything; she was living in and knew the exact meaning of each and every sound. She was like the dog as we are accustomed to see it in repose, sitting or lying down, with chin on paws, seemingly dozing, but awake in a world of its own, as we may note by the perpetual twitching of the nose. He is receiving a constant succession of messages,

and albeit some are cryptic, they mostly tell him something he understands and takes a keen interest in. And they all come to him by one avenue – that of smell; for when we look closely at him we see that his eyes, often half-closed and blinking, have that appearance of blindness or of not seeing consciously which is familiar to us in a man whose sight is turned inwards, who is thinking and is so absorbed in his thoughts that the visible world becomes invisible to him. The dimmed eye in the reposing dog and the absent-minded philosopher is in both cases due to the fact that vision is not wanted for the time, and has been put aside. The resting, but wakeful, deer and dog differ only in this, that the first is living in a bath of vibrations, the other of emanations. To return to our listening hind. The sounds that held her attention were inaudible to me, but I dare say that a primitive man or pure savage who had existed all his life in a state of nature in a woodland district would have been able to hear them, although not so well as the hind on account of the difference in the structure of the outer ear in the two species. But what significance could these same little woodland sounds have in the life of this creature in its present guarded, semi-domestic condition – the condition in which the herd has existed for generations? It is nothing but a survival – the perpetual alertness and acute senses of the wild animal, which are no longer necessary, but are still active and shining, not dimmed or rusted or obsolete as in our domestic cattle, which have been guarded by man since Neolithic times. But as I have seen on the Argentine pampas, these qualities and instincts, dormant for thousands of years, revive and recover their old power when cattle are allowed to run wild and have to protect themselves from their enemies.[1]

Hudson's description of the hinds he was observing gives an account of the park in the early 1920s, and throughout its history the importance of deer to Richmond Park has been highlighted, from its enclosure by Charles I in 1637 as a royal hunting ground, to the daily management of the park after

the disbanding of the Royal Hunt by Edward VII. Michael Baxter Brown, superintendent from 1971 to 1990, closely studied the deer and became an acknowledged expert on the subject. However, it is without doubt C. L. Collenette – a chartered accountant by profession, who devoted much of his life to studying natural history – who wrote the definitive early history of Richmond Park, with a detailed account of its birds and animals. He served on the Committee for the Birds of the Royal Parks and also assisted in the compilation of *Birds of the London Area*, a publication of the London Natural History Society, of which he had been a member since 1907. His expertise stood him in good stead when he began his close study of the flora and fauna of Richmond Park, eventually publishing his findings in 1937. As he wrote in his preface to Part II, 'much has been written on the birds of Richmond Park, but I believe that no attempt has previously been made to prepare a comprehensive list based on all the published records'.[2] Collenette had taken on the post of official bird observer from the late Mr J. Rudge Harding in 1932, and started compiling a comprehensive list. The list he compiled came to 133 species, which he grouped under 'residents' (those birds that usually breed, and some individuals of which remain throughout the year); 'summer residents' (migrants that usually breed); 'winter residents' (birds that as a rule remain regularly through the whole or part of the winter); 'passage migrants' (birds that appear regularly on their way to and from their nesting quarters); and 'irregular visitors'.[3] Remarkably, despite the enormous increase in people and dogs frequenting the park, there are still approximately 118 species to be seen, but of these barely fifty are now permanent residents, and the remainder are seasonal migrants and a handful of rare strays. The changes relate to a number of species and the changing balance over time. A good example is the magpie, described in 1937 as 'an occasional visitor to the park … occurrences usually take place during the winter months'. A century earlier, on the

other hand, Edward Jesse wrote of 'constant fights between the Mistletoe Thrush and the Magpie'.[4]

The pressure on the Royal Parks into the twenty-first century is intense in relation to managing biodiversity. The eight Royal Parks offer current visitors a huge diversity of experiences, from historic landscapes with iconic views, to monuments ancient and modern, as well as open space for healthy recreation and sport, events and exhibitions, horticultural areas, waterfowl collections and wildlife. Each park has its own character and history. In total, the Royal Parks enclose around 2,060 hectares (5,100 acres) of multi-purpose open space including: 280 buildings and monuments, 32 miles of roads, 68 miles of paths, cycle paths, horse rides, 49 miles of boundary walls and fences, 15 miles of river (River Longford in Bushy Park, and Beverley Brook in Richmond Park), and an estimated 150,000–175,000 trees. An estimated 30 million visitors per year, from over 100 countries, visit the Royal Parks. In 2005–6 an average of 73,000 people per month visited the Diana Memorial Fountain in Hyde Park. In July 2005 alone, more than 200,000 attended the Live 8 concert, over 6,000 children and their parents enjoyed the Peter Pan treasure hunt, and 85,000 visited the week-long Second World War event in St James's Park. With such intensive use, managing for biodiversity in the Royal Parks is a challenge. All the Royal Parks are designated as Sites of Metropolitan Importance for nature conservation, and none is managed without wildlife conservation in mind. Richmond Park is now a Site of Special Scientific Interest (SSSI), a National Nature Reserve (NNR) and a European Special Area for Conservation (SAC).

Grassland management is a key issue in all the Royal Parks. Areas of Hyde Park were grazed by sheep until the 1950s, but then were converted to closely mown amenity grassland. However, in the middle of the 1980s a survey revealed a relict area of mediaeval fields, with wild grasses persisting in the grass sward. From 1986 onwards, the site

management was changed to meadow management, with a single autumn cut, and plugs of wildflowers were reintroduced over a number of years. In 2001 a survey found twenty-one species of grass, plus twenty-nine species of other flora, but only seven of the twenty-two species that had been planted persisted. In 2003 the Royal Parks altered the management to a rotational cutting regime, leaving different refuge areas uncut each winter in order to allow invertebrate populations to overwinter. Early observations suggested that numbers of butterflies and moths were gradually increasing as a result. Grassland management to improve biodiversity continues to take place in all the Royal Parks, often side by side with more intensively managed amenity swards and their high-quality horticultural areas.

Lowland acid grassland is both a London and UK Biodiversity Action Plan (BAP) priority habitat. The Royal Parks takes an active role in numerous local, London and national BAPs and is the lead partner in London for acid grassland. Richmond Park and Bushy Park are the first- and second-largest areas of acid grassland in the London area, with more than 280 hectares of this grassland community – including over fifty species of grass, rushes and sedges. Despite many changes in land use, these two parks have been grazed by deer for over 400 years, and have a rich flora and fauna. The wildlife value of both these sites is extraordinary given their urban setting and visitor pressure. Richmond Park has the advantage of being twice as large, and has been better studied over the years, although Bushy Park is becoming a closer rival to Richmond as more data is collected. In 2005, as previously noted, 118 bird species were spotted in Richmond Park, and records for the site include over 250 species of fungus, more than 564 species of butterfly and moth, over 139 species of spider, about 160 species of solitary bees and wasps, and more than 1,350 species of beetle. The last count of around 160 invertebrates with national conservation status is now well out of date, and Dr Nigel Reeve, former Head

of Ecology for the Royal Parks, estimated that the figure for Richmond Park is now approaching 200 species as a result of further work.

Small mammals, such as mice, voles and shrews, are an important part of the grassland habitat, and support predators such as kestrels, tawny owls, foxes, badgers and stoats. Few mammals (other than grey squirrels) are seen by visitors, but the herds of red and fallow deer in Richmond, Bushy and Greenwich Parks do continue provide a spectacular sight to the growing number of visitors. Grazing is not the only management – some areas are hay-cut annually, both to remove nutrients from the grassland (restoring previously enriched areas) and to provide 'aftermath' grazing in the autumn for the deer. Also, a team of shire horses is used to roll and cut bracken in some areas. The cut bracken is composted to provide peat-free compost for horticultural use within the park.

Ancient trees are another conservation priority. 'Those grey, gnarled, low browed, knock kneed, bowed, bent, huge, strange, long armed, deformed, hunch backed, misshapen oak men that stand waiting and watching, century after century' (Francis Kilvert, Diary of F. Kilvert, 1876). All the Royal Parks have at least some large mature trees, but Greenwich, Bushy and Richmond Parks have particularly important numbers of ancient trees. Greenwich Park has a population of sweet chestnuts that dates back to the seventeenth century. Richmond Park has about 1,200 'veteran' trees, over 800 of which are English oaks. Many of them date from before the enclosure of the park in 1637, and some are approximately 700 years old. These ancient trees, and the decaying wood habitat associated with them, support a huge diversity of wildlife, ranging from fungi to birds and bats. These fungi perform a crucial role in breaking down dead wood and creating habitats for other species. Heartwood-rotting fungi, such as the beefsteak fungus (*Fistulina hepatica*) and chicken of the woods (*Laetiporus sulphureus*), do not kill the tree but

break down only dead wood, hollowing the centres of the trunk and heavy branches. The reduced weight makes the tree more stable. Fungi like these create habitat and food for other creatures – they recycle nutrients too.

The invertebrate communities associated with decaying wood are of great conservation importance nationally and internationally, and the stag beetle is the species for which Richmond Park is designated a Special Area for Conservation. Current survey work has (so far) topped up the species list to 319 beetle species dependent on decaying wood. Of these, twenty-seven are Red Data Book (RDB) species and 100 are Nationally Notable. Some nationally rare beetles are quite common in the park, e.g. *Ampedus cardinalis, Procraerus tibialis, Trinodes hirtus* and the rusty click beetle (*Elater ferrugineus*). Richmond Park is currently ranked fifth among the nine UK sites considered to be of international significance for saproxylic invertebrate species. Bushy Park's first survey in 2004 immediately ranked it twelfth among sites surveyed in the UK. Protection of the ancient tree resource is an important task for the Royal Parks. Richmond Park's veterans have individual management plans within a thirty-year programme of works. The work involves stabilising the trees to prevent collapse, e.g. by reducing the weight of branches in top-heavy trees, and by using a range of specialised 'natural fracture' techniques – a style of cutting that seeks to mimic patterns of natural breakage.

An interesting story exists relating to an ancient tree in Richmond Park. A century and a half ago, when medical science was as likely to kill patients as cure them, and people still sometimes turned to magic and ritual for remedies, Richmond Park had its very own spiritual healing centre, a remarkable tree. The Shrew Ash was a very ancient gnarled tree near Sheen Gate which, not uncommonly for ash trees, had a reputation for curing sick infants and animals. Mothers would bring children with whooping cough and other ailments to the tree to take part in a secret dawn ritual led

by a 'shrew mother', 'priestess', or 'witch'. The ritual involved
passing the child over and under a 'witchbar', a wooden bar
wedged into the tree, while the 'shrew mother' muttered or
sang verses, timing her recitation so that a particular word
coincided with the first of the sun's rays. If the charm didn't
work, it could be blamed on mistiming. A part of the ash still
survived, though damaged, in 1895, when photographs of it
were shown to the Folklore Society, and it was demonstrated
that the ash that then existed was the original 300-year-old
tree, not a 'mere sucker', and that belief in its curative powers
had persisted into the second half of the nineteenth century.
A Professor Owen, who lived in Sheen Lodge and regularly
walked in the park before sunrise, had, in the early 1850s,
observed a mother accompanied by a sick child and 'old
dame' heading for the tree, though they changed course when
they saw him and only returned to spend time at the tree
when they thought he had gone. At other times he saw similar
furtive groups or heard voices in unison near the tree, and
always took care not to disturb them. Though he couldn't
recall when he had last seen the Shrew Ash in use, a writer in
the *Mid-Surrey Times* of 1874 claimed that it was still used
and believed in then. The remains of the ancient tree finally
collapsed in the storm of 1987.[5]

The Royal Parks are indeed rich in wildlife, but there are
continued pressures, and, speaking in 2006, Head of Ecology
Dr Nigel Reeve stated, 'Not all is perfect.' In the last 100 years
the United Kingdom has lost over 100 species, and many
others have become rarer or locally extinct. Good examples
are found in Richmond Park: the last records of red squirrels
were in 1919, of water vole in the 1930s, water shrews in
1966, brown hares in 1972, and grey partridges in 1997.
Many of these losses, including the major decline of house
sparrows in London, are reflections of wider problems. The
Royal Parks, like many other London parks, are subject to
the effects of atmospheric pollution – clearly illustrated by the
relatively impoverished lichen flora, but also affecting many

other species. Other impacts on the local wildlife include disturbance by park visitors and their dogs, dog fouling (which has a seriously degrading impact on acid grassland communities), fires, and the effects of invasive exotic species, such as the aquatic plant *Crassula helmsii*, which is extremely difficult to eradicate from water bodies.

However, as Dr Reeve added, much can be done to mitigate these negative influences. A good example is the Skylark Protection Zone project in Richmond Park. Data collected by volunteers of the Bird Recording Group since the 1960s had shown a gradual but dramatic loss of breeding skylarks in Richmond Park. It was suspected that disturbance was a key driver of this loss, but needed confirmation. From 2001 to 2005, the Royal Parks conducted a simple controlled study of two sites: one (Lawn Field), where signs were erected in February 2002 asking visitors to keep their dogs on a short lead and to keep to the paths, and a control site. Volunteers counted skylark and other breeding bird territories on these two sites each year. Despite the small numbers, the results were clear: on Lawn Field, ground nesting birds increased by 38 per cent and the number of skylark territories quickly doubled (from three to six), maintaining this increase from 2003 until the end of the study. By contrast, the control site showed a net loss (33 per cent), and lost its last skylark territory. Their surveys also showed that 70 per cent of visitors with dogs respected the protection zone, and Dr Reeve concluded that there is now clear evidence that skylarks do benefit from a reduction in exposure to dogs and trampling; at the time they were considering further implementation of such protection zones during the breeding season. Visitor engagement and education about wildlife and the cultural and historic importance of the Royal Parks is vitally important. Not only does it enhance the visitor's experience, but raising awareness about wildlife helps to alter visitor behaviour to avoid or mitigate negative impacts. They continue to develop and deliver nature-trail leaflets and other visitor information,

such as the excellent interpretation boards in Richmond Park National Nature Reserve.[6]

In 2011, the Friends of Richmond Park published the most up-to-date guide on the park, which describes in greater detail its ecology, birds, butterflies and moths, beetles, bats, trees and flora. A description of these essential areas is important to complete the history of Richmond Park as well as to acknowledge and recognise the importance of the park today and to ascertain what the future of the park may be with its daily pressures. To assist and guide is the Richmond Park Operations Plan, which is prepared as the daily working document for the ongoing management of the park. It contains the annual action plan for the park, and records progress made in the previous year. It is updated and reviewed every year. The Operations Plan complements the Richmond Park Management Plan. The Operations Plan format was first developed in 2005, and is presented in a readily accessible form and set out using the criteria for the Green Flag Award, which recognises and rewards the best green spaces in the country. Richmond Park has held the Green Flag Award since 2009.

The park's ecological value is recognised nationally and internationally. As we know, in 1982 it was designated as London's largest Site of Special Scientific Interest (SSSI), in 2000 as a National Nature Reserve (NNR), and in 2005 as a European Special Area of Conservation (SAC). The natural landscape owes much of its character to its geology. Areas of high ground are deposits of 'River Terrace' gravels left behind by the Thames, which has repeatedly changed course and level through successive ice ages. Over thousands of years, softer soils, such as clays and silts, have washed away to leave the erosion-resistant gravel terraces as high points in the landscape, with stony, low-nutrient soils unsuitable for agriculture. It is Richmond Park's multi-layered topography, and its complexity of soils and hydrology that are fundamental to the park's scenic beauty and extraordinary diversity of

habitats. It consists of a mosaic of habitats, ranging from ancient trees and decaying woodland habitats to grasslands, water bodies and wetlands. Trees and grasslands have already been described. However, with about thirty ponds, many kilometres of ditches and streams, a reed bed, flooded woodland, and the 2-kilometre stretch of Beverley Brook, the park has an impressive range of wetland habitats. Little of this, though, is truly natural. The management of water in the park has a long history, which includes the drainage of many boggy areas and the harnessing of streams using conduits and reservoirs to provide a water supply for the large houses surrounding the park. A large number of the ponds were dug in the late nineteenth century to provide water for cattle. A good example is the creation of nine ponds for the purpose, which were added to the park during Josiah Parke's major drainage and pond creation scheme between 1856 and 1861. These ponds vary greatly in nature, and provide great diversity and ranges of habitats, with many in the open and some in deep shade. Those that dry out stay free of fish and are therefore excellent habitats for frogs, toads and newts. The largest ponds are the Upper and Lower Pen Ponds in the centre of the park, and are still fished today. Resident waterbirds include coots, moorhens, tufted ducks, mute swans, great crested grebes and grey herons. Along with such birdlife is found a range of species, including damselflies and dragonflies. The secluded south-western end of the Upper Pen Pond is of particular value for its wetland habitats. There is a fine reed bed, where species such as the reed warbler and the very rare and shy bittern can also be seen. Within the plantation behind the reed bed there are areas of flooded willow and alder woodland, rare habitats in the London area.[7]

C. L. Collenette's study of birds in Richmond Park is still a milestone despite being eighty years old. With its range of habitats, Richmond Park still has a wide variety of birds, both resident and migrating. In its large areas of woodland,

the many ancient oak trees provide numerous cavities for a variety of hole-nesting birds. These include kestrels, stock doves, tawny and little owls, the three species of woodpecker and nuthatch, blue tits and great tits, starlings and jackdaws. The recently established exotic ring-necked parakeet has increased to the point of being at times the most obvious bird in the park, usurping the native jackdaw. Songbirds such as thrushes and warblers are dependent on the presence of shrubs and ground vegetation within the park's woods. With the large population of deer there is little, if any, of this habitat in the unenclosed woods, so they are almost devoid of songbirds. The enclosed woods hold more songbirds, such as blackbirds, song thrushes, dunnocks, blackcaps, chiffchaffs, garden warblers and long-tailed tits. However, in the park large swathes of the enclosed woods are choked with non-native rhododendron, which was planted extensively several years ago for screening and has spread throughout the woods, allowing little light through to the woodland floor and preventing the growth of shrubs and ground vegetation. The Royal Parks' long-term management plans include removal of much of this, including Prince Charles' Spinney, designed to recreate some of this lost habitat. The best woods for songbirds are the Isabella Plantation and Conduit Wood. The parkland covers the less densely wooded parts of the park, usually with an understorey of bracken. The characteristic bird of this habitat is the little owl, which occurs in a very high concentration in the park. The mistle thrush also favours this habitat, preferring to nest high up in a tree fork and to feed in an open area. Grassland, as previously described, is featured across large areas of the park, some of it acid grassland – a scarce and important habitat. From early spring skylarks fly up high, uttering their rich and sustained song. As discussed previously, they were on the brink of extinction as a breeding bird in Richmond Park, mainly due to the ongoing disturbance of increased visitor numbers and their dogs as well as kite flyers. These ground nesters are sensitive to disturbance

because their well-hidden nests may easily be trodden upon, or the adults kept from the nest by the proximity of people, causing either the eggs to chill or the nest to be abandoned. With changes to management regimes in the park, there has been and continues to be an increase in numbers of breeding pairs in many grassland areas.

With its wild grasslands and oak and chestnut woodlands, Richmond Park is a very different environment from most of London. Its butterflies are also very different, even from those found in nearby town gardens, which are only occasional visitors to the park. Common butterflies include the meadow brown, small heath and small copper. Other residents include the common blue, small blue and painted lady, an occasional visitor from North Africa. Ragwort also attracts many other types of butterfly. One of the most common of these, in its season, is the gatekeeper or hedge brown, which is also closely associated with bracken and brambles in the park.

As we have already noted, the historic landscape of Richmond Park enables many beetles to survive here, because of the special mix of habitats created by the combination of grassland, trees, open water and deer. The park is rich in beetles that depend on decaying wood, in particular the stag beetle. The beetles in the park can be divided into three lifestyle groups: hunters and gatherers, such as the cockchafer, rose chafer, and the great silver water beetle; dung-dependent beetles, including the dor and minotaur, often found near rabbit warrens; and the saproxylic (dead- and decaying-wood-dependent) beetles. As mentioned above, the many ancient trees in Richmond Park have helped beetles dependent on dead and decaying wood to survive. These include not just the stag and lesser stag, but also the cardinal click and the longhorn.

Richmond Park supports at least nine of the country's seventeen bat species, each adapted to different habitat niches. The park provides a vital continuity of environment and relatively low disturbance, and has done for over 400

years. Only the very rare barbastelle bat has been pushed to extinction here, because its requirements could only be met by a landscape much larger than the park. Nonetheless the park remains an exceptional site for bats, including uncommon species such as Leisler's, Nathusius' pipistrelle and Natterer's bats. The park is also large enough to fully support a large breeding population of brown long-eared bats.

Much has already been written in relation to trees in Richmond Park, but it is worth considering these further in relation to the ecology of the park. The park has about 130,000 trees in its woodlands and parkland. The veteran oaks, the tall boundary beeches and the younger plantations of mixed species create unique atmospheres, supporting a vast array of wildlife. They define the landscape's character, filtering out the presence of London. Natural regeneration of trees is very limited in the park, and only those protected from deer will mature. We can be confident that only the trees older than the 1637 enclosure could have seeded naturally. All other trees have been planted, or at least protected from deer, until mature. Of Richmond Park's trees, 45 per cent are oaks, another 20 per cent are beech, and 5 per cent are sweet and horse chestnut. Their acorns, beech mast, conkers and chestnuts provide a critical part of the deer diet. Hawthorn, birch and hornbeam together are another 20 per cent, meaning that 90 per cent of the trees in the park come from just seven species. The remaining 10 per cent are a variety of indigenous and exotic species, from willows and alders to eighteenth-century cedars and twentieth-century sugar maples.

The veteran trees are perhaps the park's most outstanding feature, dotted throughout the parkland and woodlands, and some are in obvious lines, indicating very ancient field boundaries. Historically, many veteran trees were pollarded – a management technique where branches were cut above the grazing height of deer or cattle. This systematic way of producing timber started to decline in the late eighteenth century when we started building steel, rather than wooden,

ships. A better railway infrastructure brought alternative commodities to local communities, and mechanisation favoured the production of timber from plantations. We stopped pollarding and started to closely plant trees in uniform rows to produce tall, single-stemmed trees that were easier to mechanically harvest and process. The veteran oaks predate the enclosure of the park, and while we cannot be sure of their age we can be confident that they are at least 500–700 years old. We know from historical records that funds were raised to repair the wall in 1659 'by felling and cutting of ... pollards and under woods', so 350 years ago the trees must have been 150–350 years old. It also indicates that there were at least some areas of underwood in the park – a layer of shrubby trees, most notably hazel, that would have been protected from the deer and managed for the products it supplied. Establishing the age of veteran trees is a popular pastime for the many visitors to the park. However, their significance lies in their condition and the habitats they support. The relative age of veteran trees also differs between species. It is for these reasons that the accepted definition of a veteran tree is 'a tree that is of interest biologically, culturally or aesthetically because of its age, size or condition'. Of the greatest significance is the number of trees the park supports – offering continuity of habitats by having several specimens in close proximity to one another. Veteran and hollowing trees support abundant wildlife, associated with their decaying wood. In contrast, tall, straight trees grown for sound timber are at an optimal stage for felling when they contain as much sound heartwood as possible – just before the decaying/hollowing process takes place. There are around 1,000 veteran oak trees across the whole park, with good concentrations in High Wood and Queen Elizabeth Plantation. There are a few hundred veteran hawthorns, with good examples to be found on the west-facing slopes between Ham and Kingston Gates. Other veteran tree species include field maples, ash, hornbeam and the very unusual black poplar. Today the veteran pollards

have oversized and heavy limbs. It is possible to see where limbs have fallen off, often with detrimental effects on the longevity of the tree. Although they are no longer managed for timber production, it is necessary to conserve them as cultural and biological assets.

Woodlands are well defined in Richmond Park as areas that were enclosed by a fence to protect a large number of trees from deer. In the parkland, the low density of trees was given individual protection while the deer roamed among them. As described previously, many of the woodland blocks are around 200 years old and were planted under the management of Henry Addington, Viscount Sidmouth. He would have selected species of trees to supply timber or bear large seeds that would feed the deer. In the early eighteenth century, timber was a valuable commodity, as world trade depended upon ships built from it. Each ship would require around 3,000 trees – 50 acres of mature oak woodland. Richmond Park followed the national trend to create woodlands but, by the late eighteenth century, shipbuilding favoured steel, and the management of oak woodland became less profitable – sparing the Richmond Park woodlands from the axe. These 200-year-old trees are often found as tall, single-stemmed mature trees that are starting to show signs of age and are undergoing the natural processes that produce dead wood and hollowing not offered by younger trees.

The park has little room for any new large-scale plantations, but tree planting continues to maintain continuity of woodland areas and replace lost trees. The health of the park's trees varies between species and the evidence is clear that some are not faring very well. All mature elms were lost in the park when nationally they were ravaged in the late twentieth century by Dutch elm disease. Elms do survive in the park but only as 'suckers' – young growth from underground roots. Most trees tend to suffer from a modern unhealthy lifestyle. The compound effects of air pollution, climate change, root compaction, pathogens such as mildew and non-native insects,

and squirrel and bird damage all take their toll. Of particular concern are the horse chestnuts and English oaks. They are surviving in Richmond Park and some are still flourishing, but the number of trees with poor growth and sparse crowns is a concern to many. The trees in the park will always survive, although the composition of species and variation in cover may alter a little over time. The quintessential image of the treetops is safe. Each human generation has good intent when they claim to manage this landscape, but trees are long-lived and their presence is humbling. Woodland colour illuminates the changing seasons and creates a year-round rhythm for the daily visitor. As W. H. Auden wrote, 'A culture is no better than its woods.'[8] Finally, although it is not renowned for its flora, Richmond Park has some surprising and subtle gems, particularly the mosaic of plants associated with the predominantly acid soil. The majority of these plants are native to the British Isles and have arrived in the park unaided, with over 450 species recorded.

The former Royal Parks Head of Ecology, Dr Nigel Reeve, sums up the park in relation to its exemplary ecology:

> The park as it is today is not a pristine wilderness, but a collage of many changes and influences over the years. In the future, its resilience and that of its wildlife communities will be tested by increasing human demands and by environmental changes, including climate change.

# Captured in Art

Richmond Park has been captured in art since as early as the seventeenth century, from landscape paintings to more contemporary railway posters. The earliest is an oil painting, *The Carlile Family with Sir Justinian Isham in Richmond Park* by Joan Carlile (1600–79), who lived at Petersham Lodge, and is held at Lamport Hall in Northamptonshire. Her father was a Royal Parks official. She married Lodowick Carlile in 1626; he was keeper and deputy ranger at the park, and so had accommodation at Petersham Lodge. Joan died four years after her husband, in 1679, and was buried next to him. Her other most noteworthy painting in relation to Richmond Park was a portrait of Sir Lionel Tollemache, who later became ranger of the park, with his wife and sister-in-law.

Into the eighteenth and nineteenth centuries, a number of paintings were produced. Peter Tillemans' *View of Richmond Park from Twickenham Park*, painted in around 1720, is in the British Government Art Collection. Peter Tillemans (1684–1734) was a Flemish painter and one of the founders of the English school of sporting painting. He lived in England from 1708 until he died on 5 December 1734. He produced several

paintings of Richmond, including *A View of Richmond from Twickenham Park* and *A View from Richmond Hill and The Thames at Twickenham*, which was commissioned by either Alexander Pope or John Robartes. *The Thames from Richmond Hill* was one of three paintings for the Earl of Radnor.

A portrait by T. Stewart in 1758 of *John Lewis, Brewer of Richmond, Surrey*, whose legal action forced Princess Amelia to reinstate pedestrian access to the park, is in the Richmond-upon-Thames Borough Art Collection, and on display in Richmond Reference Library. Stewart was a pupil of Sir Joshua Reynolds.

Joseph Allen's *Sir Robert Walpole (1676–1745), 1st Earl of Orford, KG, as Ranger of Richmond Park (after Jonathan Richardson the Elder)* is in the collection of the National Trust, and is held at Erddig, Wrexham. Allen was born in Lambeth, and worked in Taunton for some time. When he decided to become a painter, he worked as an assistant to a picture dealer and as a painter of theatre backdrops.

Artist and caricaturist Thomas Rowlandson's drawing *Richmond Park* is at the Yale Center for British Art. He was born in Old Jewry, but later moved to Yorkshire. His aunt paid for him to go to school.

*The Earl of Dysart's Family in Richmond Park* by William Frederick Witherington (1785–1865) is in the Hearsum Collection. Several oil paintings have been added to the continually growing Hearsum Collection, which is being catalogued by the Friends of Richmond Park volunteers before making it accessible to the public. These paintings are mainly nineteenth-century landscapes, showing scenes in and around Richmond Park. Several of the Hearsum Collection paintings are by James Isaiah Lewis (1861–1934), a prolific local artist. Selling paintings – often to local pubs – was his livelihood. He regularly painted small pictures in pairs, finding these popular with local newlyweds. Lewis died a poor man, but now his pictures are prized in collections in

the USA, Japan and Germany, along with those few now back in Richmond Park.

*Landscape: View in Richmond Park*, painted in 1850 by the English Romantic painter John Martin is at the Fitzwilliam Museum in Cambridge. Born in Northumberland, he became an apprentice of heraldic painting, and was later apprenticed to an Italian artist. When he was nineteen, he got married and worked as an artist. One of his paintings was hung in the Royal Academy in 1811, and he continued to produce oil paintings.

William Bennett's watercolour *In Richmond Park* was painted in 1852, and is held by Tate Britain. He died in 1871.

John Buxton Knight's *White Lodge, Richmond Park*, painted in 1898, is in the collection of Leeds Museums and Galleries. One of his paintings was hung at the Royal Academy in 1861.

The twentieth century saw many more paintings and artwork captured of the park. Spencer Gore's painting *Richmond Park*, thought to have been painted in the autumn of 1913 or shortly before the artist's death in March 1914, was exhibited at the Paterson and Carfax Gallery in 1920, and later across Europe. It is now in the collection of the Tate Gallery under its original title but is not currently on display. The painting is one of a series of thirty-two landscapes painted in Richmond Park during the last months of Gore's life. According to Tate curator Helena Bonett, Gore's early death from pneumonia at the age of thirty-six was brought on by his painting outdoors in Richmond Park in the cold and wet winter months. It is not certain where in the park the picture was made but a row of trees close to the pond near Cambrian Gate has a very close resemblance to those in the painting. Another Gore painting with the same title (*Richmond Park*), painted in 1914, is at the Ashmolean Museum and *Wood in Richmond Park* is in the Birmingham Art Gallery's collection.

The oil painting *Autumn, Richmond Park* by Alfred James Munnings is at the Sir Alfred Munnings Art Museum in

Colchester. He tended to paint rural scenes (being particularly renowned for his pictures of horses), and was associated with the Newlyn School.

Chinese artist Chiang Yee wrote and illustrated several books while living in Britain. *Deer in Richmond Park* is Plate V in his book *The Silent Traveller in London*, published in 1938.

Henry Moore's oil painting *In Richmond Park* is in the collection of the York Museums Trust and shows cattle grazing under one of the many veteran oak trees in the park with one of the ponds in the background. Similarly, *Richmond Park No 2* by the English Impressionist painter Laura Knight shows two ancient trees in the park and is at the Royal Academy.

Trees feature heavily once again in further works. Kenneth Armitage (1916–2002) made a series of sculptures and drawings of oak trees in Richmond Park between 1975 and 1986, including *Richmond Park: Tall Figure with Jerky Arms* which is currently held at the British Embassy in Prague.

A significant number of posters have also been produced and specifically by the Underground Electric Railways Company. These include *Richmond Park*, designed by Charles Sharland, which is at the London Transport Museum. The London Transport Museum also holds a District Line poster; *Richmond Park* by Arthur G. Bell; *Richmond Park by Tram* by Charles Sharland; *Richmond Park* by Harold L. Oakley; *Natural History of London; No. 3, Herons at Richmond Park* by Edwin Noble; *Rambles in Richmond Park* by Freda Lingstrom; *Richmond Park for Pleasure and Fresh Air* by an unknown artist; *Richmond Park* by Charles Paine; *Richmond Park; Humours No. 10* by Tony Sarg; *Richmond Park* by Emilio Camilio Leopoldo Tafani; *Richmond Park* by the artist Dame Laura Knight; *Visit the Royal Deer Park; Richmond Park Charles I* by Austin Cooper; and *Richmond by District Line* by M. Entwistle.

Still popular with local artists, the park in the twenty-first century is the inspiration for local, national and international

photographers, such as Joanna Jackson, Steve Morgan and National Geographic photographer Alex Saberi, a photographer who rose every day before dawn for a year to unlock the secret world of Richmond Park's majestic wildlife. The stunning scenes, which occur right under the noses of the 8 million people living in the capital, are incredible.

# The Rangers
# of Richmond Park

Throughout this book there has been continued reference to the rangers and the position as ranger of Richmond Park. As discussed previously, the office of ranger was much sought after, especially by the younger sons of noblemen. The medieval tradition of granting the keepership of a royal park to a member of the nobility or a high-ranking member of the court or household was one which survived until the beginning of the twentieth century. It was a position of honour and great importance. The first ranger of Richmond Park, selected by Charles I on its enclosure, was Jerome, Earl of Portland, the son of Sir Richard Weston of Mortlake Park, as 'Keeper of His Majesty's New Park near Richmont' in June 1637. It was not until a few years later that the title of the office was changed to ranger. The role of ranger throughout the history of Richmond Park should not be underestimated and they are summarised below:

**1637–49**, Jerome Weston, Earl of Portland.

Certificate to the Committee of the Revenues, that King Charles, by letters patent under the Great Seal, dated 15 June

1637, granted to Jerome, Earl of Portland, the keepership of
the New Park in Richmond, Surrey, with the fee of 12*d*. per
diem, besides wood, pasture for four horses, etc., for the term
of his life.

In 1650 he is referred to as having been the 'Cheife Raynger'.

**1649–60,** the Corporation of the City of London was
appointed on the beheading of Charles I on 30 January 1649.
It was resolved in the House of Commons on 30 June 1649
'that the City of London have the New Park, in the County
of Surrey, settled upon them, and their Successors, as an Act
of Favour from this House, for the Use of the City, and their
Successors: And that an Act be brought in to that Purpose'.
The Act was brought in and passed on 17 July 1649.
Although other officials of the staff were retained in office,
the Earl of Portland, who had been a royalist, was heavily
fined, and lived peacefully at Walton-on-Thames during the
Commonwealth. He died in 1663. On the restoration of
Charles II, the Corporation of the City of London, in their
Common Council on 7 May 1660, passed the following
order:

> That the Right Honourable the Lord Mayor doe at the first
> opportunity of His Majestyes comeinge to this City in the
> name thereof and of this Court, present the newe Parke to his
> Majesty and informe his Majesty that this Citty hath beene
> only his Majestyes stewards for the same.

**1660–73,** Sir Lionel Tollemache, Bart, and his wife, the
Countess of Dysart, followed. 'Grant with survivorship to Sir
Lionel Tollemache, Bart., and Elizabeth his wife, Countess of
Dysart, of the office of keeping the New Park, Richmond, Co.
Surrey, and overseeing and preserving the Deer there; fee 1/- a
day.' Also noted in August 1660: 'Grant to Sir Daniel Hervey,
in reversion after Sir Lionel Tollemache and his Lady, of the

custody of the New Park near Richmond.' Tollemache died in France in 1669, and his widow remarried, on 17 February 1672, in Petersham church, the Right Hon. John, Earl (later Duke) of Lauderdale.

**1673–82**, John Maitland, 1st Duke of Lauderdale was appointed 'for his life of the custody of the New Park, near Richmond, with the lodges, walks, etc.'. His great seal of appointment was dated 30 May 1673, and he received 6s a day. Although he probably received the appointment through his wife, she is not mentioned in the grant, and by this time Sir Daniel Hervey, who had the reversion, was dead. The Duke of Lauderdale died in August 1682, and his wife in June 1698.

**1683–1711**, Laurence Hyde, 1st Earl of Rochester, was appointed as ranger, and in 1702 Queen Anne, his niece, granted the position of ranger to him for a further two generations. He died in May 1711, and his son Henry succeeded him.

**1711–27**, Henry Hyde, Earl of Clarendon and 2nd Earl of Rochester, with the concurrence of his son, Lord Cornbury, sold the remainder of the term to George II for £5,000; the king appointed, on 3 October 1727, Robert Walpole.

**1727–51**, Robert Walpole, 2nd Earl of Orford, the son of Sir Robert Walpole, the Prime Minister. The latter was made joint ranger on 7 May 1740, and died on 18 March 1745. The son died on 31 March 1751.

**1751–61**, Princess Amelia, daughter of George II, the controversial ranger who restricted all access to Richmond Park, sold her interest to George III, who bestowed it on 23 June 1761 to the 3rd Earl of Bute.

**1761–92**, John Stuart, 3rd Earl of Bute, held it until his death on 10 March 1792.

**1792–1814**, George III took on the position of ranger himself. In 1814 the Prince Regent, afterwards George IV, appointed his sister.

**1814–35**, Princess Elizabeth was ranger, and was married in 1818 to Landgrave of Hesse-Homburg. She was succeeded on 29 August 1835.

**1835–50**, Adolphus Frederick, 1st Duke of Cambridge had the custody and management of game and deer, and the appointment of all park keepers, gamekeepers, and gatekeepers, as well as their allocation to lodges and houses. However, he had no authority over the timber, and was not responsible for the maintenance of houses, walls, gates, or roads. He received 6s a day, three bucks and three does in each season, and the right to pasture cows. He held the position until his death in 1850, and was succeeded on 12 November 1850.

**1850–7**, Princess Mary, Duchess of Gloucester, fourth daughter of George III, held it to her death in 1857.

**1857–1904**, George, 2nd Duke of Cambridge was appointed on 13 July 1857. On his death, King Edward VII resumed into his hands the duties, rights and powers of the ranger, and ultimately entrusted the whole care of the park to the Commissioners of Works.[1]

Since 1904, the park, along with the other Royal Parks, has been under the direct control of central government, but under the day-to-day auspices of a park superintendent. The park superintendent manages Richmond Park day to day, overseeing the maintenance of landscape, woodland, roads and buildings; managing the deer herds; servicing and clearing up after human users; and occasionally having time to start new projects. In 2013, he had eight staff and oversaw

140 contracted staff. The official title is now park manager, but most people still use the term 'superintendent'.

Richmond Park has had eight superintendents since 1904; clearly it is a job that its holders enjoy. The longevity and expertise built up by these superintendents is vital in a park where thinking has to be long-term, and who would blame them for wanting to stay in such a post for so many years? Those lucky enough to hold this important position are, from 1904–19, S. Pullman; 1919–27, Benjamin Wells; 1928–31, R. W. L. Lucas; 1931–51, A. E. Wilson; 1951–71, George Thomson MVO; 1971–90, Michael Baxter Brown; 1990–7, Michael Fitt; and from 1997 onwards, Simon Richards.

# Richmond Park Today

Hunter Davies, writing in 1983, describes Richmond Park as

> different ... you don't find any statues, or museums or stately
> homes to visit, and few of those neat little tarmac paths for
> pedestrians which criss-cross other London Parks. Throughout
> most of it, you are on your own, walking on un-made tracks
> which look little more than wide sheep tracks. Richmond Park
> is more natural than so many so called countryside areas of
> England, at least outside the National Parks.

He advises to 'bring your wellies'.[1] At the time of his visit,
Michael Baxter Brown was park superintendent; he is
described as a 'lean, rather sombre Scotsman'. With a staff
of seventy to manage and maintain the park, the bane of his
life is road traffic through the park, and he estimates that
between thirty and thirty-five deer a year are injured or killed
through motor-car accidents, although deer themselves will
often rush out in front of cars when being chased by dogs,
as was witnessed in the YouTube sensation of Fenton the
Labrador in 2011, which had nearly 10 million 'hits' by 2013.
Speeding motorists and cyclists in Richmond Park are no new

phenomenon; it was just the same a century ago. In the early 1900s the speed limit in the park was 10 mph, and the park keepers (not the police) hauled offenders before the County Magistrates in Kingston for speeding. In one year, 1907, three motorists were fined £3 each for driving at 19 mph, 20 mph and 21 mph. Another motorist was prosecuted for towing a bicycle in the park at 22 mph; both motorist and cyclist were fined. When a young Chelsea cyclist was prosecuted for speeding, a letter from the defendant's father admitted that his son's speed had been 20 mph. He was fined £3, plus costs. Speeding was not the only ground for prosecution – one motorist was prosecuted for giving driving instruction 'against a Park by-law'; the Bench dismissed this as a first offence and imposed 8s 6d costs. A Richmond motorist was prosecuted for 'allowing visible vapour to issue from a motor car'; according to the park keeper, 'the defendant puffed smoke for 300 yards and completely smothered the road'. The offending driver paid his 5 shilling fine, said he had now adjusted the lubricator and added, 'I thank the keeper for his observation.'[2]

To return to Hunter Davies's walk in Richmond Park, he describes the solitude he finds, and having the whole wood to himself as he enters Isabella Plantation, a 'secret forest no one else knew about'.

In a central London Park, you can *feel* alone at certain times, but a few yards ahead, round the bend, behind that tree, there is always the chance of meeting someone face to face. In Richmond, the skies do seem enormous and the Park appears to stretch away for ever. With careful timing, you could bring Charles I back for an hour or two and persuade him nothing had changed since 1637 ... almost! Those occasional aeroplanes (now constant) overhead would have to be explained as God playing tricks, hanging toys from the sky, and those strange blocks on the horizon must be your imagination playing tricks, creating castles in the air.[3]

However, Richmond Park today is under pressure. Over the last fifty years, the wildlife in the park has declined measurably. The brown hare was last seen in 1972, driven away by increasing dog numbers (the hare lives entirely above ground, unlike the rabbit), and hedgehogs and water shrews have also disappeared. We have lost sheep, which grazed alongside deer, but that was a deliberate decision by park management, who are now experimenting with introducing cattle. The Richmond Park Bird Group's annual bird counts show the complete loss of breeding pheasants, the grey partridge, woodlark, tree pipit, redstart, house and tree sparrow, linnet, bullfinch and yellowhammer, and the major decline of the willow warbler, spotted flycatcher and meadow pipit. Some have been gained as breeding species, most of them 'urban' birds – mandarin duck, red-crested pochard, Egyptian goose, common tern, collared dove and, of course, the ring-necked parakeet. Many park users continue to have concerns over the effect of traffic and increased visitor numbers on biodiversity and the ecology of the park, along with concerns over the effects of climate change.

> Signals abound that the loss of life's diversity endangers not just the body but the spirit ... The ethical imperative should therefore be, first of all, prudence. We should judge every scrap of biodiversity as priceless while we learn to use it and come to understand what it means to humanity. (Edward O. Wilson, 1992)

In 2014, to manage Richmond Park, the largest enclosed urban park in Europe, a total of eight people are directly employed by the Royal Parks and are based at Holly Lodge. Along with the park superintendent, there are assistant park managers, wildlife officers and support staff. Their duties, unlike their predecessors, now include managing events and filming, education, community development, ecology and arboriculture. Richmond Park is, however, a substantial

employer, primarily through outsourced services, which keep the park functioning on a day-to-day basis. This includes traditional horticultural operations, such as planting, watering and aftercare of young trees, spring and summer seasonal and herbaceous planting, maintenance of paths and ditches, sports pitch maintenance, mowing, hay cutting, bracken rolling and cutting, and small landscape improvements. More mundane tasks include clearing the litter and all the other detritus left by the millions of visitors to the park. Contractors are also employed to maintain the built fabric of the park, including the boundary wall and lodges. There are 8 miles of roads and car parks that support 10 million cars using the park annually, with 90 per cent of them using it as a thoroughfare. Other service contractors carry out the toilet cleaning and gate locking, and there are highly skilled arboricultural teams who have developed a specialism for working on the park's ancient trees. Pembroke Lodge is now the largest operation in the park, with catering a major output, as well as the busiest wedding venue in West London, operating up to eighteen hours a day, seven days a week, at peak times.

Volunteers play a major part in the management and operation of Richmond Park today. The Friends of Richmond Park staff the visitor centre, lead walks and work on conservation projects along with the Richmond Park Wildlife Group. Despite the current pressures, the park today is a magical place. As eighteenth-century poet James Thomson wrote,

> Ye, who from London's smoke and turmoil fly
> To seek a purer and a brighter sky...

It may be a noisier sky but it is a place to come back to time and time again, and has been and continues to be captured in art, photography and literature. Celebrated children's author Jacqueline Wilson, who lives locally, describes it as 'heavenly on a warm summer's day when you hear a skylark overhead,

and magical in the depths of winter when the ponds are frozen over and children are sledging down the hills', as well as mentioning her experiences of climbing inside the ancient oaks as a child. Those ancient oaks are described by Francis Kilvert in his diary in 1876 as 'those grey, gnarled, low browed, knock kneed, bowed, bent, huge, strange, long armed, deformed, hunch backed, misshapen oak men that stand waiting and watching, century after century'.

However, it is local author Joanna Jackson in her book *A Year in the Life of Richmond Park* who describes the legacy of Richmond Park.

When Charles I created Richmond Park in 1637 by enclosing the area with a brick wall, he made himself very unpopular with the locals; but nearly four hundred years later all the people who enjoy the park are reaping the benefit of his arrogance, for it guaranteed that this vast and unique area was left untouched by development. There is no doubt that if the wall had not been erected Richmond Park would now be just another built up area of houses and shops. Instead the enclosure of the park has allowed the ancient oaks and dry acid grasslands to provide a rich and varied habitat for many animals, birds and insects; and, in turn, people from an overcrowded city have a wonderful place to visit. This haven for wildlife and peaceful recreation, only ten miles from the heart of London, is one of the largest green areas in any city in the world.[4]

As Richard Church is quoted saying in the introduction, Richmond Park is 'a great repository of history, and especially Royal history, the tale of our kings and queens, and the part they have played in the growth of our democratic way of life'.

# Notes

## 1 Early Days and the Pre-Enclosure Commons: The Medieval Parks

1   Lasdun, Susan, *The English Park, Royal, Private and Public*; Andre Deutsch Ltd, London, 1991.
2.  Hart, C., *The Vederers and the Forest Laws of Dean*; David and Charles, 1971.
3.  Rackham, Oliver, *Trees and Woodland in the British Landscape – The Complete History of Britain's Trees, Woods & Hedgerows*; Orion Books Ltd, London, 1996.
4.  Lasdun, Susan, *The English Park, Royal, Private and Public*; Andre Deutsch Ltd, London, 1991.
5.  *Ibid.*
6.  Sir H. Ellis, *A General Introduction to Domesday Book* (2 Vols, Public Commission of Public Records, 1833), Vol 1, p. 231.
7.  Lasdun, Susan, *The English Park, Royal, Private and Public*; Andre Deutsch Ltd, London, 1991.
8.  PRO, Calendar of the Close Rolls 1468–76 (Vol. 2) (HMSO, 1953), No. 209, p. 55.

9. Revd W. J. B. Kerr, *op. cit.*, p. 151: 'The entire circuit of the Park extending to a little over three and a half miles was fenced by a ditch and dead hedge.'

10. Rackham, Oliver, *op. cit.*, *Ancient Woodland*, p. 181.

11. W. H. Holdsworth, *A History of English Law*, Vol. 1; Methuen, 1922.

12. Lasdun, Susan, *The English Park, Royal, Private and Public*; Andre Deutsch Ltd, London, 1991.

13. Beresford, M., *History on the Ground*; Lutterworth Press, 1957.

14. Lasdun, Susan, *The English Park, Royal, Private and Public*; Andre Deutsch Ltd, London, 1991.

15. *Ibid.*

16. Moryson, F., *An Itinerary: Containing His Ten Years Travel Through Twelve Dominions*, divided in 3 parts; J. Beale, 1617, Pt 3, p. 147.

17. Hoskins, W. G., *The Making of the English Landscape*; Hodder and Stoughton, 1955.

## 2 Richmond Park: A Royal Hunting Ground

1. Cloake, John, *Richmond Palace – Its History and Its Plan*; Richmond Local History Society, 2000.

2. *Ibid.*

3. *Ibid.*

4. *Ibid.*

5. *Ibid.*

6. *Ibid.*

7. *Ibid.*

8. Calendars of Patent Rolls, 1436–41.

9. Fletcher Jones, Pamela, *Richmond Park, Portrait of a Royal Playground*; Phillimore, Chichester, 1972.

10. Baxter Brown, Michael, *Richmond Park – The History of a Royal Deer Park*; Robert Hale, London, 1985.

11. Hyde, Edward, Earl of Clarendon, *The History of the Rebellion*, Edited by W. Dunn Macray, Vol i, 1888.

12. Collenette, C. L., *A History of Richmond Park*; Sidgwick & Jackson Ltd, London, 1937.

13. Manning and Bray, *History and Antiquities of the County of Surrey*, Vol. 1.

14. *Ibid.*

15. State Papers, Dom. Ser., 1635.

16. State Papers, Dom. Ser., 1636–7, Vol. cccxliv, 98.

17. *Monarchy and the Chase*; Sabretache, p. 83.

18. *Two Historical Accounts of the Making of the New Forest in Hampshire by King William the Conqueror, and Richmond New Park by King Charles the First*; 1751.

19. Collenette, C. L., *A History of Richmond Park*; Sidgwick & Jackson Ltd, London, 1937.

20. Public Record Office, Ref. Work 5-176/4.

21. Nelson, Sir Thomas J., *Richmond Park, Extracts from the Records of Parliament and the Corporation of London.*

22. Baxter Brown, Michael, *Richmond Park – The History of a Royal Deer Park*; Robert Hale, London, 1985.

23. Hore, J. P., *History of the Royal Buckhounds*; Newmarket, 1895.

24. Collenette, C. L., *A History of Richmond Park*; Sidgwick & Jackson Ltd, London, 1937.

25. *Ibid.*

26. Corporation of London Record Office, Repertories of the Court of Aldermen for the Corporation, Repertory 60, f. 66, f. 796–80, f. 135b, f. 181.

27. Corporation of London Record Office, Journal of the Common Council, Journal 41, f. 83b.

28. Collenette, C. L., *A History of Richmond Park*; Sidgwick & Jackson Ltd, London, 1937.

29. Repertory Vol. 61, f. 218, 13 September 1651.

30. Repertory Vol. 63, f. 204b, 7 November 1654.

31. Repertory Vol. 62, ff 318b and 354, 21 June and 5 July 1653.
32. Common Council Journal 41*, f. 232b, 7 May 1660.
33. *Ibid.*, f. 234b, 2 June 1660.
34. CSP Dom 1660–1, p. 142.
35. Collenette, C. L., *A History of Richmond Park*; Sidgwick & Jackson Ltd, London, 1937.
36. CSP Dom 1660–1, p. 210.
37. Calendar, Treasury Books, Volume I, 1660–7, p. 424 (Early Entry Book 3, p. 437, 6 September 1662).
38. CSP Dom 1663–4, p. 75.
39. CSP Dom 1666–7, p. 569.
40. Calendar, Treasury Books, Volume II, 1667–8, p. 641.
41. Calendar, State Papers, Domestic, Charles II, undated papers 1668 (SP Dom., Car. 11, 251, No. 144).
42. Calendar, Treasury Books, Volume III, Part I, 1669–72, p. 146.
43. Baxter Brown, Michael, *Richmond Park – The History of a Royal Deer Park*; Robert Hale, London, 1985.
44. CSP Dom, 1673, p. 223.
45. Calendar, Treasury Books, Volume III, Part II, 1669–72, p. 782 (Early XVA, pp. 107, 139–40, 8 February 1671).
46. Calendar, State Papers, Domestic, Charles II, 1676–7, 17 November 1676 (Home Office Warrant Book I, p. 226).
47. Calendar, Treasury Books, Volume VI, 1679–80, p. 550 (Out Letters, General, p. 512, 24 May 1680).
48. Fletcher Jones, Pamel, *Richmond Park, Portrait of a Royal Playground*, p. 24.
49. CSP Dom, 1685–9, ii, p. 752.
50. CTB XIV, 1698–9, p. 154; CRES 6/20, p. 212.
51. CTB 1698–9, p. 259.

## 3 Eighteenth-Century Developments

1. Calendar, Treasury Books, Volume XXX, Part II, 1716, p. 281 (Ref. Book IX, p. 280, 14 June 1716).
2. E367/4177.
3. *A History of Richmond New Park* by 'a resident', 1877, p. 57, quoting *Reed's Weekly Journal* for 7 October 1721.
4. CTBP II, p. 41 No. 118; CRES 38/1786.
5. E367/4346; CTBP II, p. 531, No. 14.
6. CTP VI, p. 204.
7. Walpole, H., *Reminiscences* (1788), ed. P. Toynbee; Clarendon Press, Oxford 1924, p. 16.
8. HKWV, p. p230–2, quoting WORK 4/3, 4/4, 5/57, 5/141 and 6/15, and T56/18, pp. 245, 300; see also *CTBPI*, pp. 72 and 82.
9. Cloake, John, *Palaces and Parks of Richmond and Kew, Volume II: Richmond Lodge and the Kew Palaces*; Phillimore & Co. Ltd, Chichester, 1996.
10. *Ibid.*
11. The Works of the Right Honourable Lady Mary Wortley Montagu, ed. J. Dallaway, Volume III.
12. Cundall, H. M., *Bygone Richmond*.
13. Collenette, C. L., *A History of Richmond Park*; Sidgwick & Jackson Ltd, London, 1937.
14. Hore, J. P., *History of the Royal Buckhounds*; Newmarket, 1895.
15. *Two Historical Accounts of the Making of the New Forest ... and Richmond New Park*; London 1751, pp. 58–9.
16. *Two Historical Accounts*, pp. 63–4. The author of the book may well have been John Lewis.
17. Calendar, Treasury Books, Volume II, 1731–4, p. 387.
18. Baxter Brown, Michael, *Richmond Park – The History of a Royal Deer Park*; Robert Hale, London, 1985.
19. *Two Historical Accounts*, p. 67.

20. Walpole, H., *Correspondence*, XX, p. 322.
21. *Post Boy*, 28 July 1752.
22. *Merlin's Life and Prophecies*, pp. 62–72.
23. *A Tract on the National Interest*, 1757, pp. 31–5.
24. *Memoirs of the Life of Gilbert Wakefield, Written by Himself*, 1804, I, p. 260.
25. *HKWV*, p. 232.
26. Walpole, H., *Reminiscences*, p. 17 note.
27. Cloake, John, *Palaces and Parks of Richmond and Kew, Volume II: Richmond Lodge and the Kew Palaces*; Phillimore & Co. Ltd, Chichester, 1996.
28. WORK 5/142; 1/3, p. 156.
29. Hore, J. P., *History of the Royal Buckhounds*; Newmarket, 1895.
30. Jesse, Edward, *Gleanings in Natural History*, Volume I, pp. 136–7, 4th ed.
31. *Letters from George III to Lord Bute*, ed. R. Sedgewick; London 1939, p. 237, No. 333.
32. *Letters and Journals of Lady Mary Coke*, ed. J. A. Home, Edinburgh, 1889–96, I, p. 61.
33. Lady Mary Coke, *op. cit.*, IV, p. 408.
34. Revd Daniel Lysons, *The Environs of London*, Vol. I, Surrey, 1792, pp. 456–7. Lysons explained that, under the Flemish system, 'two horses only are used in ploughing, and the lands are cultivated for alternate crops for man and beast'.
35. WORK 16/212.
36. Cloake, John, *Palaces and Parks of Richmond and Kew, Volume II: Richmond Lodge and the Kew Palaces*; Phillimore & Co. Ltd, Chichester, 1996.
37. WORK 16/212.
38. CRES 38/1786.
39. Cloake, John, *Palaces and Parks of Richmond and Kew, Volume II: Richmond Lodge and the Kew Palaces*; Phillimore & Co. Ltd, Chichester, 1996.

40. Baxter Brown, Michael, *Richmond Park – The History of a Royal Deer Park*; Robert Hale, London, 1985.
41. *Ibid.*

## 4 The Nineteenth Century

1. Pellew, George, *Life and Correspondence of Henry Addington, First Viscount Sidmouth*, I, p. 410.
2. Pellew, *op. cit.*, pp. 608–10; Philip Zeigler, *Addington*, London 1965, p. 128.
3. Repton, H., *Fragments on the Theory and Practice of Landscape Gardening*, 1816, pp. 83–5.
4. Soane's account book 1781–86.
5. Cloake, John, *Palaces and Parks of Richmond and Kew, Volume II: Richmond Lodge and the Kew Palaces*; Phillimore & Co. Ltd, Chichester, 1996.
6. *Ibid.*
7. *Ibid.*
8. Collenette, C. L., *A History of Richmond Park*; Sidgwick & Jackson Ltd, London, 1937.
9. *Ibid.*
10. CRES 38/1790; WORK 16/4/9.
11. Cloake, John, *Palaces and Parks of Richmond and Kew, Volume II: Richmond Lodge and the Kew Palaces*; Phillimore & Co. Ltd, Chichester, 1996.
12. *Ibid.*
13. *The Diary of HM Shah of Persia During His Tour Through Europe in 1873*, trs. J. W. Redhouse; London, 1874.
14. *History of Richmond New Park*, 1877, p. 50.
15. Sawyer Family Papers. Diaries of James Sawyer, Head Keeper, Richmond Park, 1825–70.
16. *History of Richmond New Park*, pp. 45–7.
17. Collenette, C. L., *A History of Richmond Park*; Sidgwick & Jackson Ltd, London, 1937.

18. Baxter Brown, Michael, *Richmond Park – The History of a Royal Deer Park*; Robert Hale, London, 1985.
19. Robert Hartmann, *The Remainder Biscuit*; Andre Deutsch, London, 1964.
20. Baxter Brown, Michael, *Richmond Park – The History of a Royal Deer Park*; Robert Hale, London, 1985.
21. *Ibid.*
22. Sawyer Family Papers. A letter from Henry Sawyer of Petworth Park to James Sawyer of Richmond Park, 25 February 1798.
23. *Ibid.*
24. Baxter Brown, Michael, *Richmond Park – The History of a Royal Deer Park*; Robert Hale, London, 1985.
25. *Ibid.*

## 5 A Medieval Park into the Millennium

1. Fletcher Jones, Pamela, *Richmond Park*, pp. 37–8.
2. Baxter Brown, Michael, *Richmond Park – The History of a Royal Deer Park*; Robert Hale, London, 1985.
3. Public Record Office, Ref. Work 16–408, Report on the Deer Herds of Richmond Park, dated 30 April 1907.
4. Baxter Brown, Michael, *Richmond Park – The History of a Royal Deer Park*; Robert Hale, London, 1985.
5. *Ibid.*
6. *Ibid.*
7. Collenette, C. L., *A History of Richmond Park*; Sidgwick & Jackson Ltd, London, 1937.
8. Public Record Office, Ref. Work 16–1061, Richmond Park, Annual Report on Deer, April 1916.
9. Public Record Office, Ref. Work 16–547, Correspondence between Sir Lionel Earl, Commissioner of Works, and Sir Derek Keppal, Master of the Royal Household, May 1918.
10. *Ibid.*

11. Memorandum from Park Superintendent, 2 February 1922.
12. Baxter Brown, Michael, *Richmond Park – The History of a Royal Deer Park*; Robert Hale, London, 1985.
13. A letter from Sir Lionel Earle to the owners of various deer parks dated 23 October 1922.
14. Baxter Brown, Michael, *Richmond Park – The History of a Royal Deer Park*; Robert Hale, London, 1985.
15. *Ibid.*
16. McDowall, David, *Richmond Park, The Walker's Historical Guide*, 1996.
17. http://www.stmgrts.org.uk/archives/2011/03/the_phantom_in_richmond_park.html.
18. Baxter Brown, Michael, *Richmond Park – The History of a Royal Deer Park*; Robert Hale, London, 1985.
19. *The Surrey Comet*, 11 February 1956.
20. McDowall, David, *Richmond Park, The Walker's Historical Guide*, 1996.
21. Baxter Brown, Michael, *Richmond Park – The History of a Royal Deer Park*; Robert Hale, London, 1985.
22. *Ibid.*
23. Karter, John, ed., *Guide to Richmond Park*; London, 2011.
24. Baxter Brown, Michael, *Richmond Park – The History of a Royal Deer Park*; Robert Hale, London, 1985.

# 6 Artefacts and Architecture of Richmond Park

1. *Buildings and Monuments in the Royal Parks*, the Royal Parks, 1997.
2. The Wren Society, Vol. XVIII.
3. AL7224/4, AL3275/6, AL7203/1, Work 16/1496, District Works Office, Richmond Public Library Collection.
4. Richmond Park – Historical Survey, 1983, Artefacts

Schedule, Land Use Consultants.

5. *Ibid.*
6. AL 7232/1, AL 7209/26 District Works Office, Richmond Public Library Collection.
7. AL 7232/1 District Works Office, Richmond Public Library Collection.
8. Rapp 5348 (186).
9. AL 7232/1 District Works Office, Richmond Public Library Collection.
10. PRO.MB.
11. AL 3547/1 Pt 2.
12. Collenette, C. L., *A History of Richmond Park*; Sidgwick & Jackson Ltd, London, 1937.
13. *History of Richmond Park* by a resident.
14. Investigation into Ancient Underground Waterways. DAMHB, 1972.
15. Collenette, C. L., *A History of Richmond Park*; Sidgwick & Jackson Ltd, London, 1937.
16. *Ibid.*
17. *Ibid.*
18. Richmond Park – Historical Survey, 1983, Artefacts Schedule, Land Use Consultants.
19. Russell, Bertrand, *The Autobiography of Bertrand Russell 1872–1914*; George Allen & Unwin Ltd, London (1967), p. 19.
20. McDonnell, Colleen, 'Philosophy behind ambitious restoration', *Richmond and Twickenham Times* (28 October 2005).

# 7 The Ecology and Wildlife of Richmond Park

1. Hudson, W. H., *A Hind in Richmond Park*; J. M. Dent & Sons Ltd, London, 1922.

2. Collenette, C. L., *A History of Richmond Park*; Sidgwick

& Jackson Ltd, London, 1937.

3. *Ibid.*

4. McDowall, David, *Richmond Park, The Walker's Historical Guide*, 1996.

5. *Ibid.*

6. Reeve, Dr Nigel, Community Ecologist, *Managing for Biodiversity in London's Royal Parks*, the Royal Parks, 2006, Gresham College, City of London.

7. Karter, John, ed., *Guide to Richmond Park*; London, 2011.

8. *Ibid.* Also, *Trees* by Adam Curtis, Assistant Park Manager.

## 9 The Rangers of Richmond Park

1. Collenette, C. L., *A History of Richmond Park*; Sidgwick & Jackson Ltd, London, 1937.

## 10 Richmond Park Today

1. Davies, Hunter, *A Walk Round London's Parks – A Guide to Its Famous Open Spaces*; Zenith, London, 1983.

2. Pink, John, *Kingston-upon-Thames Police versus London Motorists 1903–1913*; 2009.

3. Davies, Hunter, *A Walk Round London's Parks – A Guide to Its Famous Open Spaces*; Zenith, London, 1983.

4. Jackson, Joanna, *A Year in the Life of Richmond Park*; Frances Lincoln, 2003.

# Bibliography

Baxter Brown, Michael, *Richmond Park – The History of a Royal Deer Park* (London: Robert Hale, 1985.

Beresford, M., *History on the Ground* (Lutterworth Press, 1957).

Brace, Marianne and Ernest Frankl, *London Parks and Gardens* (Cambridge: The Pevensey Press, 1986).

*Buildings and Monuments in the Royal Parks* (The Royal Parks, 1997).

Church, Richard, *London's Royal Parks, An Appreciation*, (HMSO, 1993).

Cloake, John, *Palaces and Parks of Richmond and Kew, Volume I: The Palaces of Shene and Richmond* (Chichester: Phillimore & Co. Ltd, 1995).

Cloake, John, *Palaces and Parks of Richmond and Kew, Volume II: Richmond Lodge and the Kew Palaces* (Chichester: Phillimore & Co. Ltd, 1996).

Cloake, John, *Richmond Palace – Its History and Its Plan* (Richmond Local History Society, 2000).

Collenette, C. L., *A History of Richmond Park* (London: Sidgwick & Jackson Ltd, 1937).

Conway, Hazel, *People's Parks, The Design and Development of Victorian Parks in Britain*, (Cambridge: Cambridge University Press, 1991).

Conway, Hazel, *Public Parks* (Shire Publications Ltd, 1996).

Cundall, H. M., *Bygone Richmond* (John Lane, The Bodley Head, 1925).

Edgar, Donald, *The Royal Parks* (London, W. H. Allen, 1986).

Fletcher Jones, Pamela, *Richmond Park, Portrait of a Royal Playground* (Chichester: Phillimore, 1972).

Hart, C., *The Vederers and the Forest Laws of Dean* (David & Charles, 1971).

Hore J. P., *History of the Royal Buckhounds* (Newmarket, 1895).

Hoskins, W. G., *The Making of the English Landscape* (Hodder and Stoughton, 1955).

Jackson, Joanna, *A Year in the Life of Richmond Park* (Frances Lincoln, 2003).

Karter, John, ed., *Guide to Richmond Park* (London, 2011).

Larwood, Jacob, *The Story of the London Parks* (London: Chatto and Windus, 1881).

Lasdun, Susan, *The English Park, Royal, Private and Public* (London: Andre Deutsch Ltd, 1991).

McDowall, David, *Richmond Park: The Walker's Historical Guide* (Richmond, 1996).

Ommanney, F. D., *The House in the Park* (Longmans, Green & Co., 1944).

Rabbitts, Paul, *London's Royal Parks* (Shire Publications, 2014).

Rabbitts, Paul, *Regent's Park, From Tudor Hunting Ground to the Present* (Stroud: Amberley Publishing, 2013).

Rackham, Oliver, *Trees and Woodland in the British Landscape – The Complete History of Britain's Trees, Woods & Hedgerows* (London: Orion Books Ltd, 1996).

Ramsey, Susanne, *Family Trails in Richmond Park* (Friends of Richmond Park, 2011).

Rasmussen, Steen Eiler, *London: The Unique City* (Cambridge: MIT Press, 1934).

Russell, Bertrand, *The Autobiography of Bertrand Russell 1872–1914* (London: George Allen & Unwin Ltd, 1967).

Saberi, Alex and John Karter, *Richmond Park* (ACC Editions, 2012).

Tait, Malcolm and Edward Parker, *London's Royal Parks* (The Royal Parks Foundation, 2006).

Weir, Alison, *Henry VIII King and Court* (London: Pimlico, 2002).

White, Kathy and Peter Foster, *Bushy Park, Royals, Rangers and Rogues* (Foundry Press, 1997).

Williams, Guy, *The Royal Parks of London* (London: Constable, 1978).

Also available from Amberley Publishing

Regent's Park

From Tudor Hunting Ground
to the Present

PAUL RABBITTS

Available from all good bookshops or to order direct
Please call **01453-847-800**
**www.amberleybooks.com**

# Index